CALIFORNIA

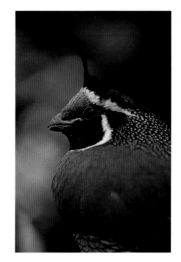

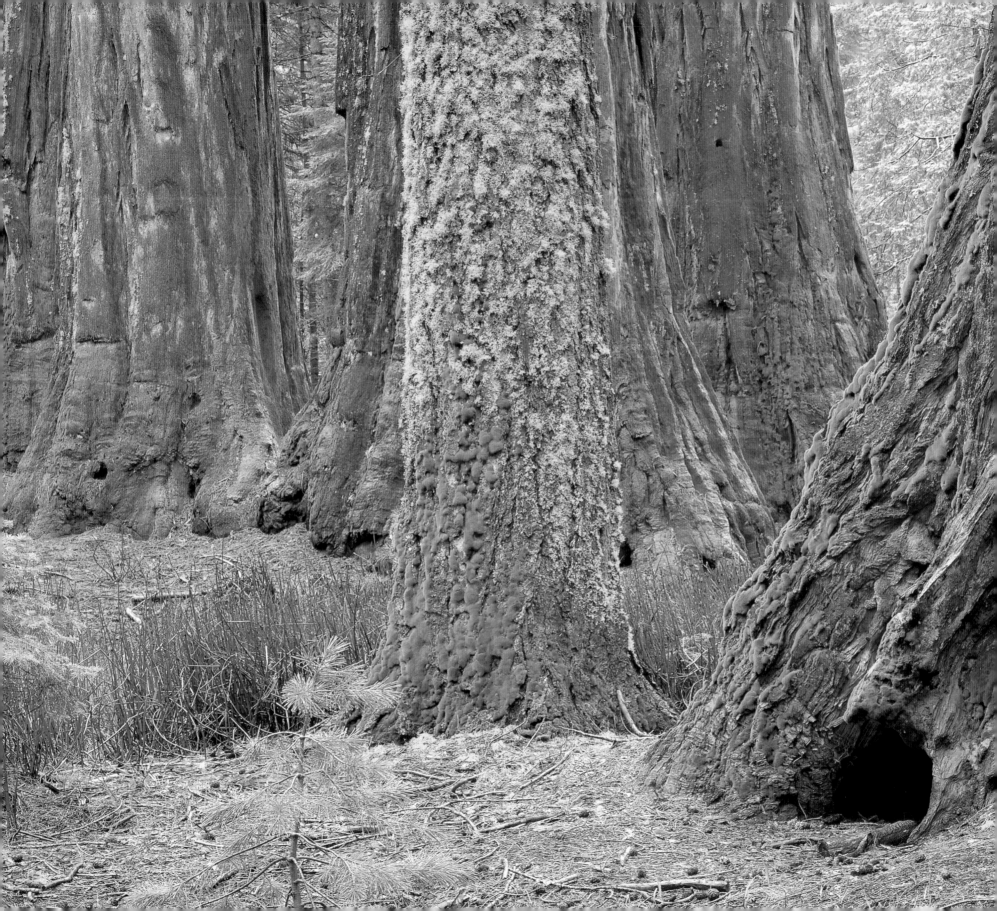

CALIFORNIA

ART WOLFE

TEXT BY PETER JENSEN

SASQUATCH BOOKS
SEATTLE

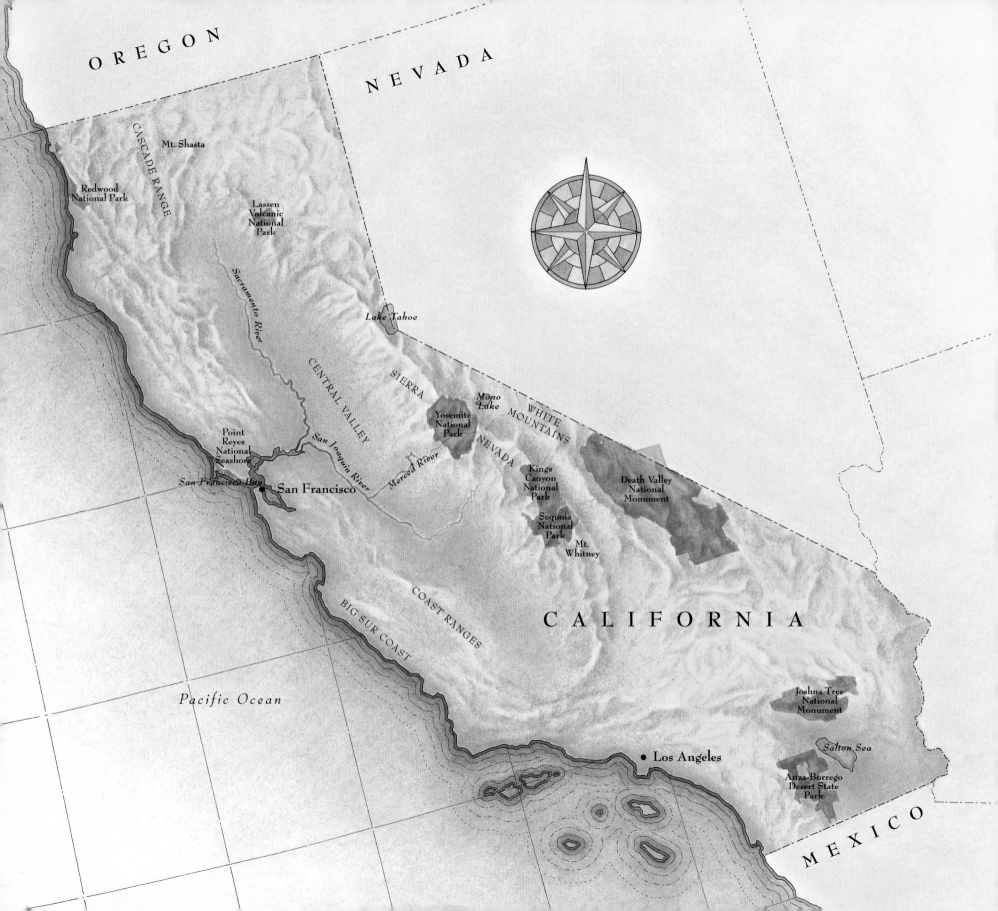

CONTENTS

For Joan Skillman, an educator who imbued thousands of students in the Bay Area and overseas with the limitless spirit of California.

ACKNOWLEDGMENTS

I gratefully acknowledge the kindness of the following friends, organizations, and people, who welcomed me to visit, took the time to share their surroundings both personally and professionally, and thereby immeasurably enriched my experience of California: Kristine Horn, Andy Bechtolsheim, Ian Mackenzie, Michael Koch, Craig Latker, Stephen Arod Shirreffs, Richard Board, Mark Jorgenson of Anza-Borrego State Park, Paul Jorgenson, and Kris Ingram, Ken Peterson, and Andy Johnson of Monterey Bay Aquarium.

A very special thank you to Gary Stolz, Chief Naturalist, U.S. Fish and Wildlife Service and Associate Professor, University of Idaho, for his expertise. Also, thank you to John Bowles, Sequoia Natural History Association, Sequoia National Park.

Additionally, I wish to extend my heartfelt appreciation to Sheila Brown, Kate Campbell, Christine Eckhoff, Gavriel Jecan, Kaarin Keil, Gilbert Neri, Ray Pfortner, Craig Scheak, Deirdre Skillman, Alexis Wolfe, and Lisa Woods for their contributions to the production of this book. I am extremely grateful for their efforts, ideas, experience, and talents, which make all I do possible.

—A. W.

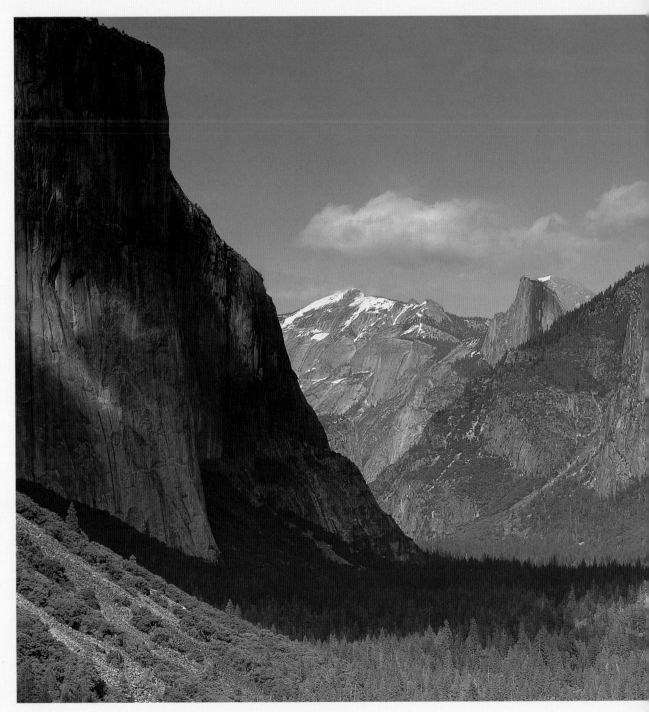

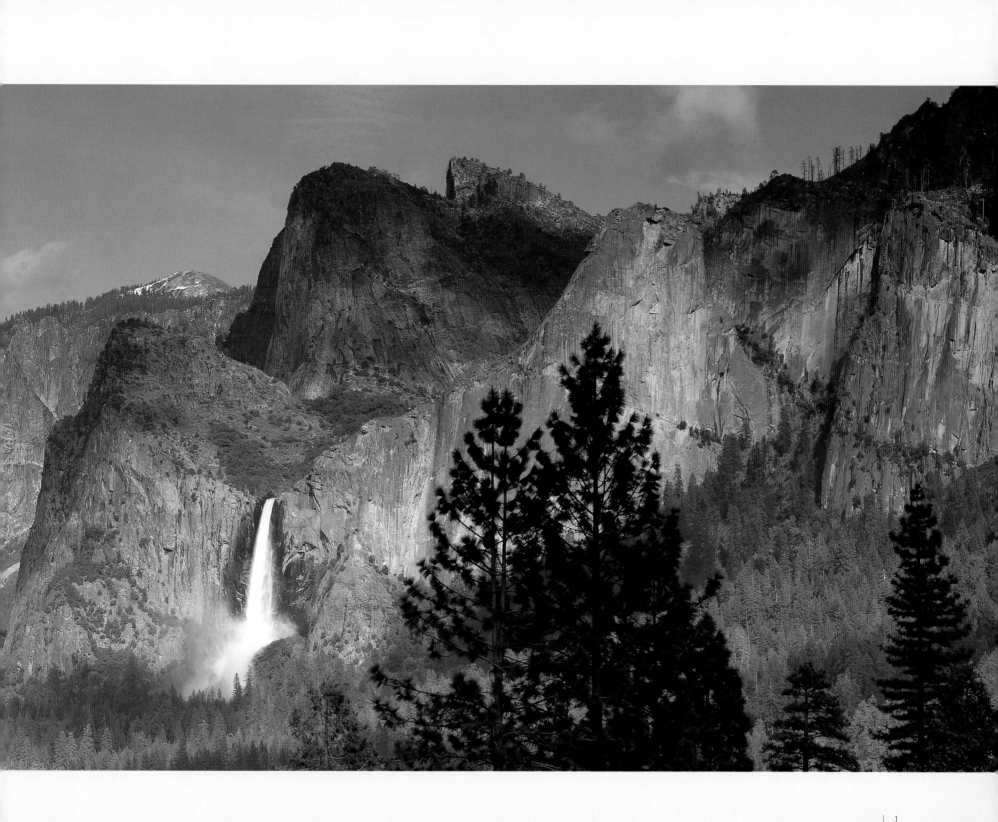

INTRODUCTION

I can remember to this day the first time I ever traveled to California. During winter break in 1969, some friends and I racked up many road miles doing the "Grand Tour" of the state. Having never been there, I had the stereotypical preconceptions of what California would be like, gleaned from television and magazines, which were the only sources of knowledge I had of the state. So of course, I knew all about Disneyland and its faux Matterhorn; I knew that Hollywood was there, and that the Golden Gate Bridge was in San Francisco, and that San Francisco was a beautiful city situated on hills very similar to my hometown of Seattle. And of course, the sun shone all the time.

We took fabled Highway 1 down the Washington and Oregon coasts and into California through the Klamath Mountains. My first impressions came from driving through Crescent City and coming to the groves of redwoods in Redwood National Park. It was there that I experienced my first true taste of what natural California had to offer. I had never seen any living thing of that magnitude in my life. The redwoods were so tall that their 350-foot-high crowns were lost in a midwinter mantle of fog, and their massive trunks dwarfed everything in their midst.

The farther we ventured into the state, the more my naïve perceptions were changed. Where was the immense population and choking smog? I found instead a stunning coastline intersected by ridges and valleys, and a pastoral beauty that was largely untrammeled and thankfully undiscovered by the casual tourist. We made our way to San Francisco where we stayed a few days enjoying the sights and scenes of that great city. Then we continued on to Big Sur and once again the raw beauty of the coastline profoundly affected me. I remember to this day sitting on a small deck outside a cabin on the Central Coast, smelling the honeysuckle vines a-buzz with hummingbirds and hearing news reports that Seattle was experiencing a snow storm. Later in the day, at an al fresco café, we looked several hundred feet down a cliff and watched sea otters frolicking in the kelp beds.

We made it as far south as San Diego, turned east, and set off into the desert. What an experience the arid and elemental landscape of Death Valley was for someone fresh out of the mossy Pacific Northwest. The December nights were unexpectedly cold, but during the day it warmed up to a pleasant seventy-five degrees. Following the eastern slope of the Sierra Nevada through Owens Valley and past monumental, yet ecologically devastated, Mono Lake—deprived of water by the Los Angeles Aqueduct—we skirted Lake

Tahoe and dropped over to the west side once again. We ended up in Yosemite, with its great granite walls etched in snow and the smell of juniper smoke wafting through the valley. The scene is still fresh in my mind thirty years later.

Since my first Grand Tour of California, I have returned countless times. It is a landscape photographer's dream, full of amazing geological diversity, and I cannot think of any state in the entire country that offers so many different experiences. If California were a state on the East Coast, it would stretch from Maine to Georgia. Truly unique is Death Valley, with its blistering heat and sub-sea level elevation—at -282 feet, the lowest in the United State. There is the tilted granite block of the High Sierra, with it alpine tarns and meadows, and home to Mount Whitney, the highest mountain in the Lower 48. The snow-capped volcanoes of Shasta and Lassen, located in the southern reaches of the Cascade Range, clearly rival the beauty and power of Washington's icon, Mount Rainier. A sea in primordial times and now productive farmland, the great Central Valley has fields of flowers near Lancaster and Bakersfield that are unparalleled in sheer size and color. The rugged coastline, made up of five mountain ranges, is every bit as wild and untamed as you would find elsewhere in the United States, and the North Coast redwood forests simply tower over the cedar and spruce forests of the Pacific Northwest.

With nearly 35 million residents and the fifth or sixth most powerful economy in the world, California must confront the major challenge of how to protect its environment from encroachment and overuse. The conflict between economic prosperity and environmental health has been an issue since the days of the Gold Rush in 1849. In the face of overnight development and environmental exploitation, the Sierra Club was founded in 1892, with John Muir as its first president. In the century since, it has evolved into one of the most effective environmental lobbies in the United States. In the last century, various commissions have been set up to protect California's 1,264-mile coast and to save San Francisco Bay from the leeching poisons of landfills. How to protect its multiplicity of delicate environments and ecosystems as well as its multiplicity of human cultures is indeed a huge challenge for California in the twenty-first century. Because of its status as a bellwether state, California's policies, successes, and failures will affect us all.

—ART WOLFE

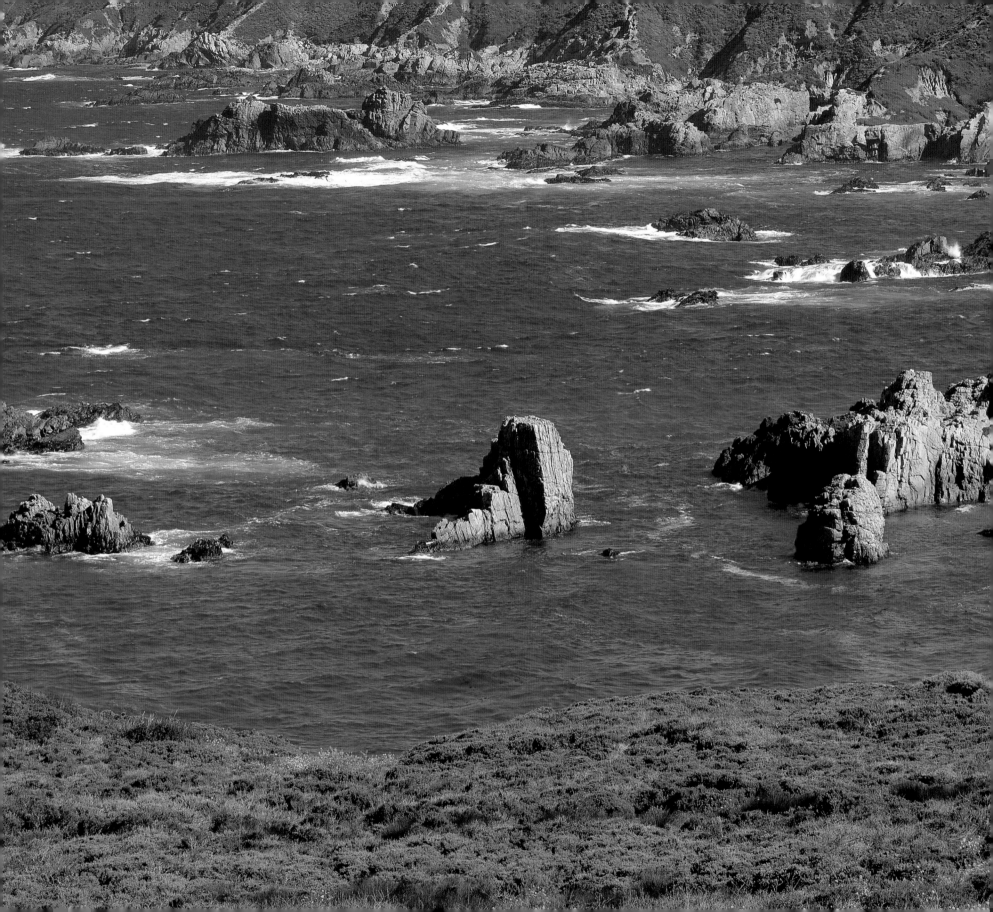

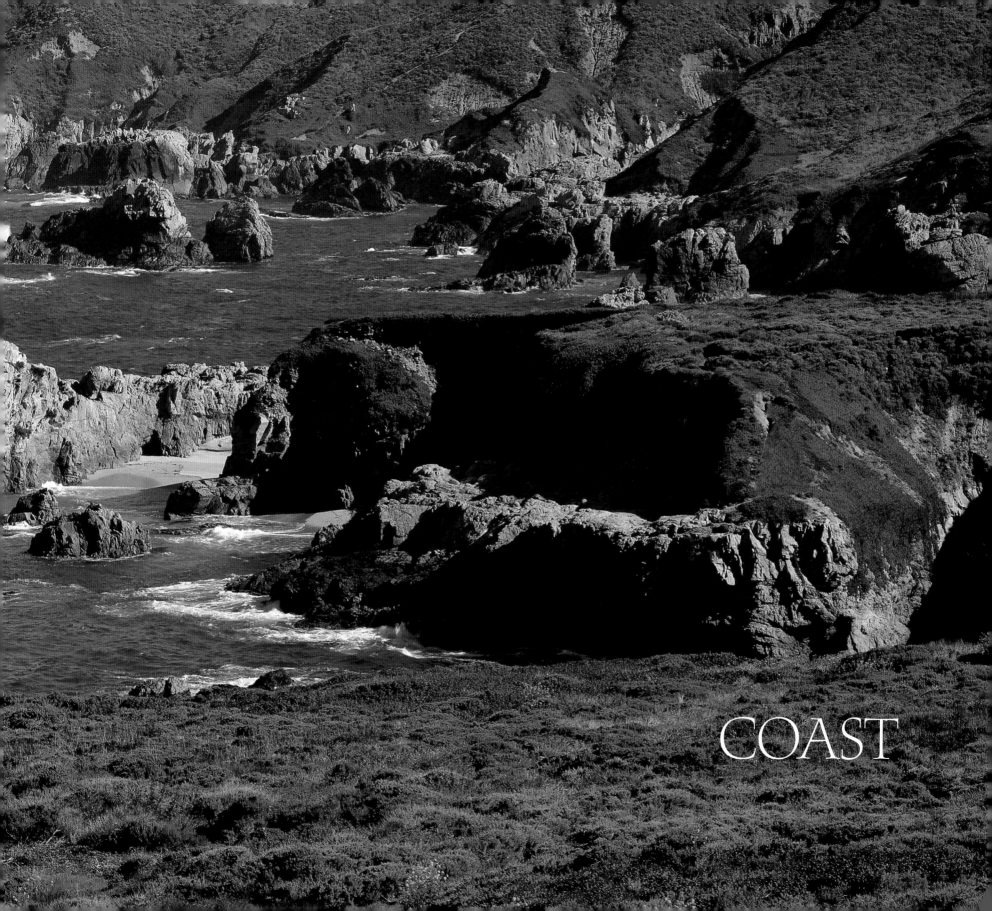

COAST

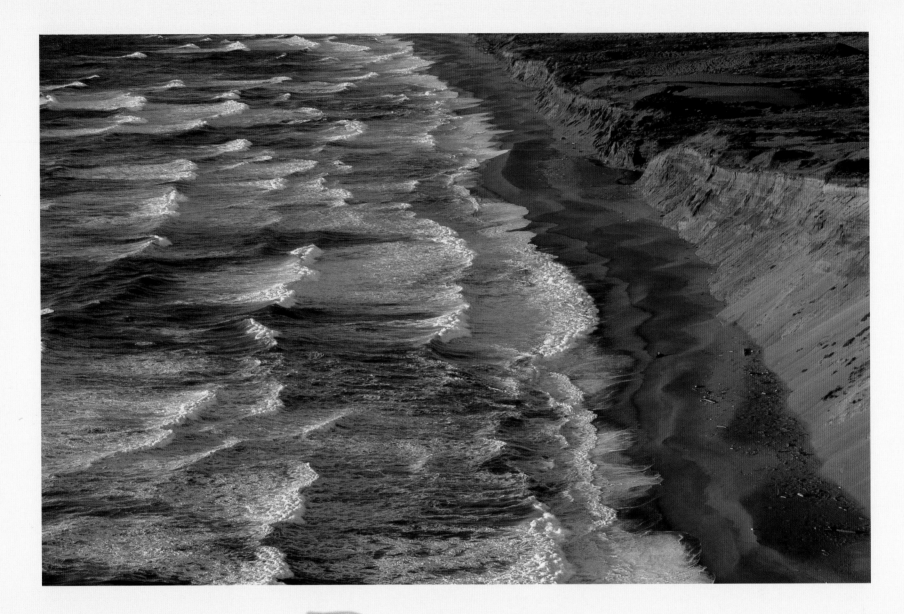

Ragged boys, we wore blue jeans and carried heavy packs and sleeping bags in the days before clothing and equipment were weighed in grams and analyzed like space shuttle components. We stumbled toward a sea hidden by soft dunes and thick clumps of gray-green grasses ten

miles up the shoreline from Point Reyes Lighthouse. Our canvas tennis shoes filled with sand. Some of us wore bandannas. Despite the cool wind curling down through the dunes, we were hot. This was work.

Louder now, the deep kettledrum sound of surf reached us, more a vibration up through the shore than a noise. Behind us the midsection of Point Reyes retreated in a sparsely inhabited duneland owned by dairy farms and divided by a few lonely country roads. No one had yet spoken of this area as a possible national park. It was simply a section of coast, about a half day's drive north of San Francisco, set off from the mainland by a series of bays and estuaries both to the north and the south. Rumor had it that Sir Francis Drake careened the *Golden Hinde* near here in an *estero* (Spanish for estuary) protected from the north swells. As a twelve-year-old obsessed with adventure, I thought often of that ship, stranded at low tide like a confused whale halfway around the world from England, its crew crawling over the wooden hull like intertidal rock lice, recaulking the leaky gaps between the strakes.

One of us, ahead of the others, reached the highest dune crest and shouted, "There's wood everywhere! Logs. Millions of logs."

Joining him, we looked out over a high-tide line of debris that stretched up and down the beach as far as we could see. On some California beaches the waves leave only a thin line of uprooted bull kelp stipes and their round, brown "baby head" floats, along with tumbled-smooth sticks, shells, agates, and other small treasures. Long before closed-cell foams, it was not uncommon to find lost Japanese glass-ball fishing net floats, stranded after their trans-Pacific meanderings.

This beach netted a forest. Redwood logs up to five feet in diameter lay strewn about in a giant's game of jackstraws. Stumps, knobbed with thick burls above torn roots, either waved their tangles at the passing clouds or seemed to search the steep beach for a new foothold. We didn't know it then, but most had been torn from riverbanks far to the north during the previous winter's historic floods, dumped into the ocean by rivers such as the Russian and Eel along with a torrent of mud, other logging debris, and sand.

California's precious sand. Maker of beaches. Packed or fluffed into place as bars or spits at the mouths of other rivers with names like Van Duzen, Mad, Klamath, Smith, Big, and Mattole. Strewn sparingly along wild steep cliffs of the

Overleaf: Coastline, Big Sur

Left: Point Reyes Beach, Point Reyes National Seashore

heavily forested King Range or Big Sur, another place where mountains step directly into sea. Piled into dunes guarding the still waters of Morro Bay just south of its Gibraltar-like rock, last of a line of ancient volcano plugs that stretch inland toward San Luis Obispo. Dropped like wide, soft blankets along the shores of Malibu, Hermosa, Redondo, Oceanside, and Coronado—the beaches that gave birth to Southern California's ocean-loving culture.

Transported grain by grain, sand travels southward with large winter wave systems, bumped along by California's longshore current, resting at beaches and river mouths until, years later, it finally swirls into the depths of a submarine canyon, such as the deep trench off La Jolla. Sand has always been lost this way off the coast. It always will be. The alarm over the narrowing of beaches in the last century along the California coast can be traced more directly to loss of the source: Dammed rivers now block millions of tons from ever reaching the sea.

I threw my pack down in a fold of the dunes to leap and roll down a steep face toward the sea. The surf roared its welcome, hissing up the beach, then ripping back into the white confusion of another breaking comber. In places I could shinny my way out onto a log that hung over a part of the beach undercut by the waves. I stood up at the end, Johnny Weissmuller on a great, round diving board, daring the whole contraption to teeter with my weight into the onrushing surf.

For three nights we camped in the dunes. The fathers who brought us pitched their tents and made their fires well away, leaving us to create our own village of driftwood. We scorned tents, creating multiroom lodges and hogans deep in the tufted maze. We built roaring fires and danced in the orange light that, seen from behind the neighboring dunes, looked like a sunrise blooming over a distant range. The pulse of wave and tide and wind became a simple music that muted our first day's whoops later into hours of silence, solitary walking, and occasional bursts of more house building. All would be torn apart by the next storm, but during this brief lull it was we who were the arrangers, not the waves.

Wilderness is most often thought of as a place of roadless forest and icebound summit, powerful rivers and labyrinthine sandstone canyons. Yet even in California's most populated coastal regions, wilderness holds sway wherever tides and waves chop at the shore and change it daily. Years later, long after Point Reyes earned pro-

tection as a national park, I returned with someone I loved and walked the dunes. The logs weren't as numerous and overnight camping was forbidden. Those boyhood bonfires were memories, but as my wife and I lay in the sun protected from the wind off the sea, I heard the same song. She raised her head and watched sanderlings and dowitchers work the shore, tagging waves with a blur of feet and probing bills. Her long hair blew around her brown face and over the soft side of a wave-tumbled log that rested warm beside us, matching its honey-silver color. Later, following an ebbing tide, we searched a place where the waves had left a narrow band of perfectly sorted stones. We each collected a handful of tiny, translucent amber bits no larger than sunflower kernels. Then, when we had enough to feel the urge to take them home and put them on a glass shelf, we turned and flung them back into the sea.

Right: Tule elk bulls (*Cervus elaphus nannoides*), Point Reyes National Seashore

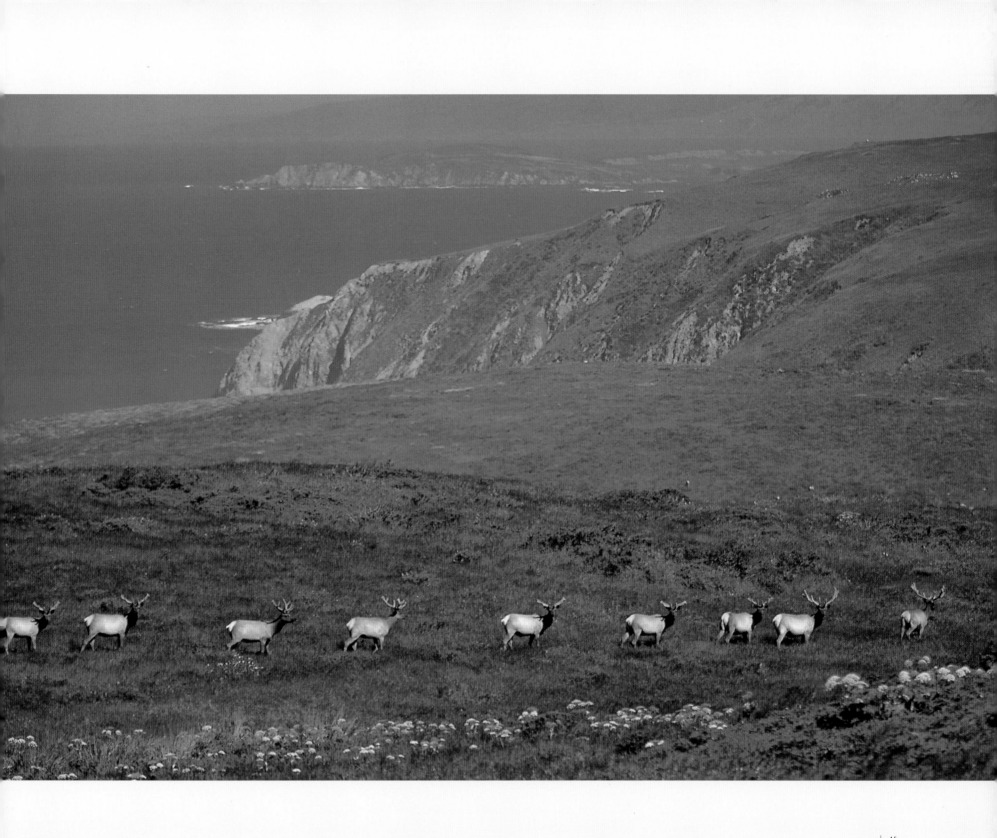

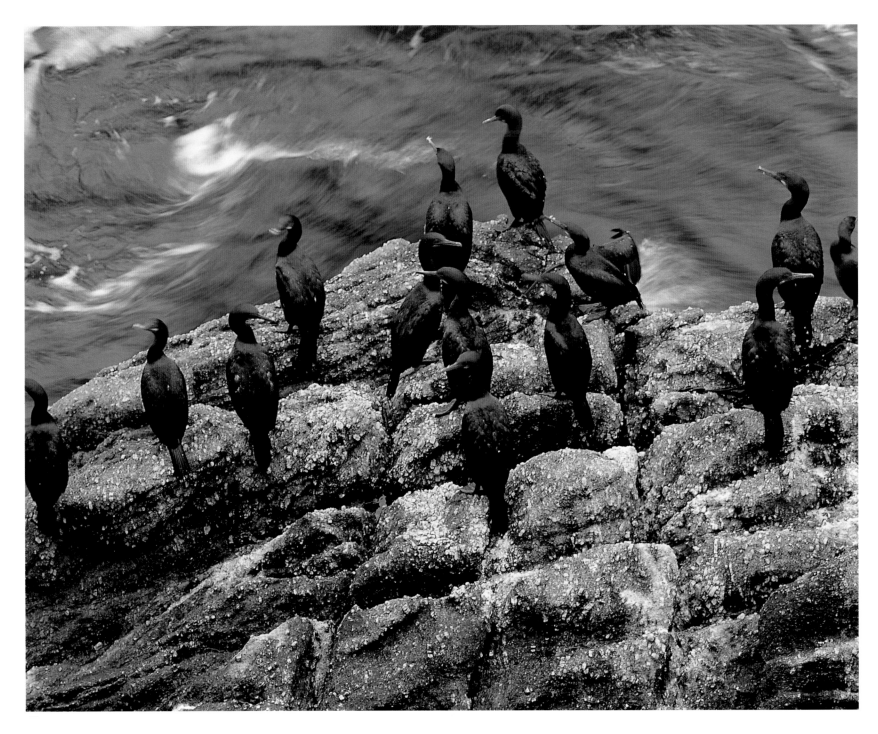

Brandt's cormorants (*Phalacrocorax penicillatus*),
Point Lobos State Reserve

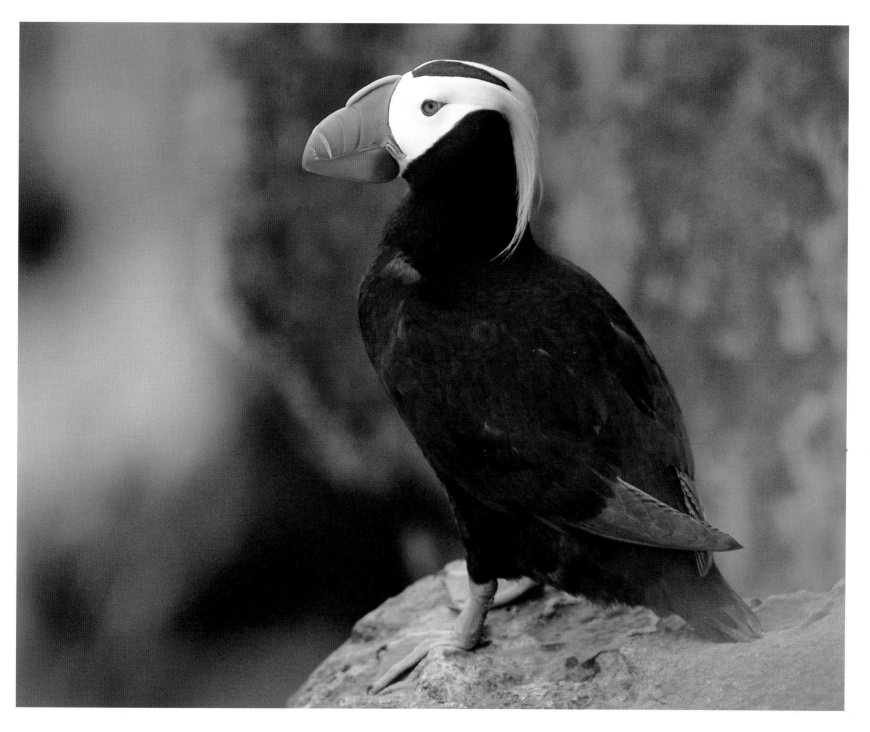

Tufted puffin (*Fratercula cirrhata*), Farallon
National Wildlife Refuge

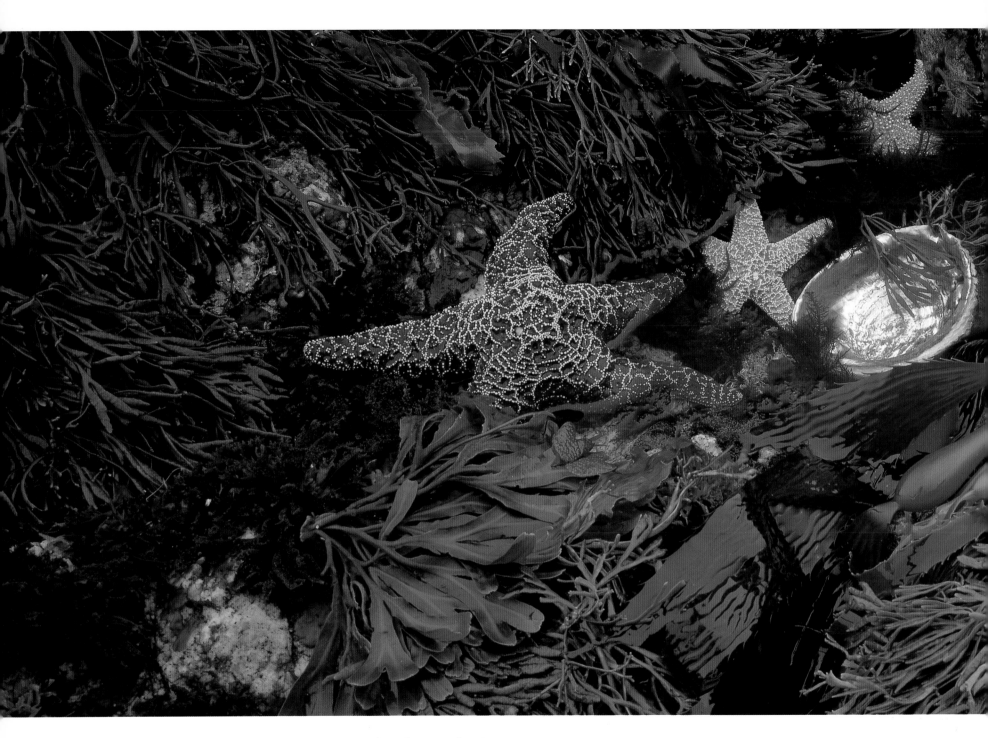

Tide pool, Point Lobos State Reserve

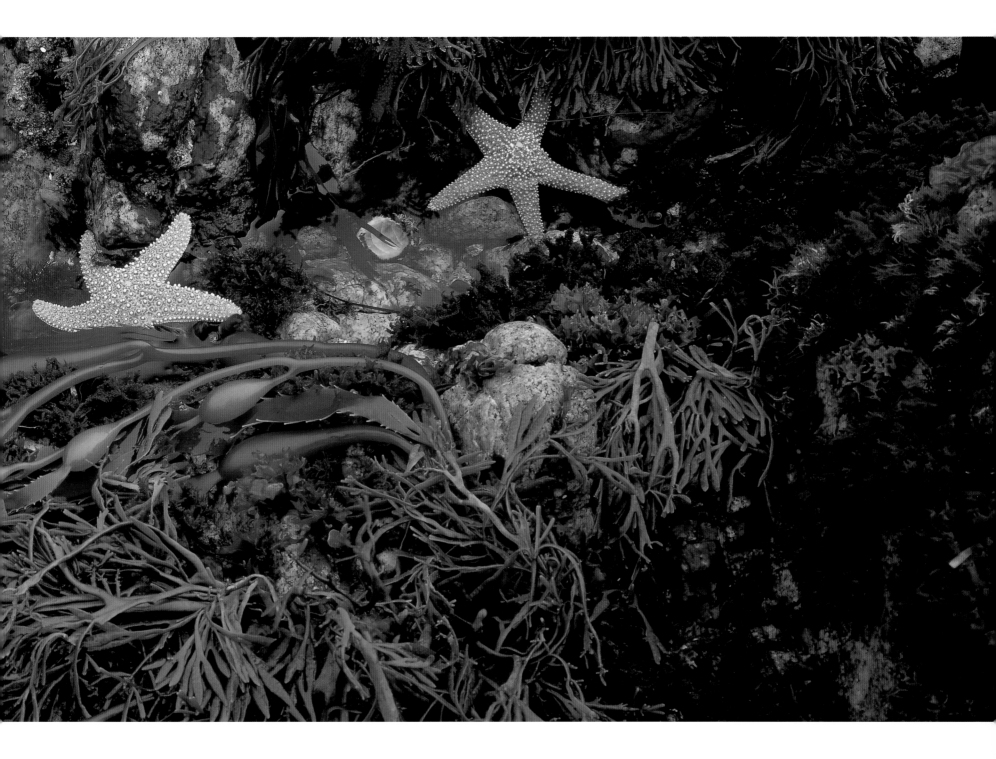

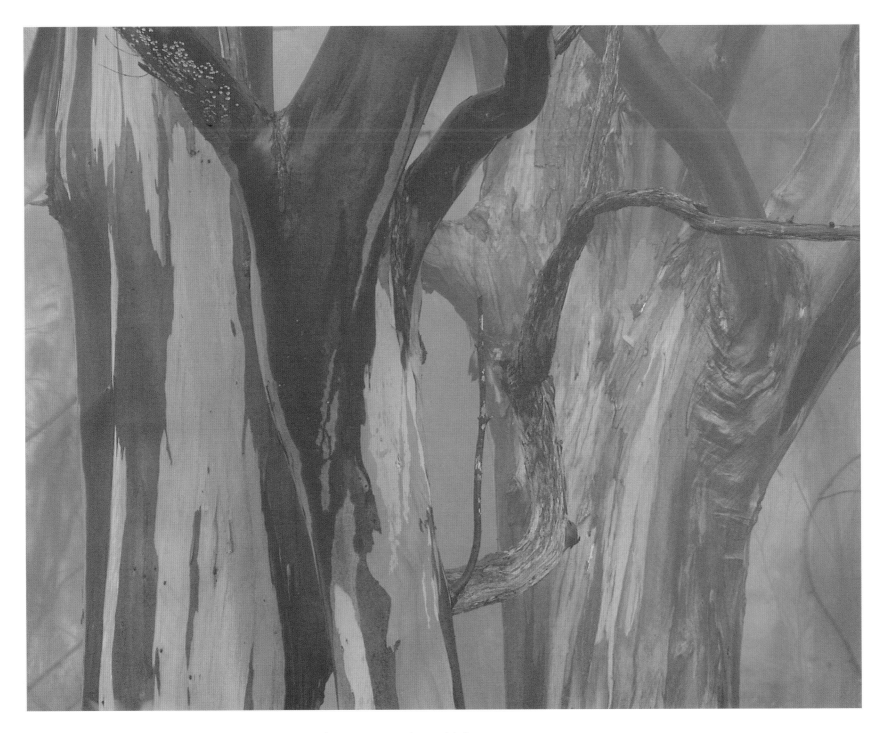

Eucalyptus trees (*Eucalyptus globulus;* non-native species), Point Reyes National Seashore

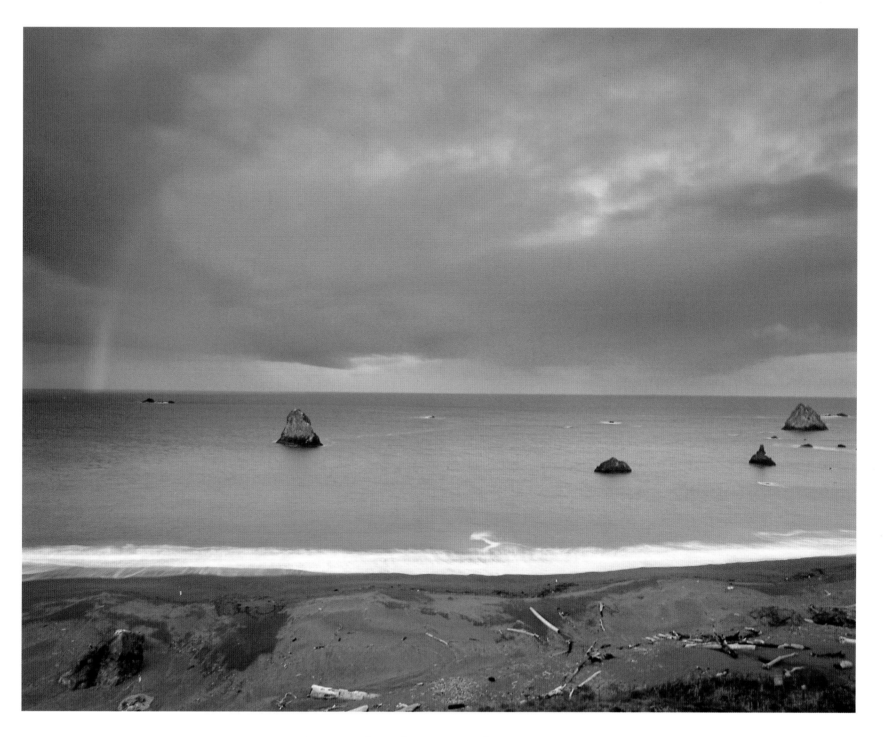

Sonoma coastline, Salt Point State Park

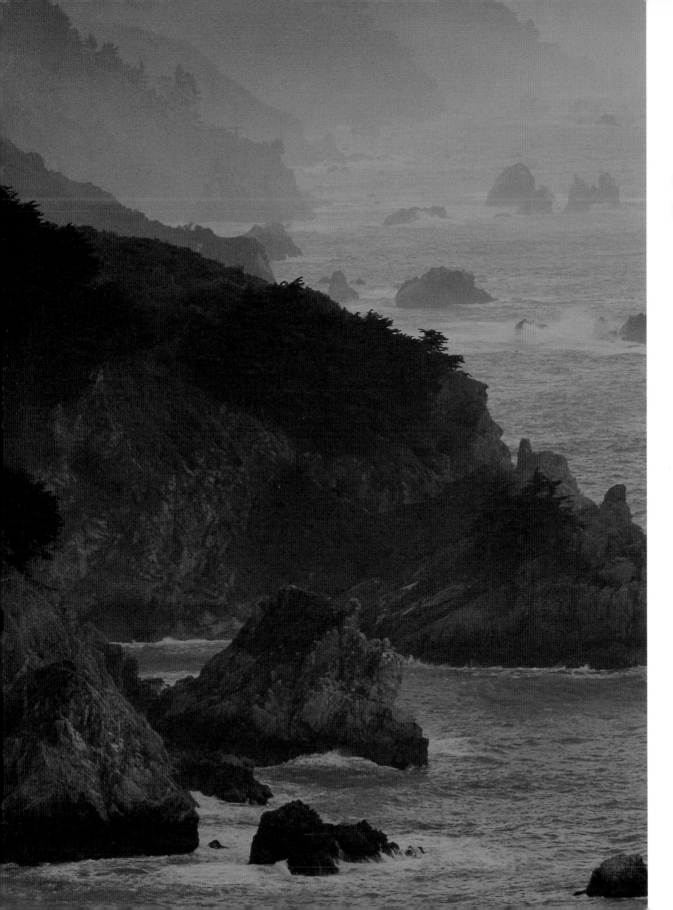

Left: Coastline, Big Sur

Right: Wave-polished rocks, Point Lobos State Reserve

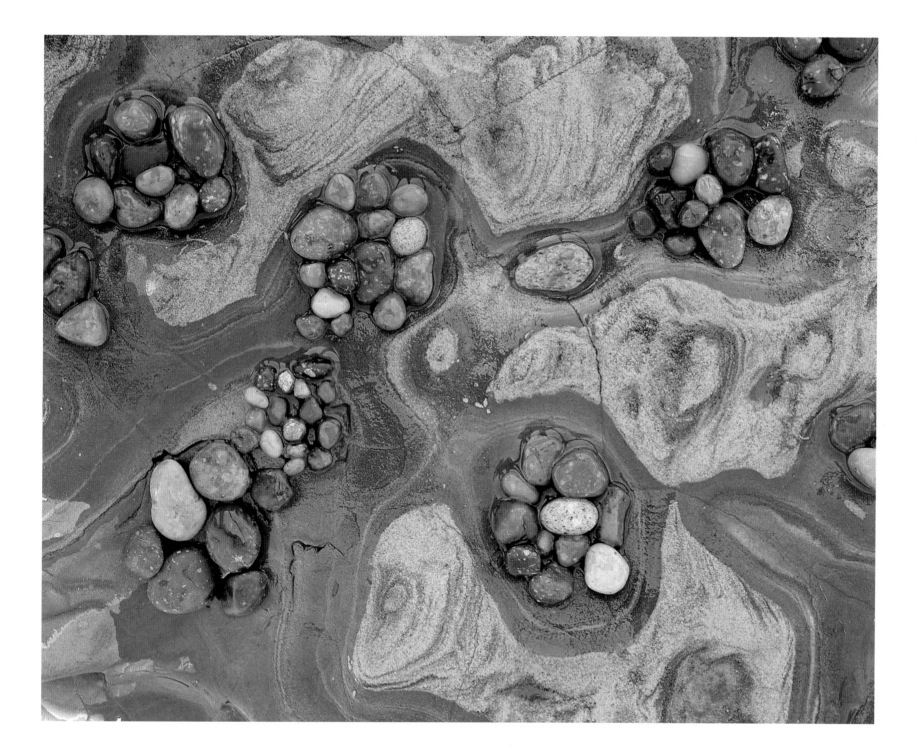

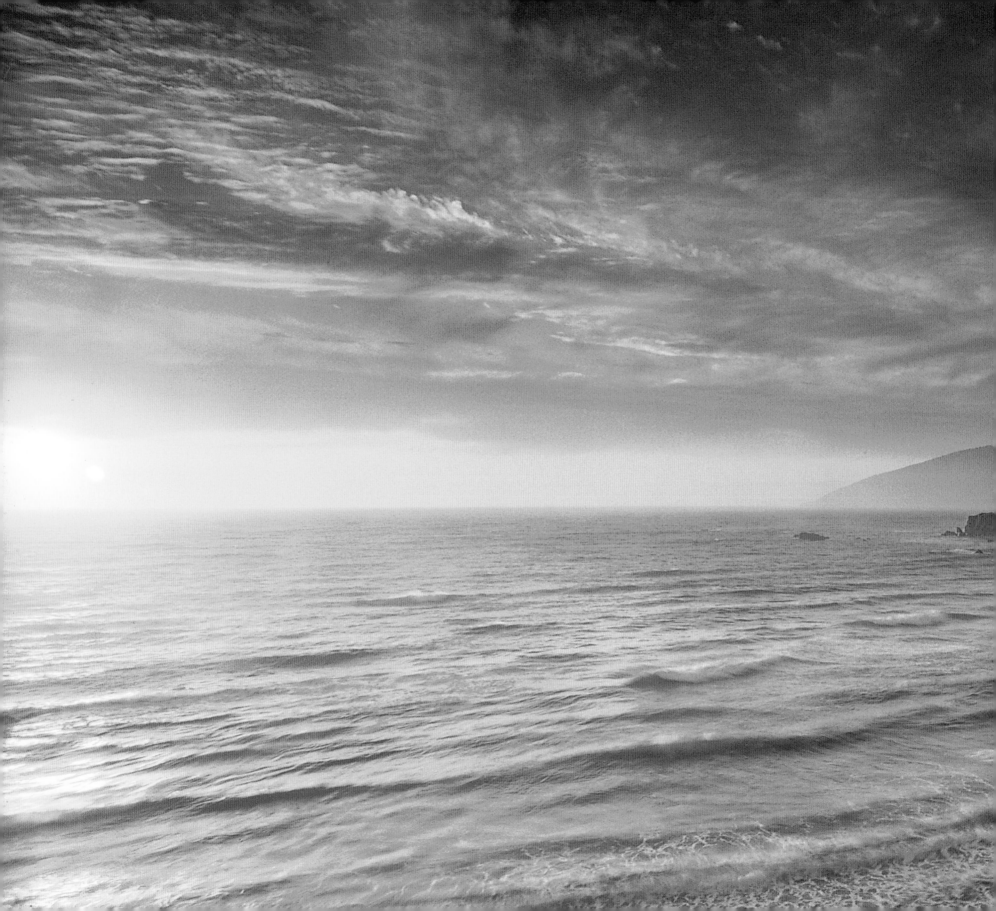

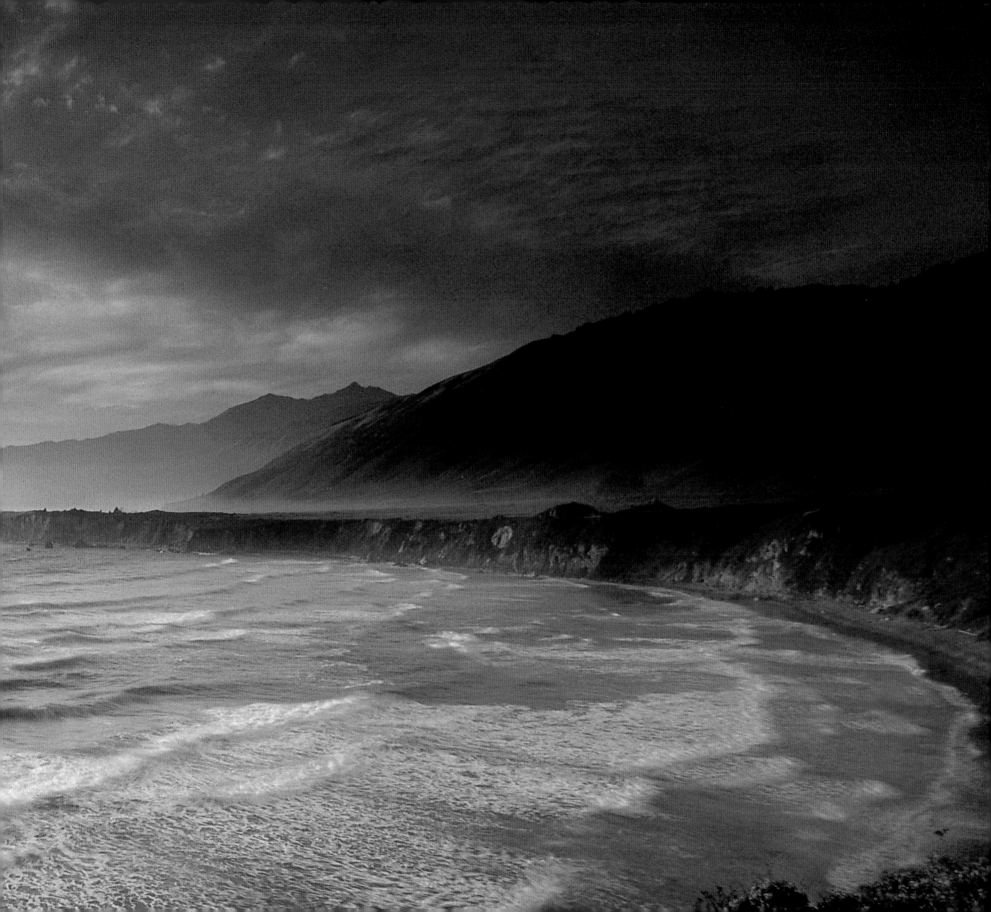

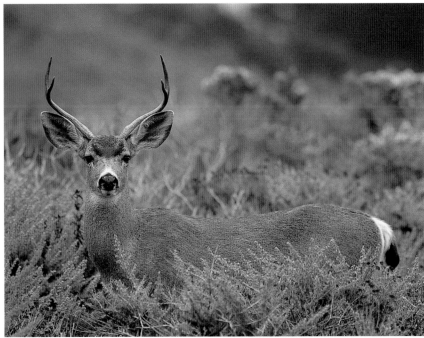

Overleaf: Sunset, Morro Bay

Left: White-tailed buck (*Odocoileus virginianus*), Point Lobos State Reserve

Below: Marbled godwits (*Limosa fedoa*), Mission Bay

Right: California sea lion colony (*Zalophus californianus californianus*), King Range National Preservation Area

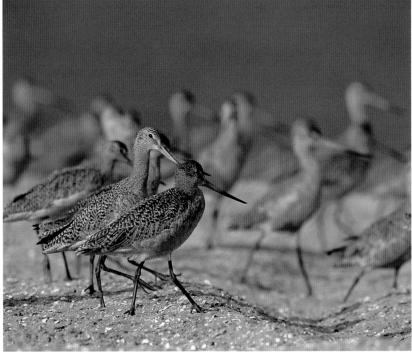

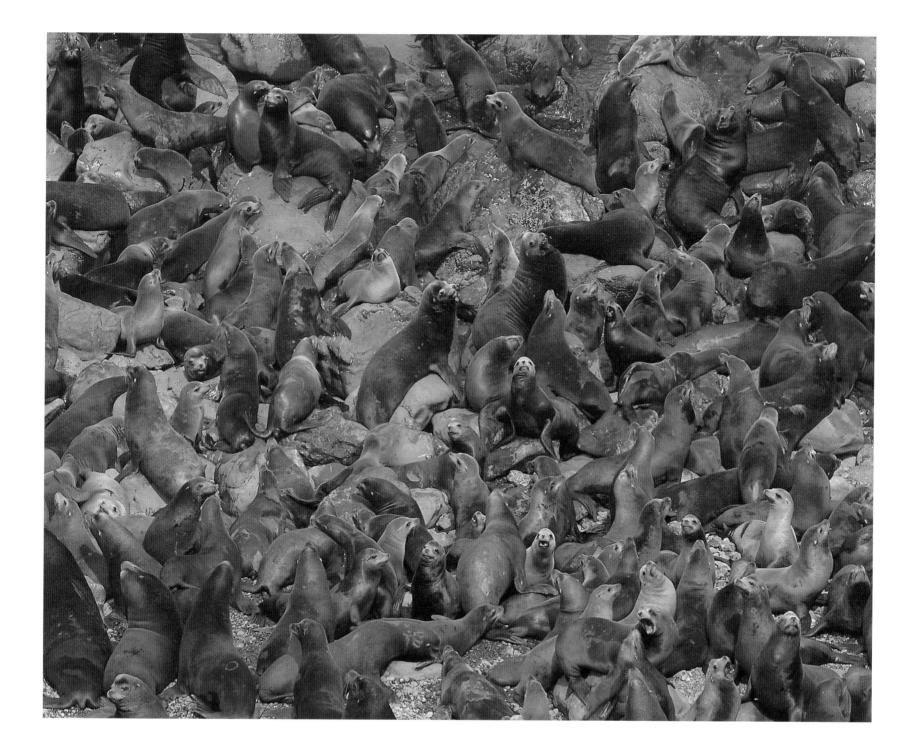

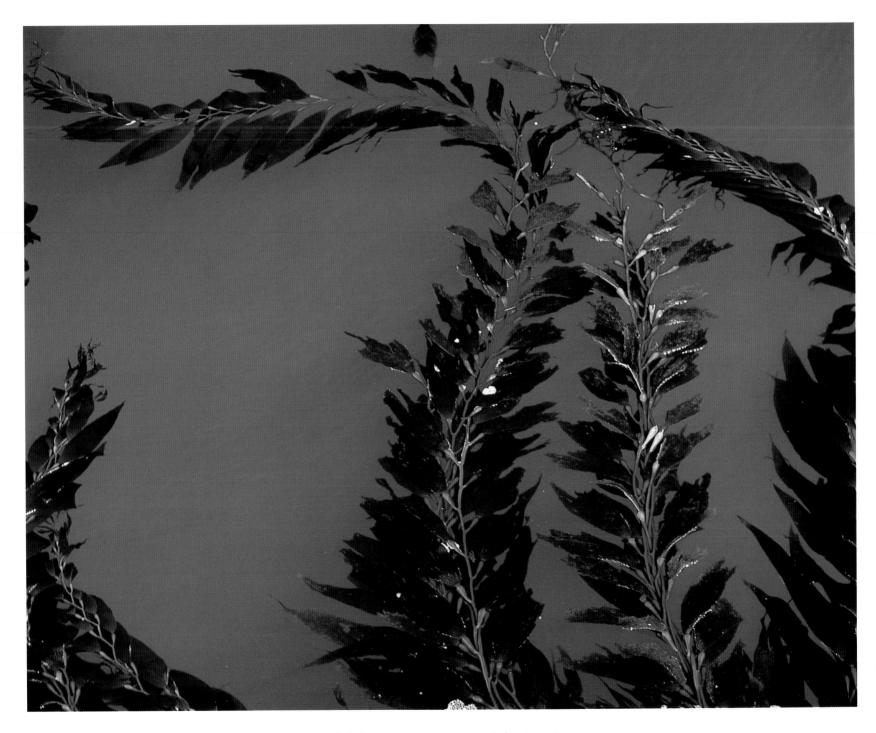

Giant kelp (*Macrocystis pyrifera*), Point Lobos State Reserve

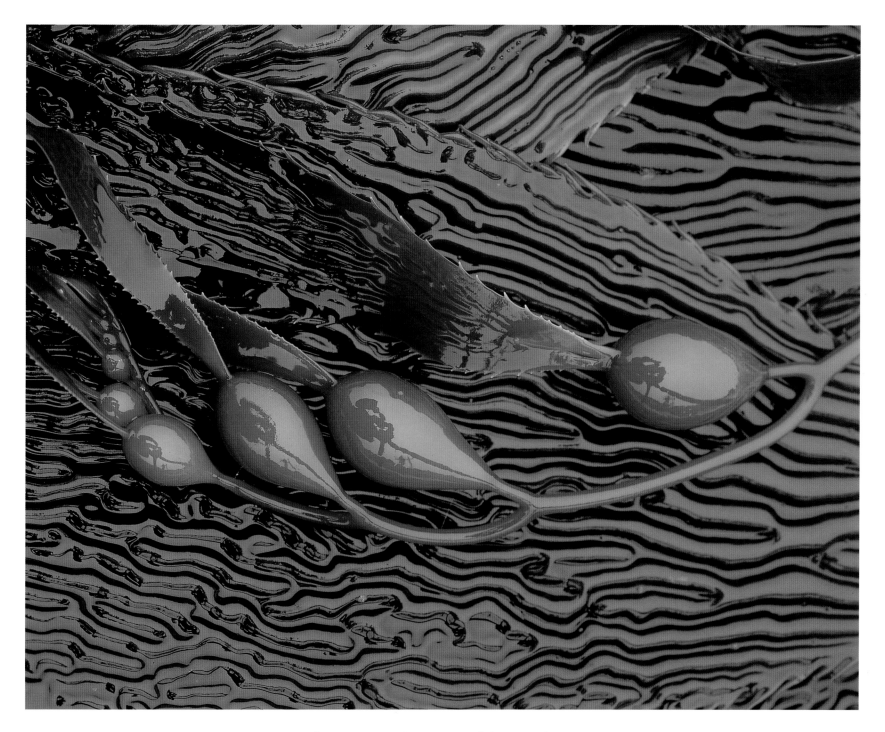

Kelp pneumatocysts (*Macrocystis pyrifera*), Point Lobos
State Reserve

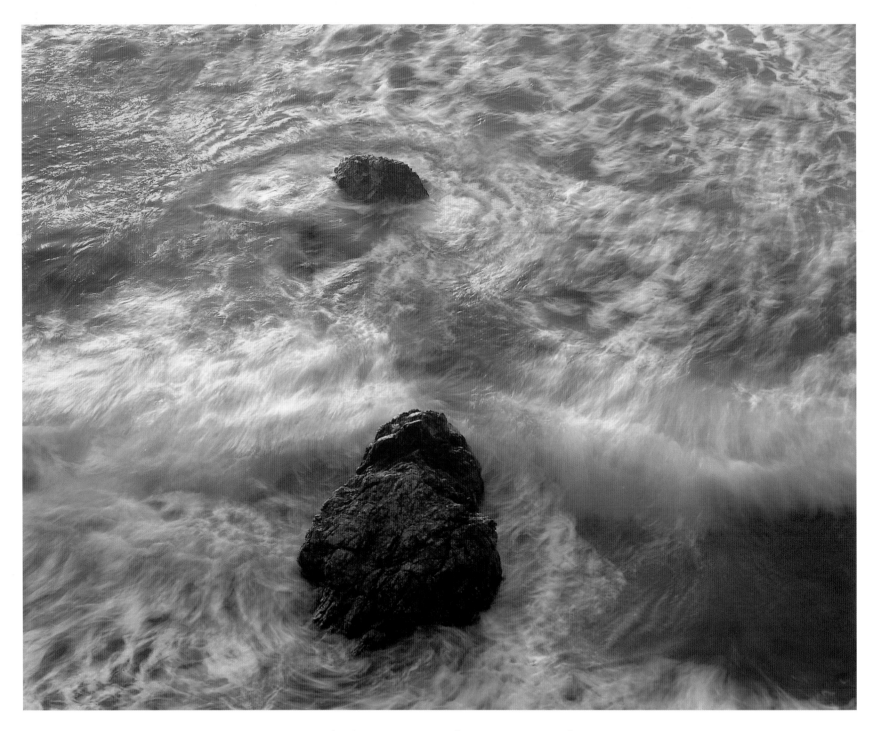

Waves breaking against coast rocks, Morro Bay State Park

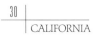

South African ice plants (*Carpobrotus chilensis*; non-native) along the rugged coast, Andrew Molera State Park

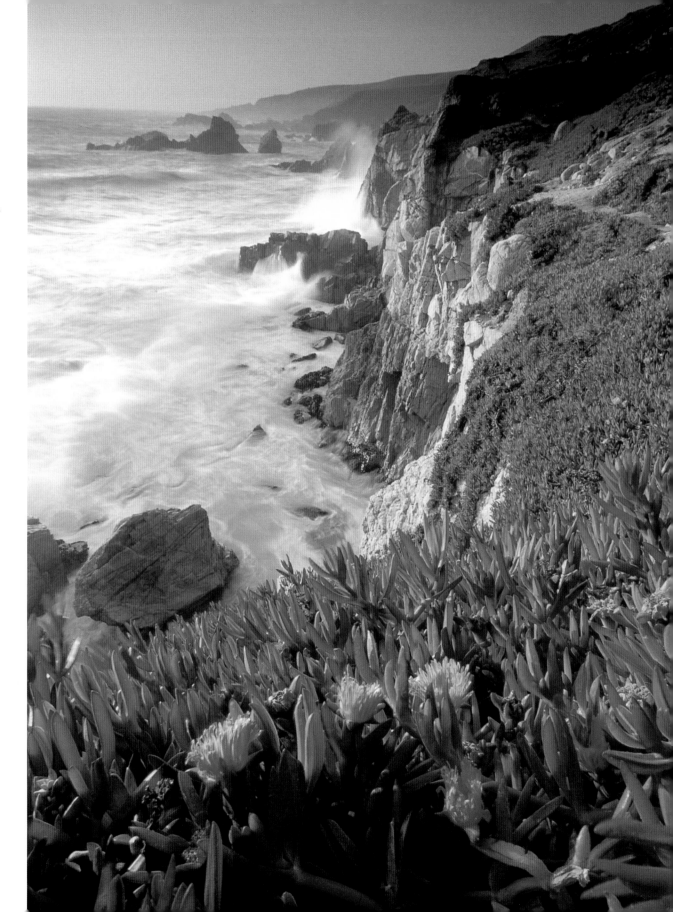

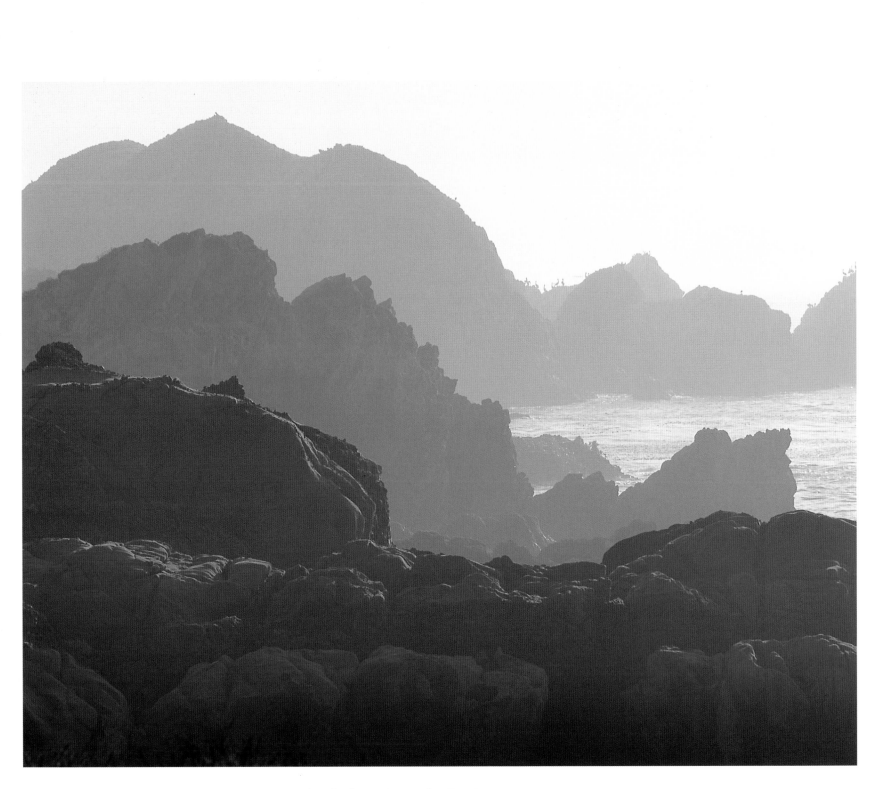

Coast landscape, Point Lobos State Reserve

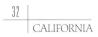

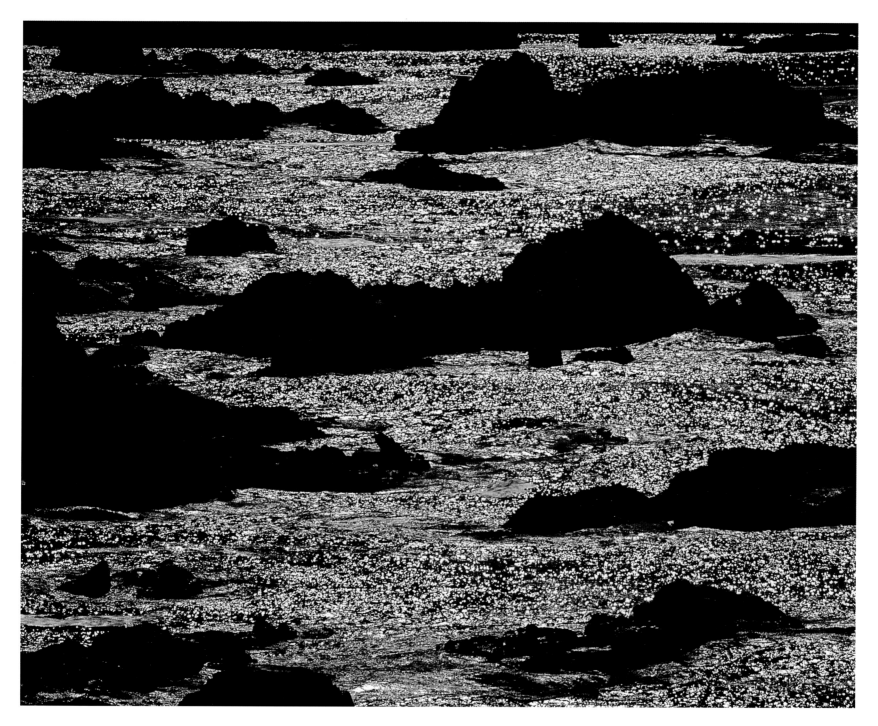

Offshore rock formations, Big Sur

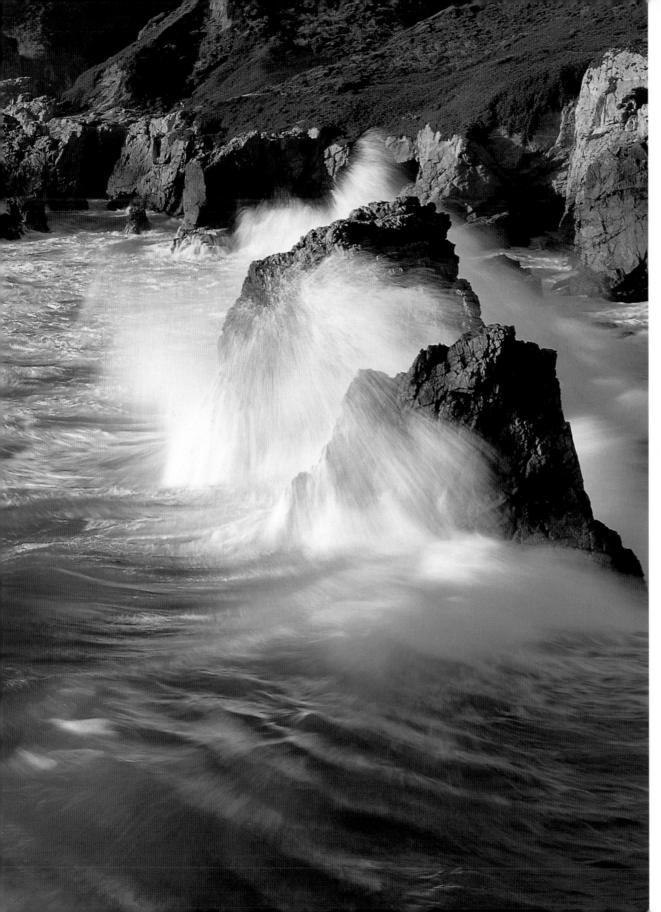

Left: Waves crashing against sea stacks, Andrew
Molera State Park

Right: Southern sea otter (*Enhydra lutris nereis*),
Elkhorn Slough

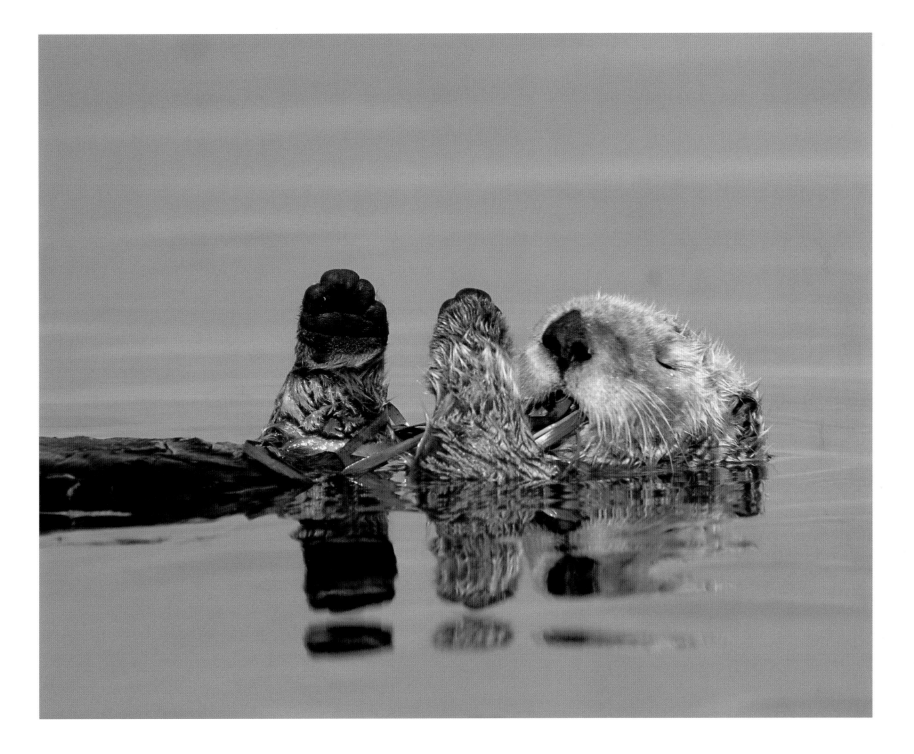

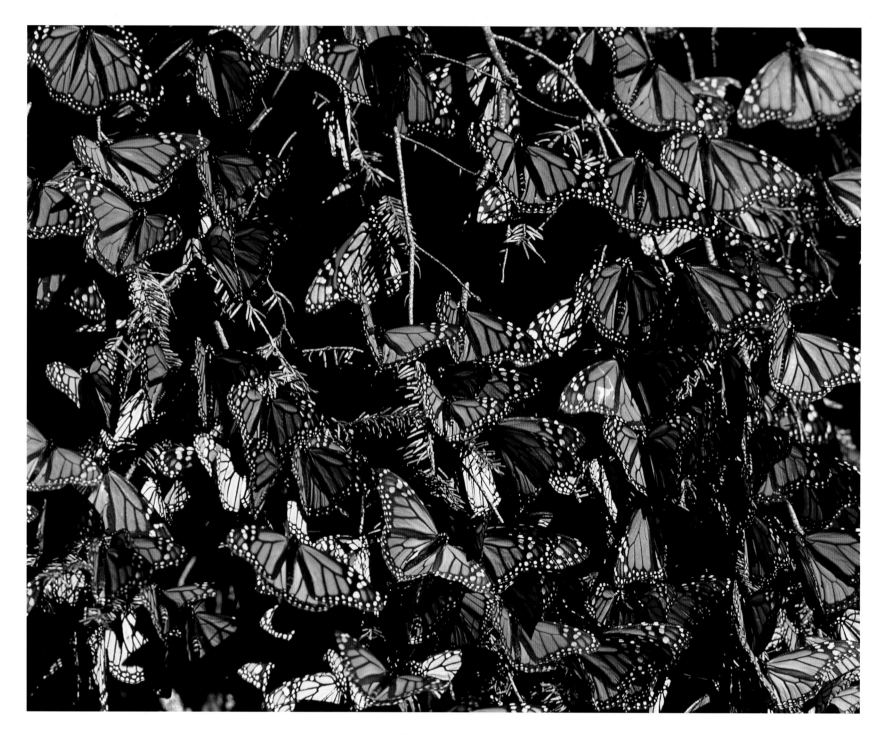

Monarch butterflies (*Danaus plexippus*), Pismo Beach

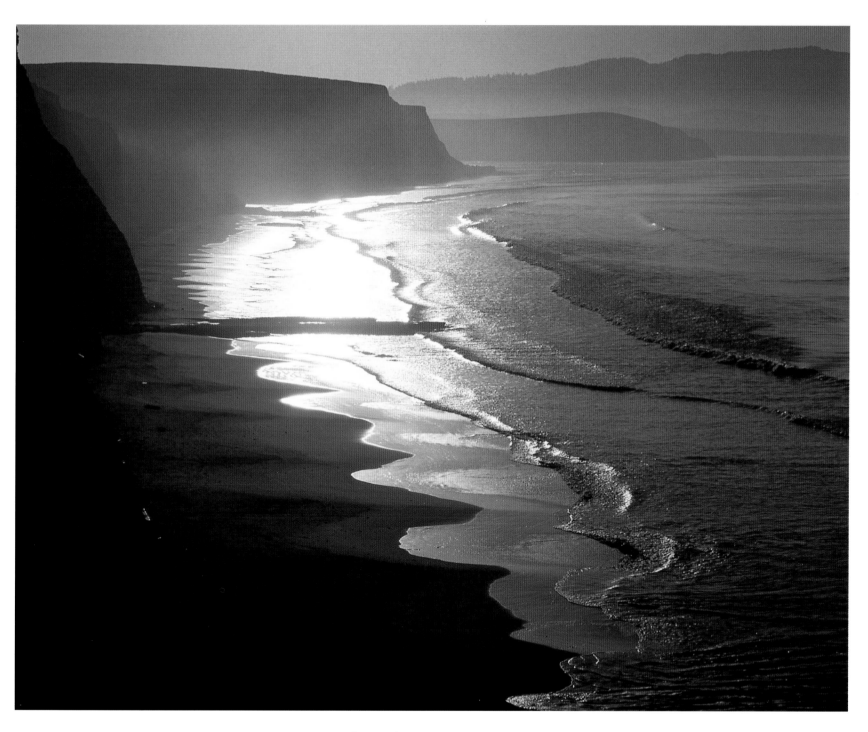

Sunrise, Drake's Beach

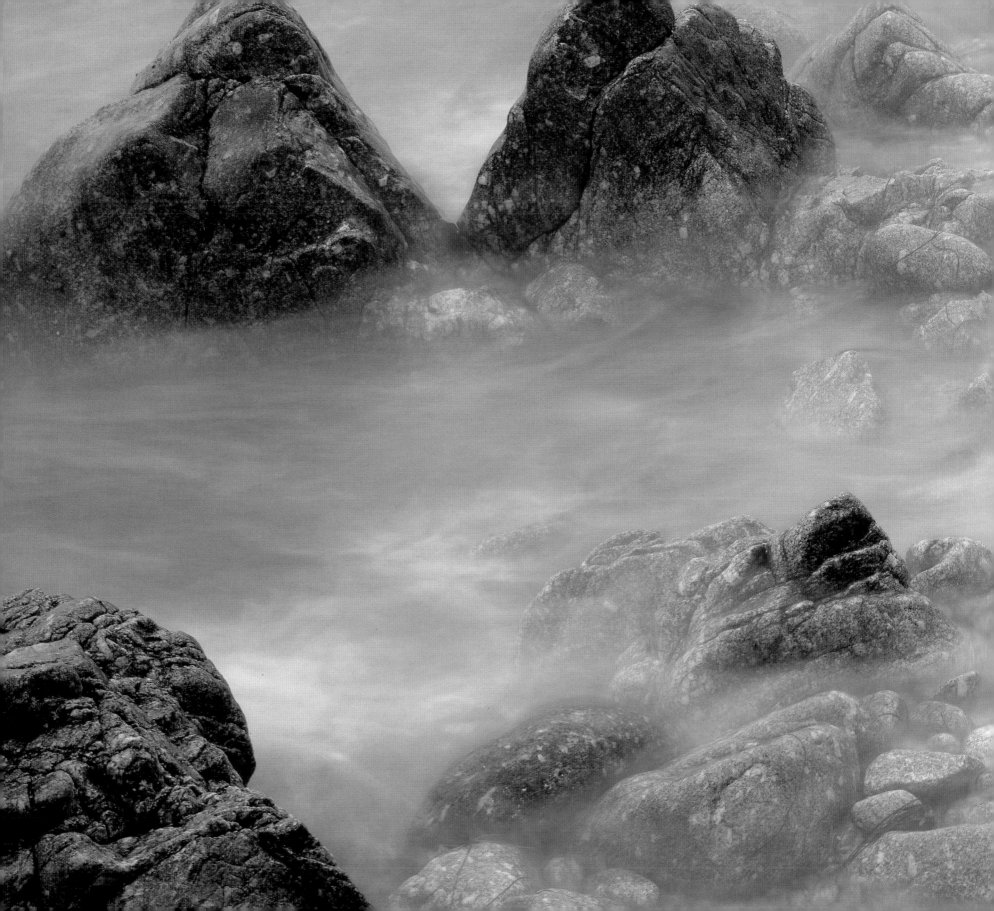

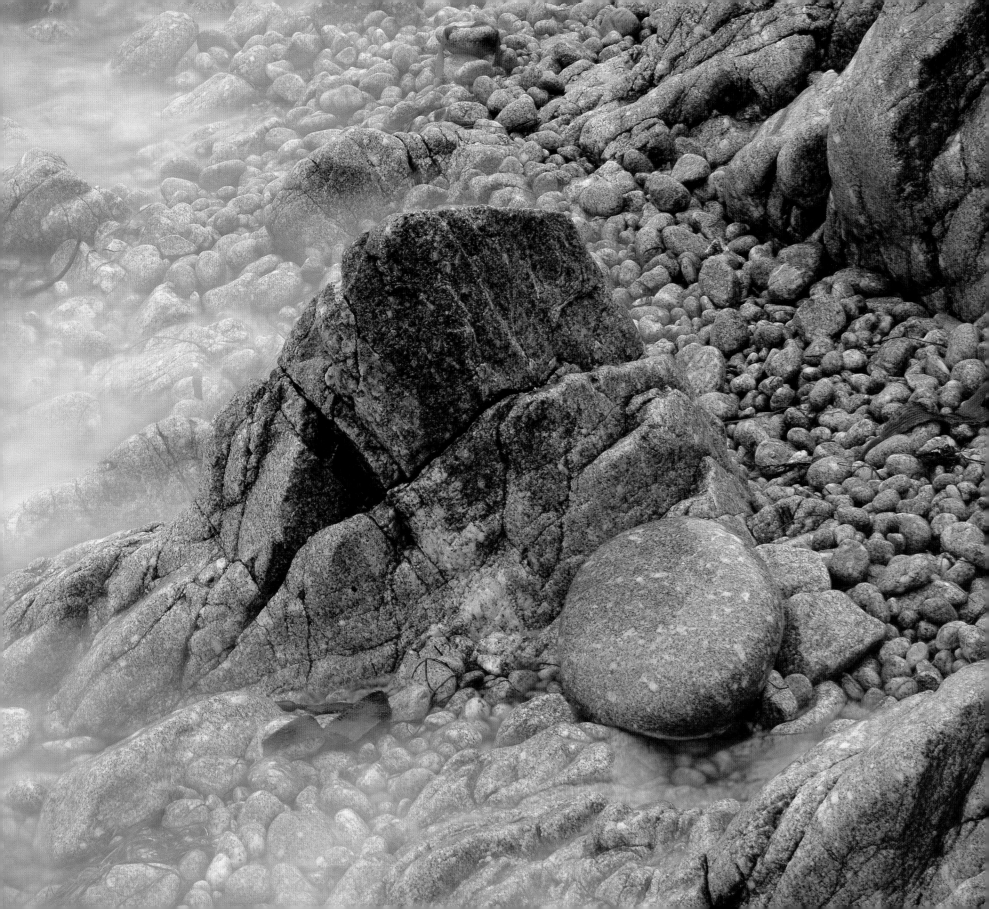

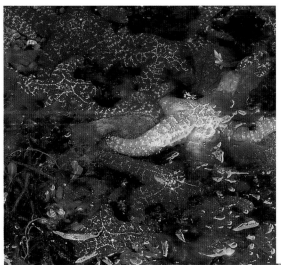

Overleaf: Coast landscape, Garrapata State Park

Left: Ochre sea star (*Pisaster ochraceus*), blood star (*Henricia leviuscula*), and purple sea urchin (*Strongylocentrotus purpuratus*), Point Lobos State Reserve

Below: Aggregating sea anenome (*Anthopleura elegantissima*), Monterey coast

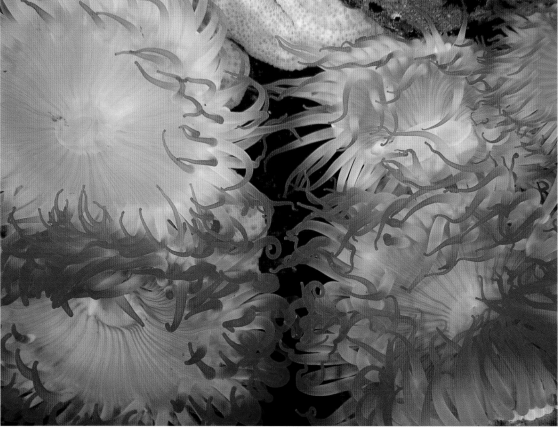

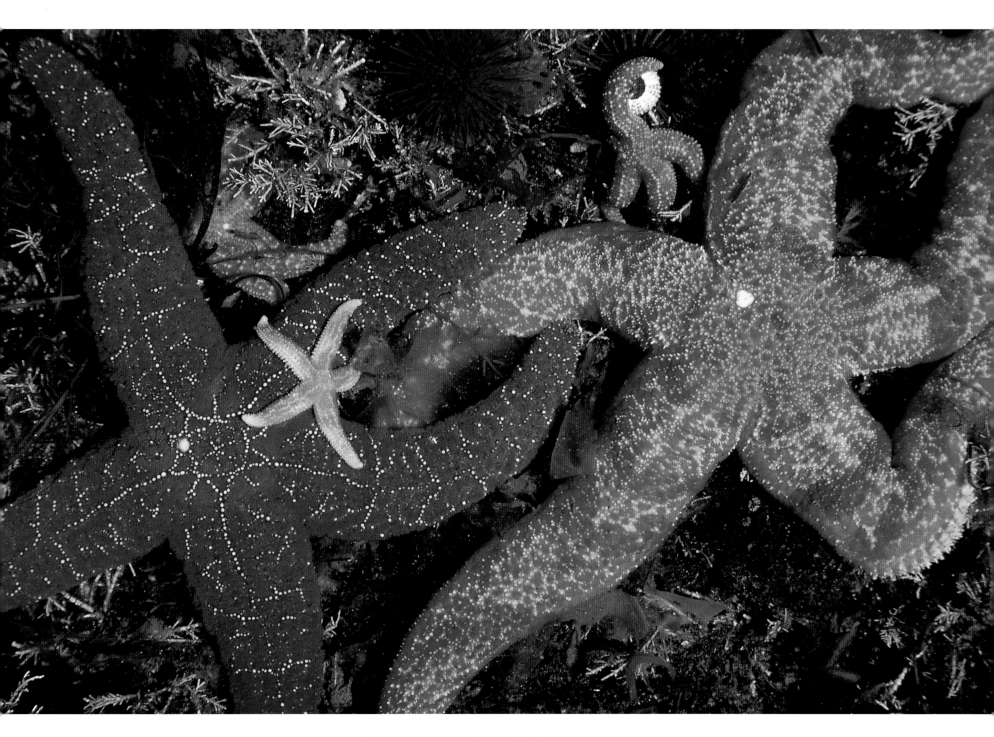

Ochre sea star (*Pisaster ochraceus*), blood star (*Henricia leviuscula*), and purple sea urchin (*Strongylocentrotus purpuratus*), Point Lobos State Reserve

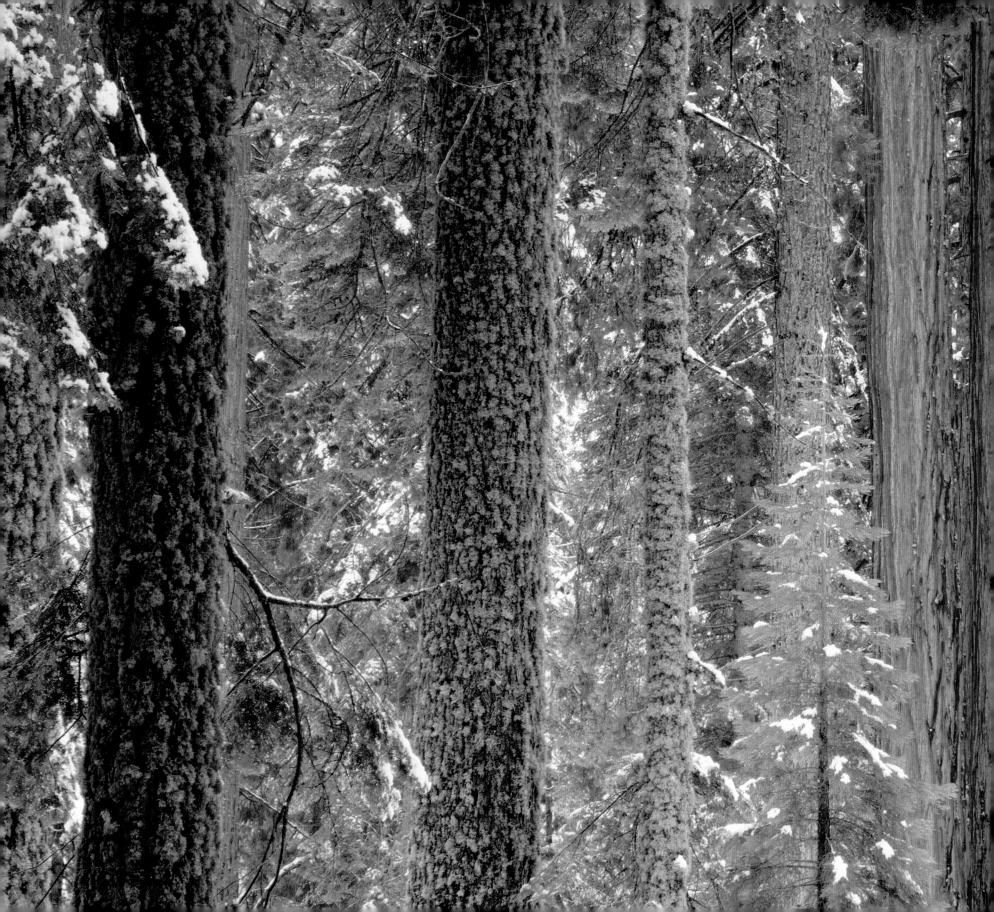

FOREST

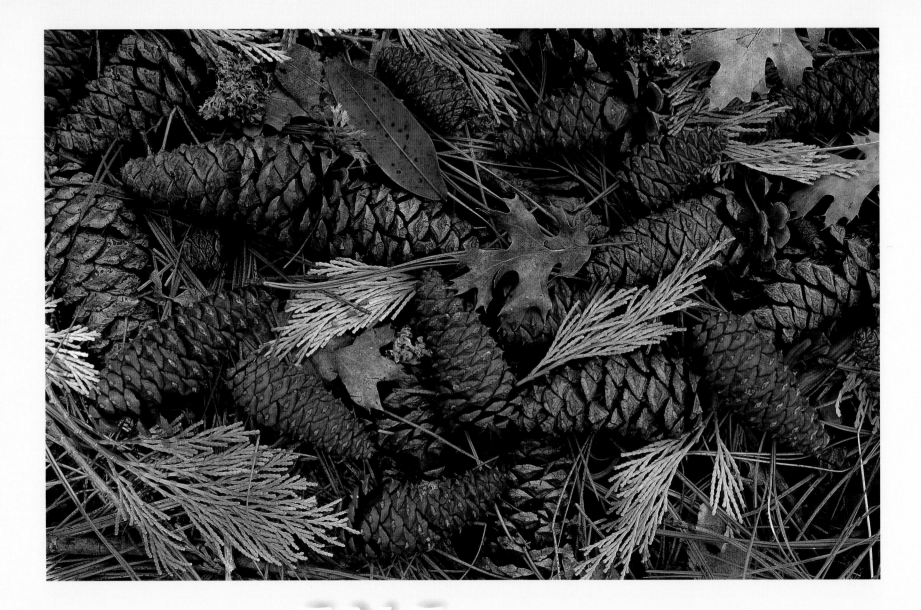

When the windstorm came, it whorled into a valley on the Redwood Coast looking to scythe down a few of the weak and the unlucky. Gusts circled the groves of reddish-barked giants like wolves, probing for entrance or for a straggler at the edge, finding few points

of vulnerability. Together the redwoods create an interlaced structure, from soil to fog-soaked crowns, of community, phenomenal engineering, and individual magnificence. But this time there had been some damage.

I wandered deeper into the grove from the roadside, my boots sinking into a thick mattress of ferns, fallen needles, and bark. In this church of luxuriant softness, I could have moved forward on my knees with little discomfort over the ancient, yielding quilt. An orange banana slug, the very essence of scavenger efficiency, slid over a rotting branch. Tiny black eyes atop its waving stalks sensed my hulking presence, shrank back, then led the way off in a different direction.

Down on one knee for a closer look, I soon felt the spongy dampness seep through my pant leg. In a virgin California forest like this, even the chilling wet seems to be on the move, seeking, accomplishing either subtle attack or act of nurture. I was in a zone of quiet relentlessness, a place where the fungal network of hyphae amid the detritus at your feet worked as ferociously as the growing cambium of the giants. After an hour I was ready to beg for the sound of a trickling creek, or the high *kree* of a hunting raptor.

I traveled through part of a sanctuary bordering California's redwood-country highway. At first the trail zigzagged through massive ten-foot-diameter columns, its path determined more by a random pattern of fallen rotting trunks than by the upright sentinels. Some of the trees, even recumbent, had a diameter greater than the height of two men. After the storm, the trail had been visited immediately by workers armed with a Brobdingnagian chain saw. In places one of the new downed trunks had been cut into chunks to create a passage.

Rolled aside, these massive rounds revealed a salmon-colored interior almost painful to look at in its fresh-cut beauty. With a surge of shame, knowing that over 95 percent of the state's old-growth redwood forests were now gone, I beat back a sudden unbidden avarice: the same desire that attracted many of the state's greatest architects and artisans throughout the Victorian and Craftsman eras to use this wood from original groves. Here in this remnant grove, the old-growth rings revealed by the saw flaunted their attributes—old redwood is a building material both dense and rot-free, yet also light and strong, with a color that mellows from new-cut pink to a deep, smoky cinnamon over years of service as beam or rail, wainscot or shingle.

This wood would see service only as part of the feast around me. The forest dines on itself,

Overleaf: Giant sequoias (*Sequoiadendron giganteum*) and incense-cedars (*Libocedrus decurrens*), Sequoia National Park

Left: Forest floor, Yosemite National Park

even though the state's conifers are all evergreen and drop their needles sparingly. In all, more than fifty-five cone-bearing species can be found in California: giant sugar and ponderosa pines, red firs, lodgepoles, twisted solitary foxtail pines at high altitudes, Douglas fir, Coulter pines with huge heavy cones, western hemlock, western red cedar, Sitka spruce, whitebark pine (ruler of the timberline zone), mountain hemlock, and pinyon pine and juniper scattered across the foothills like carefully spaced daubs of gray-green on a silvery sage canvas.

With diversity come superlatives: rarest, oldest, tallest, largest. All four occur here.

Relicts of the Ice Age, Torrey pines are now limited to a single, genetically identical stand of but a few square miles on the San Diego coast. Another grove of Torrey pines, differing in only two of fifty-nine genes from those in the San Diego forest, occurs on Santa Rosa Island off the Santa Barbara–area coast. Left behind in a climate that now sees but ten inches or less of rain in a year, both forests survive through each long, dry summer and fall by using their long needle clusters to trap moisture borne by coastal fog. In San Diego, their northernmost natural grove is located less than a quarter mile from what has been my home for more than two

decades. Hardly a week goes by when I haven't experienced their eternal early-morning "rain"— often in the form of a large drop that crashes off my forehead and splatters the lenses of my glasses—while I'm on a morning hike or trail run.

The bristlecone pine, oldest living tree, huddles on wind-blasted ridges in the White Mountains more than 10,000 feet above Owens Valley in the eastern part of the state. Some reach an age of more than 4,000 years. Even after death, the twisted trunks and branches may lie in undecayed sculptural agony for another millennium or more.

The coast redwood, the tallest, has reached a known height of over 365 feet, although debate simmers about which single tree is truly the tallest. Its cousin, giant sequoia, is the king of biomass; some of its ilk have girths that take a man on foot several minutes to circumnavigate. One giant sequoia, the General Sherman tree, is now 36 feet across at the base and 275 feet high. In 1978 one of its branches crashed to the ground; this limb alone (150 feet long and 7 feet in diameter) proved larger than any tree east of the Mississippi River.

But no other tree represents California's passionate love and lust for its forests more than the redwood. When the windstorm swept through

the area I hiked that winter morning, the gusts first had to penetrate an overstory of thick, interlaced branches, most of them hundreds of feet above the ground. Seen from the viewpoint of a marbled murrelet, the small, web-footed seabird that makes its nest high in the crowns of old-growth redwoods, the grove was another kind of ocean—a luxuriant deepness sometimes unmarked by variation other than the competing tips of its own members. Here the branchlets form such an extravagant burst of life that birds seem to swim as much as fly through the packed yet lacy biomass.

The trees have a voracious thirst, satisfied in winter by as much as 100 inches of rainfall. But in summer, when temperatures in valleys not far from the coast can range into the nineties, the redwood forest is still a place of dripping dampness. Like the Torrey pine, but on an immense scale, these great mops comb millions of gallons of water a year from heavy coastal fogs with their short, flat needles. Directed downward to the forest floor in a surreal patter of heavy droplets, this "rain" provides another ten inches a year.

Protected from drought, shielded from fire and insects by a thick rust-red bark, the giants seem almost to sleep for their life span of a millennium or more. Yet ring upon ring they build their supple cores annually, each year's span a record of good fortune brought by sunlight and ample water, or a thin triumph born of struggle. Seen from the ground, the coastal redwood grove is a series of shaggy, deeply furrowed columns stretching into an indefinable loftiness. Mature specimens have no branches for the first 100 feet or more of their height.

As I wandered deeper into their moody silence, I found a place where a stream had weakened one giant's roots. The wind had brought it down, and it fell to earth somehow unhindered by other trees. Hand over hand up the muddy roots I climbed until I reached its great back, then followed its length to the place where branches began. Most lay in shattered piles to either side, broken free by the force of the impact. I sat on this last tapered region, once so high above the forest floor, now ready to send up a new legion of trees from the latent buds along its trunk and around its base. Sprout after sprout would follow. A few would survive. One may yet stretch above the others, a new giant, a thousand years after my footsteps.

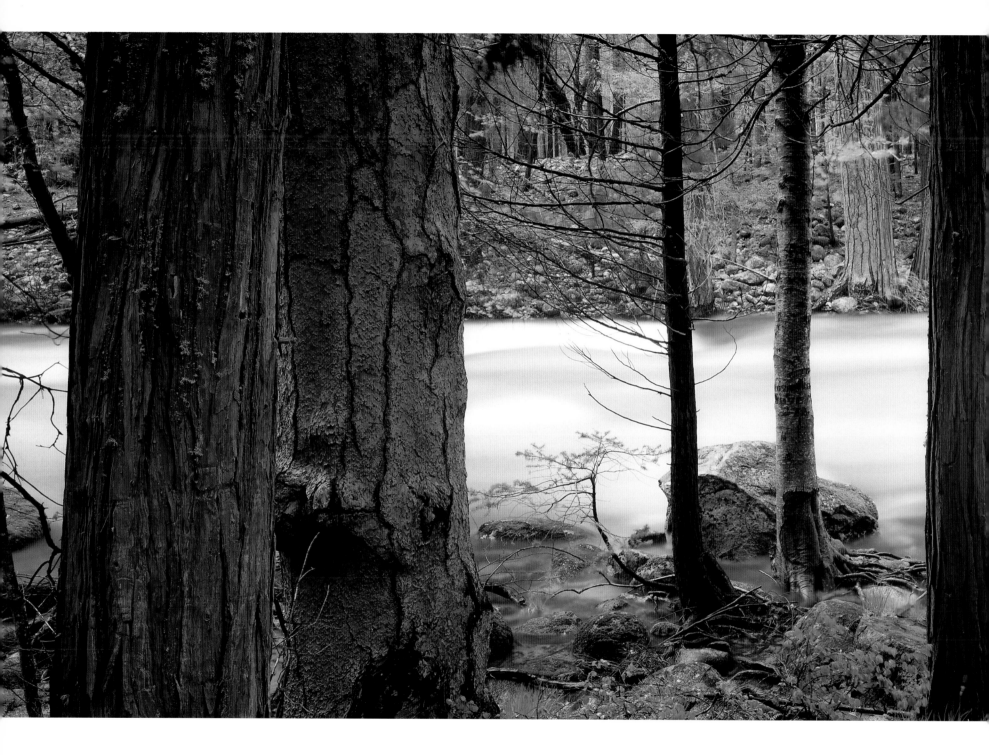

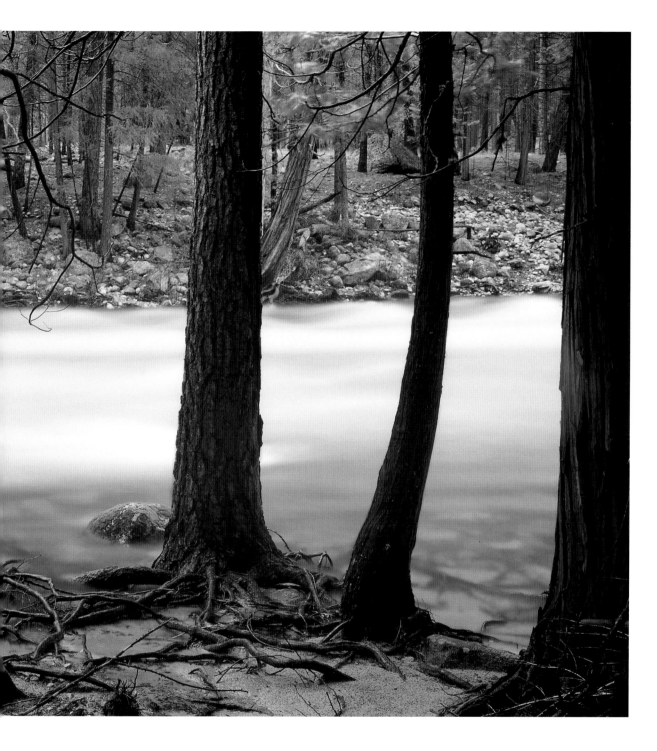

Merced River, Yosemite Valley, Yosemite National Park

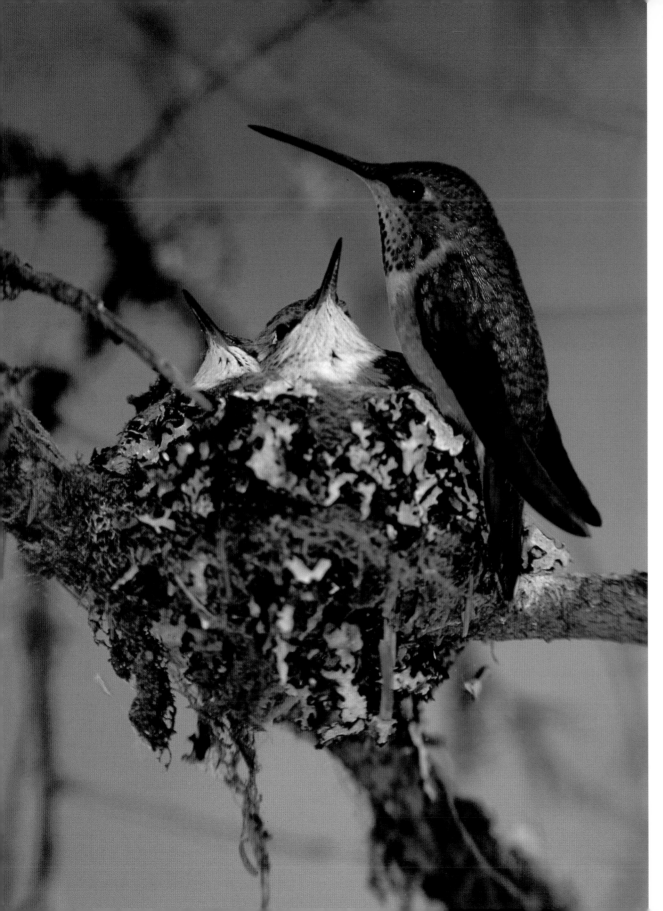

Left: Rufous hummingbird with chicks (*Selasphorus rufus*), Kruse Rhododendron State Reserve

Right: Fern variety, Fern Canyon, Prairie Creek Redwoods State Park

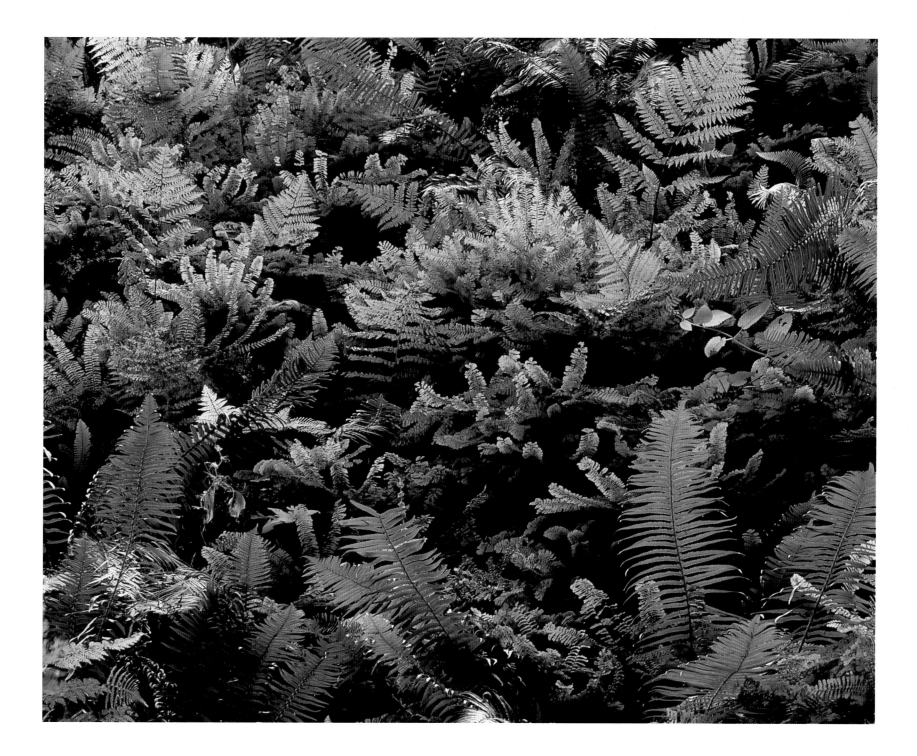

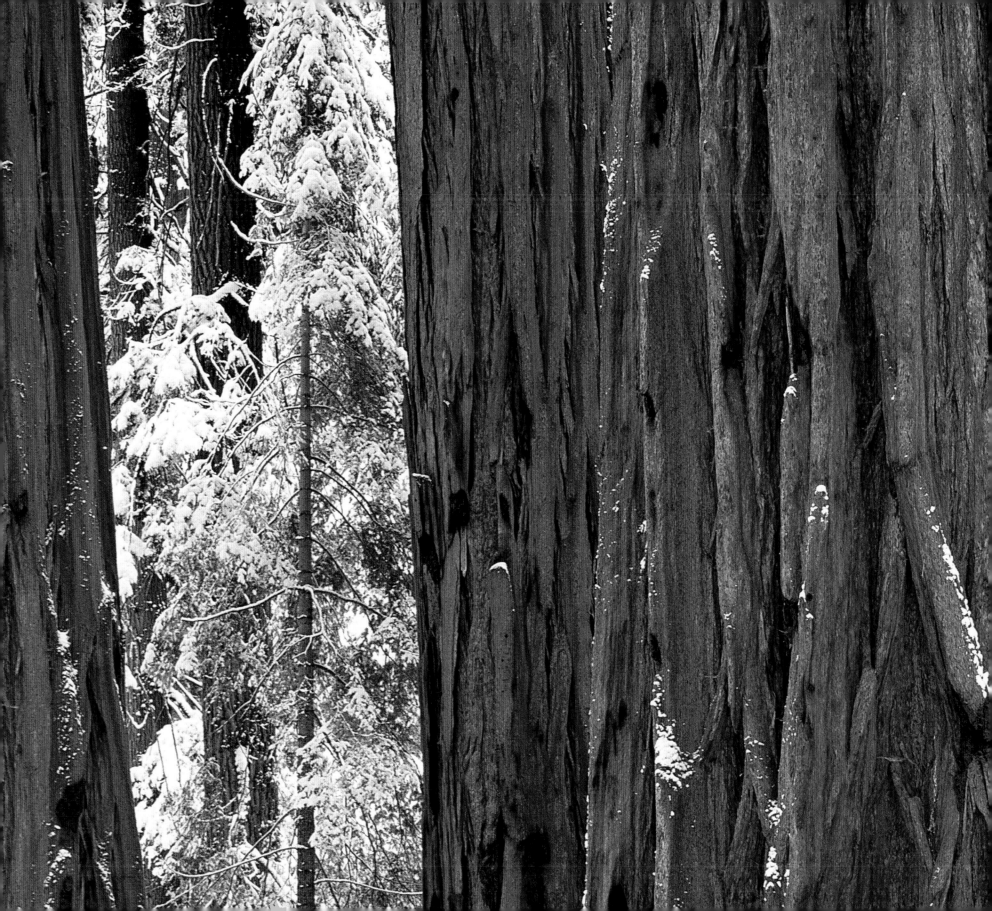

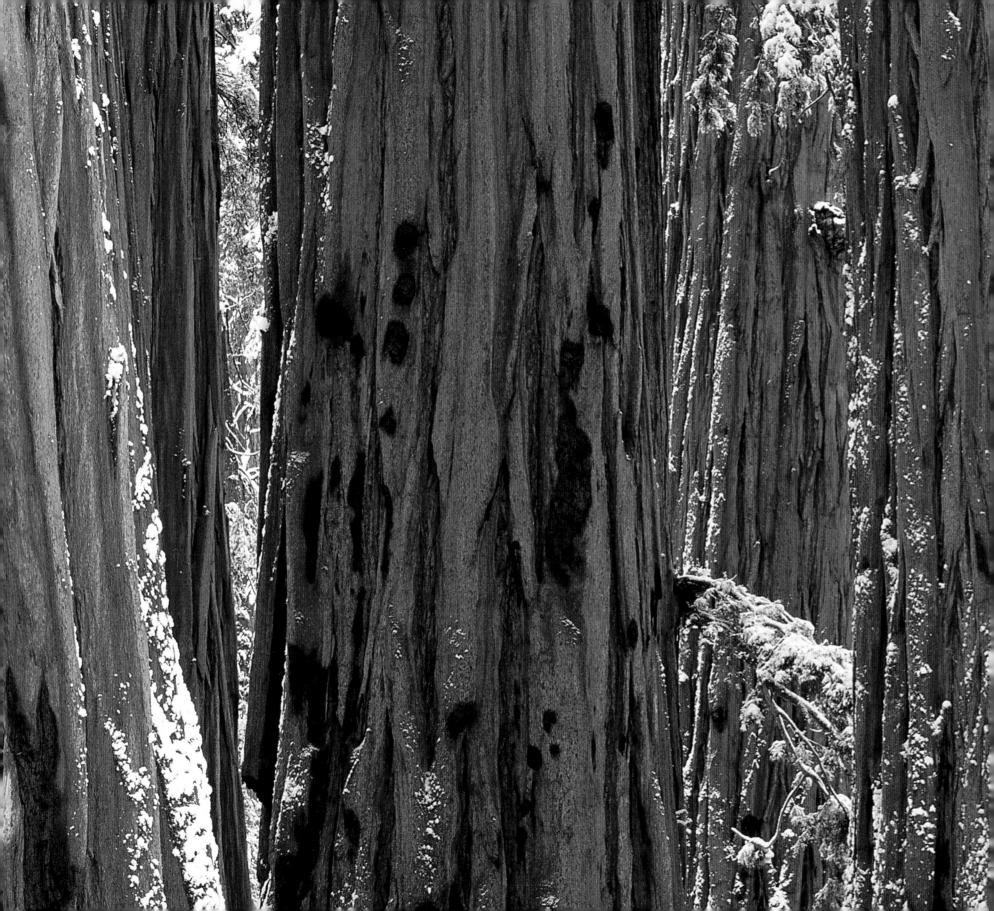

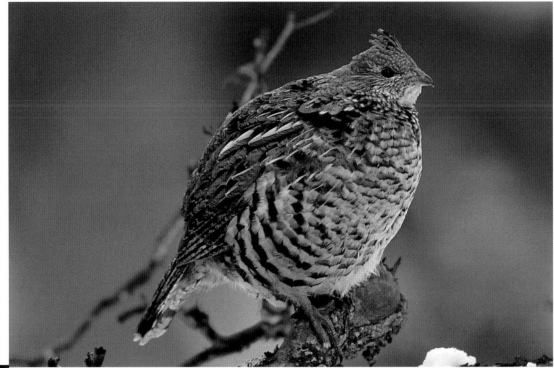

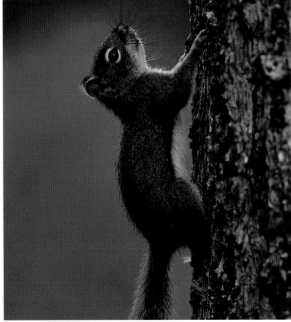

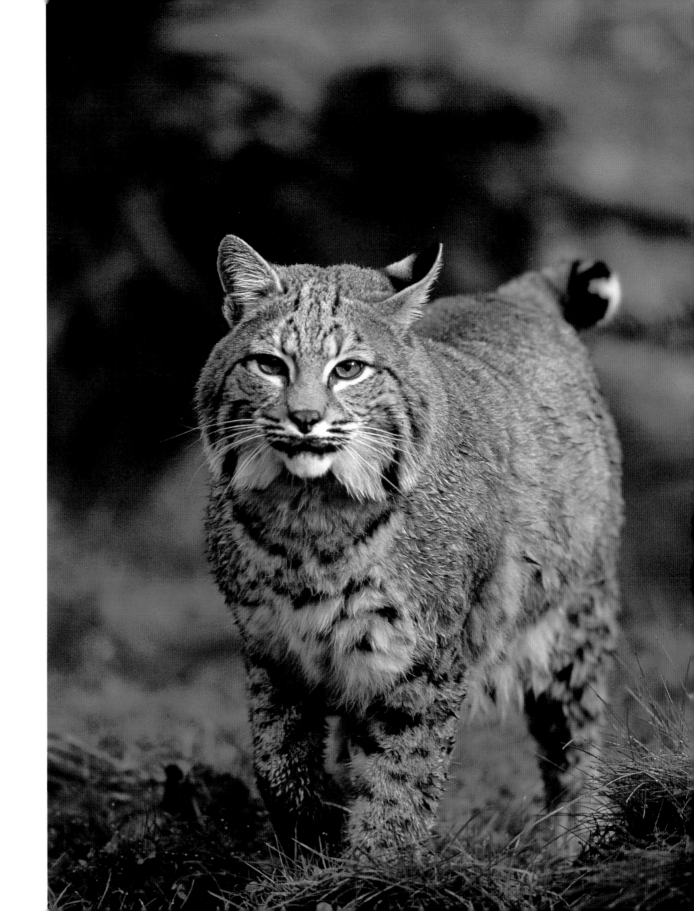

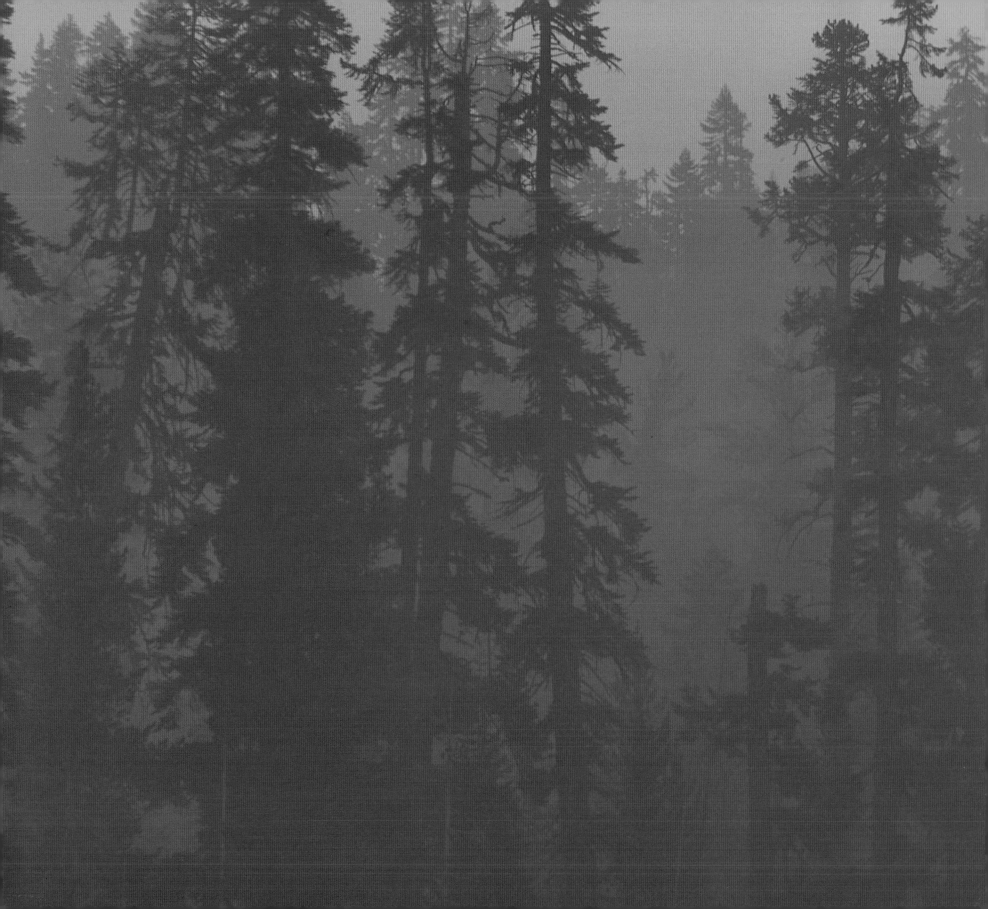

Left: Sunrise, Lassen Volcanic National Park

Right: Pacific Ocean view, Prairie Creek Redwoods
State Park

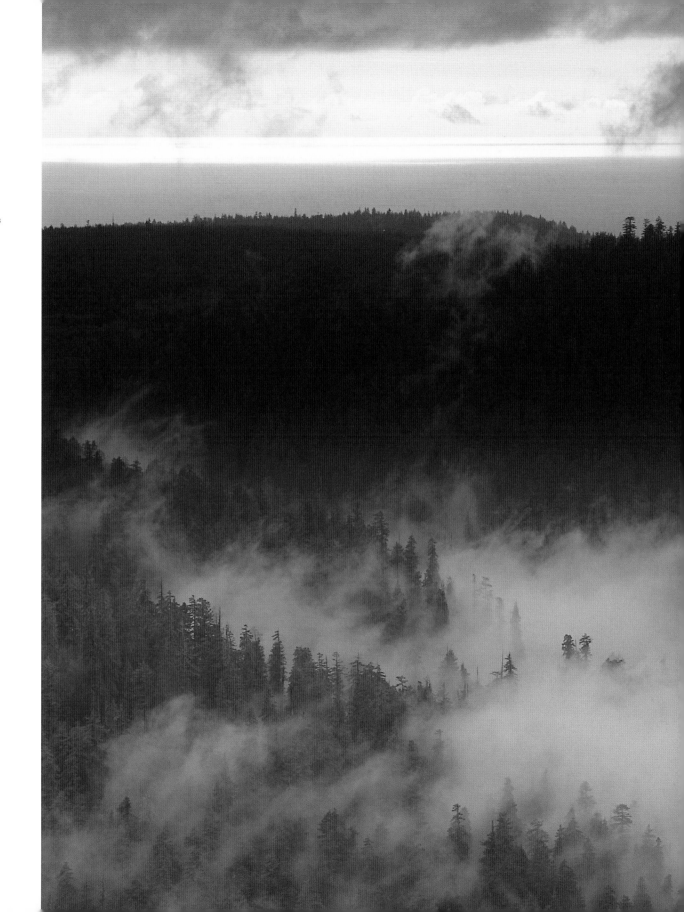

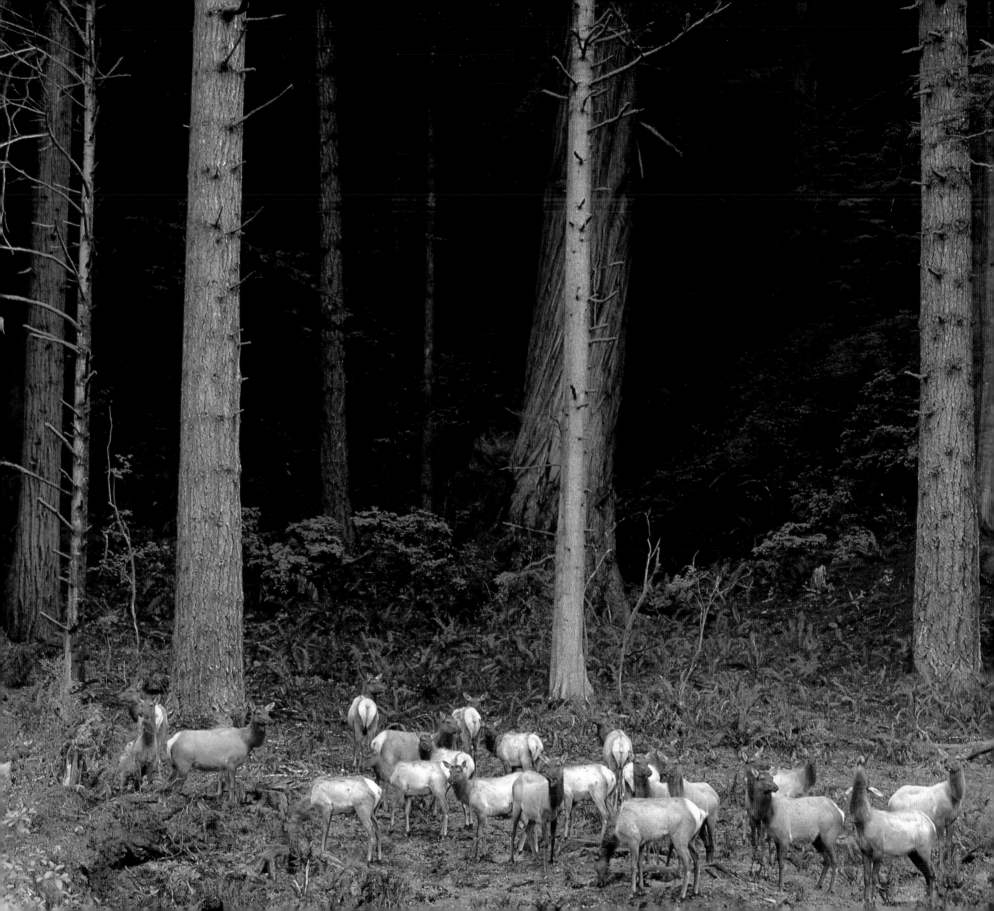

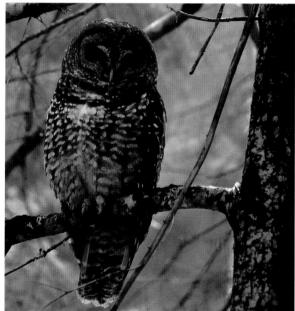

Far left: Roosevelt elk (*Cervus elaphus roosevelti*), Prairie Creek Redwoods State Park

Left: Spotted owl (*Strix occidentalis*), Prairie Creek Redwoods State Park

Below: Forest floor detail, Prairie Creek Redwoods State Park

Following page: Giant sequoias (*Sequoiadendron giganteum*) in winter, Sequoia National Park

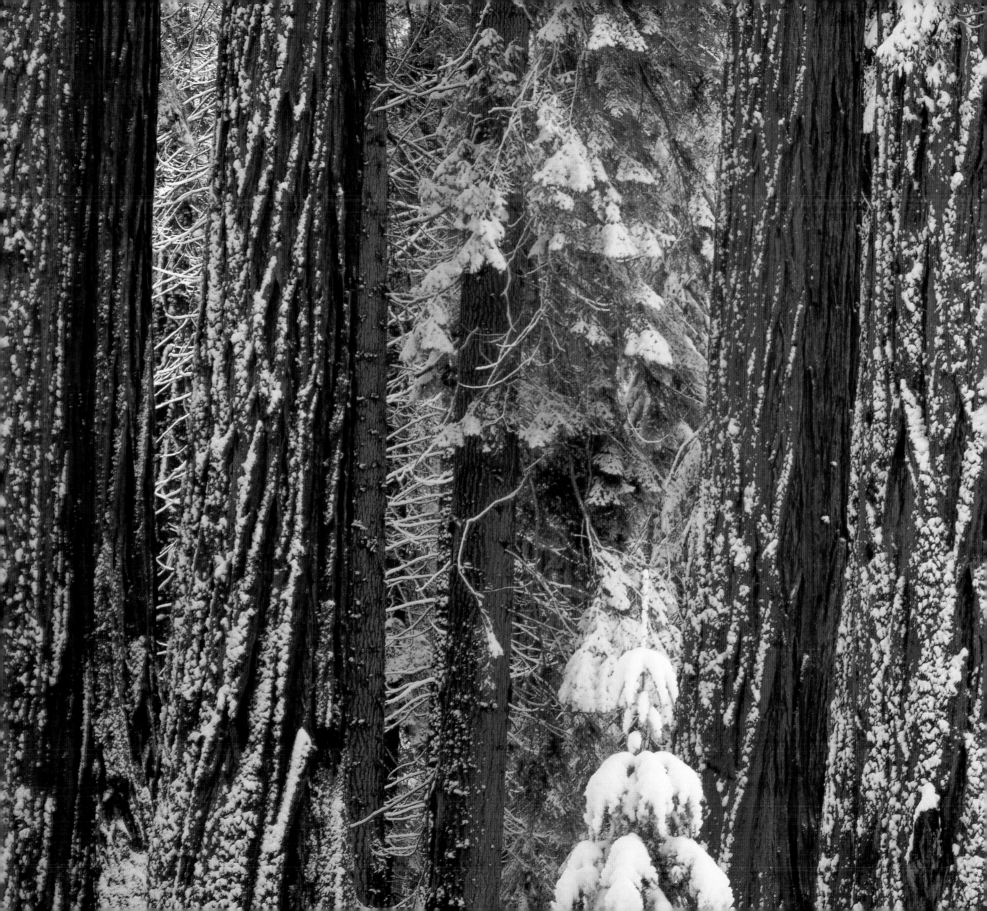

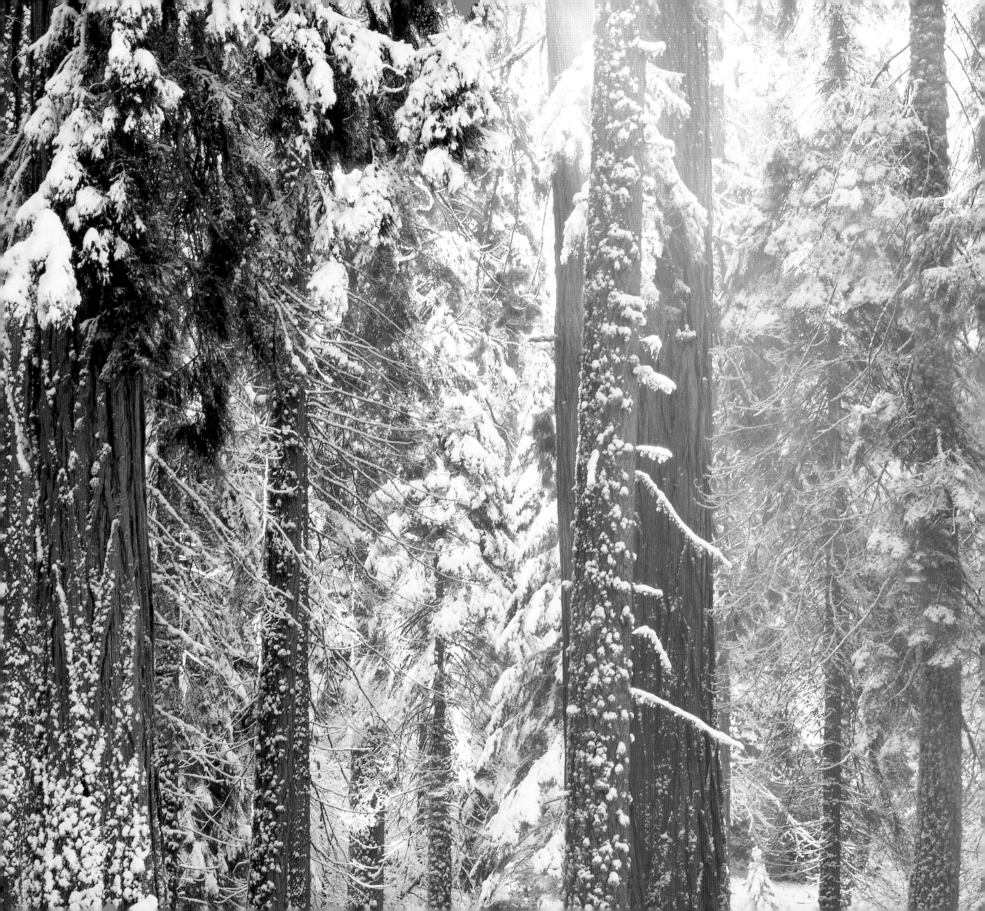

Coastal bush lupine (*Lupinus arboreus*), Prairie
Creek Redwoods State Park

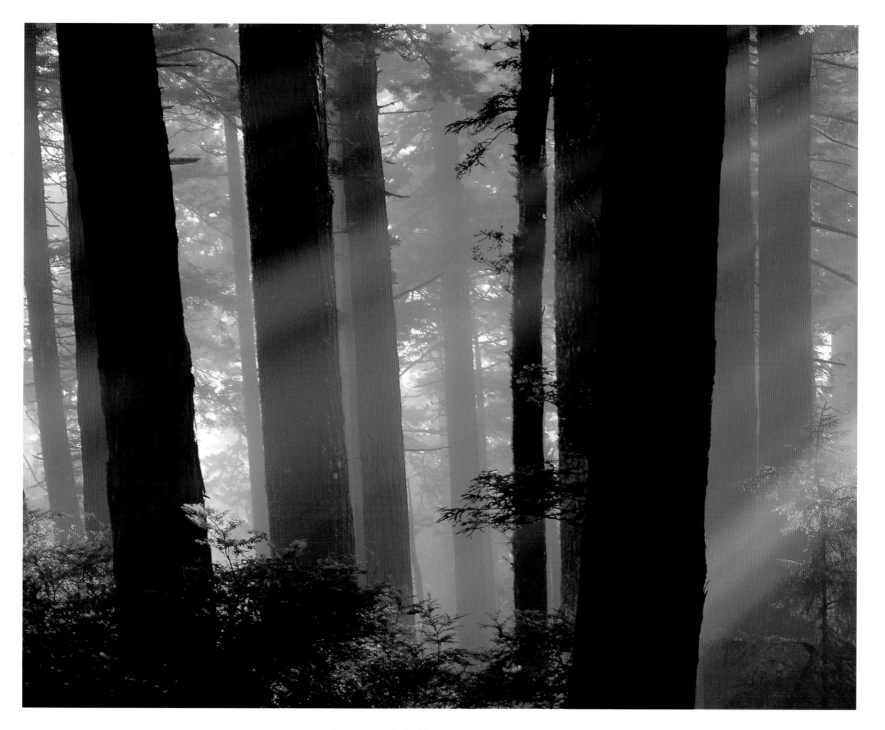

Late afternoon sunlight filtering through redwoods (*Sequoia sempervirens*), Del Norte Coast Redwoods State Park

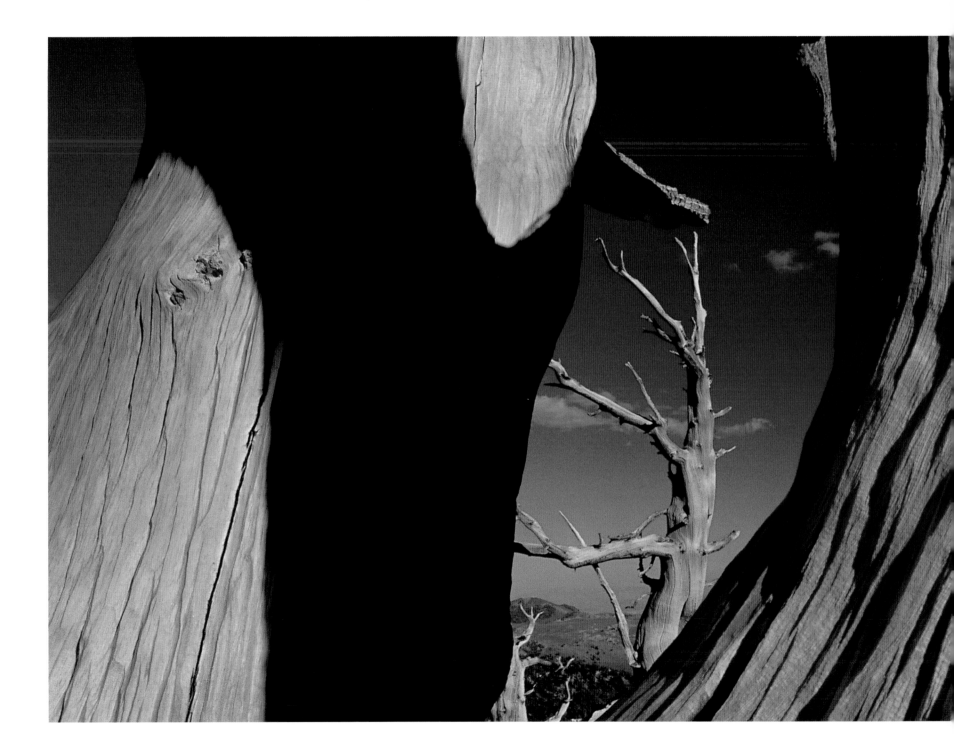

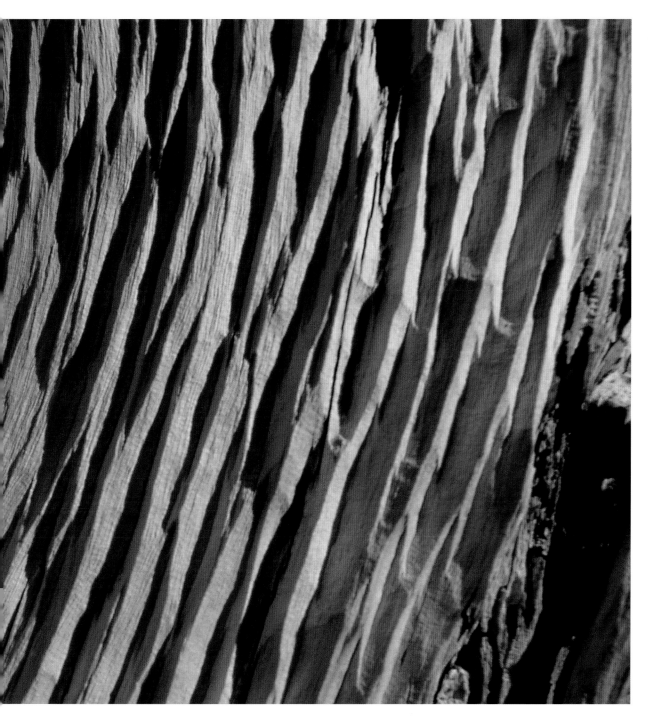

Bristlecone pine (*Pinus aristata*), Ancient Bristlecone
Pine Forest, White Mountains

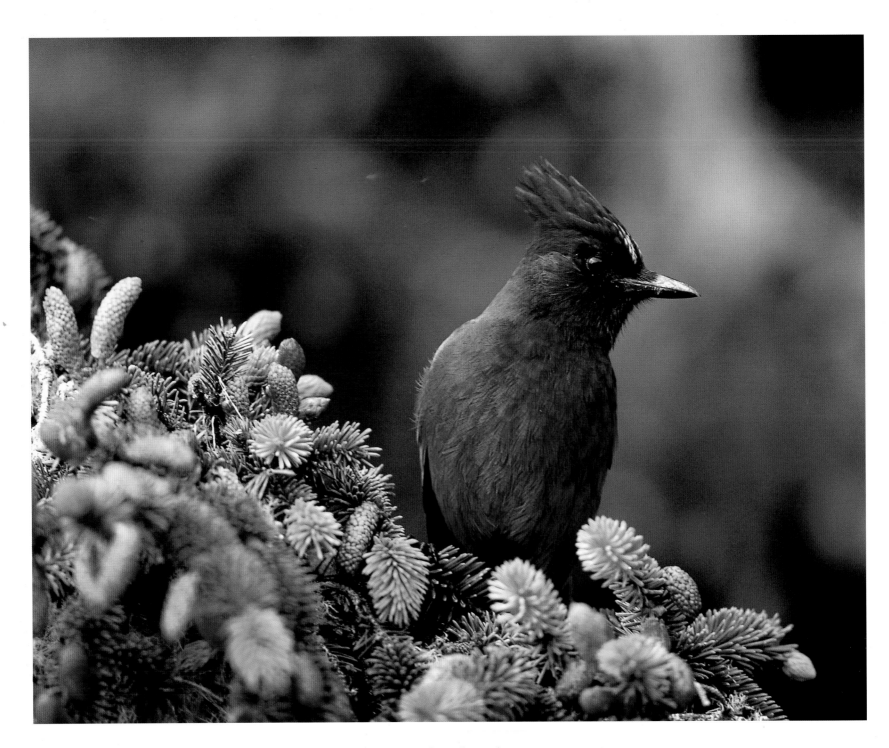

Steller's jay (*Cyanocitta stelleri stelleri*), Del Norte
Coast Redwoods State Park

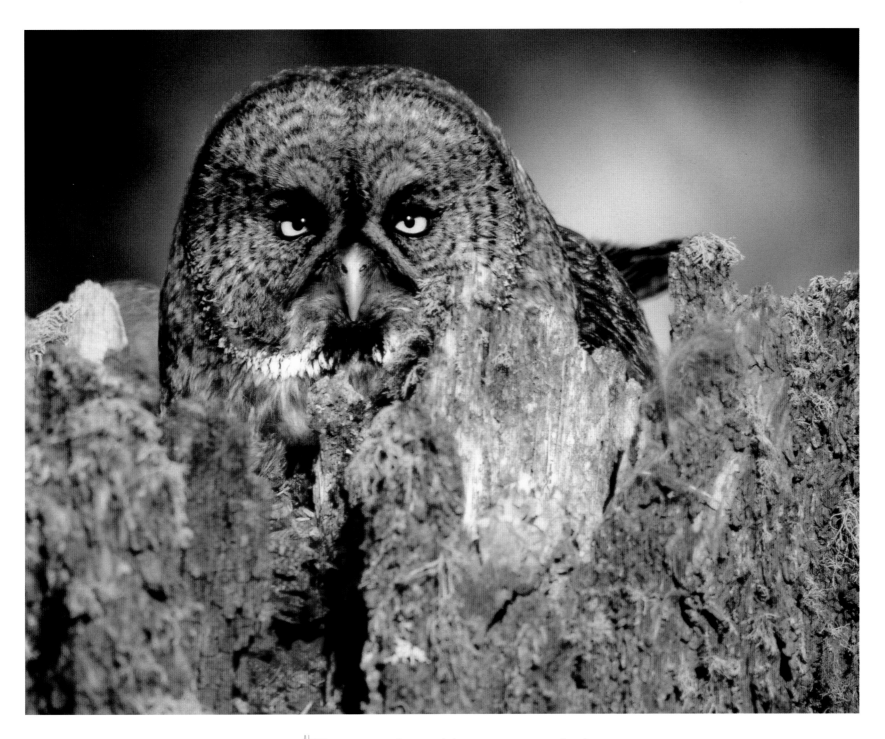

Above: Great gray owl (*Strix nebulosa*), Yosemite National Park

Following page: Redwoods (*Sequoia sempervirens*) in mist, Del Norte Coast Redwoods State Park

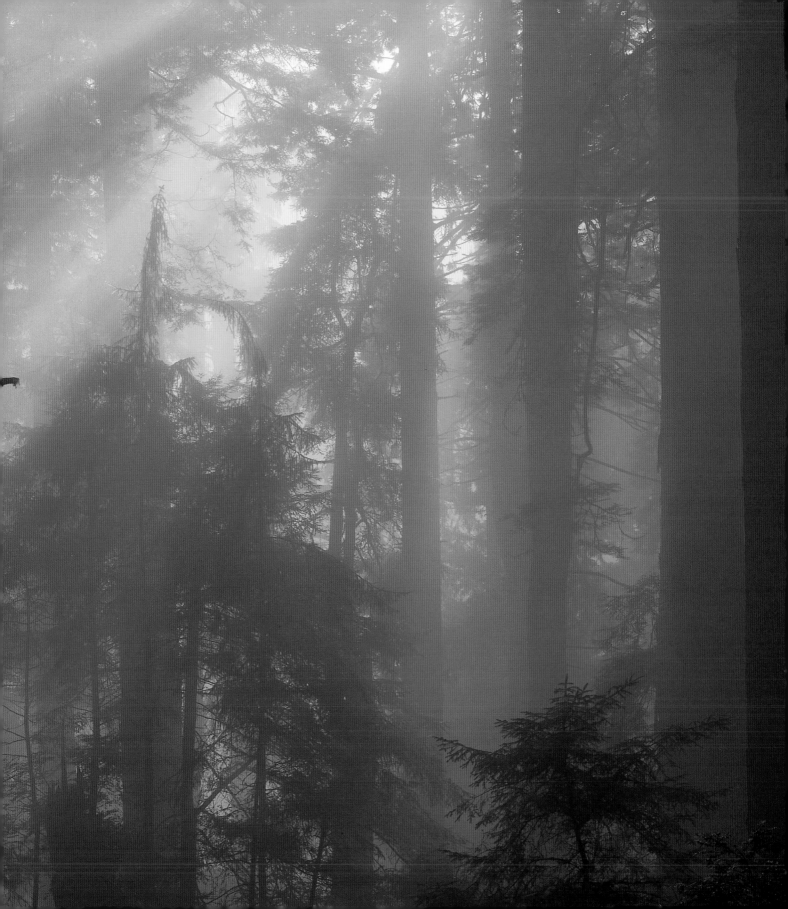

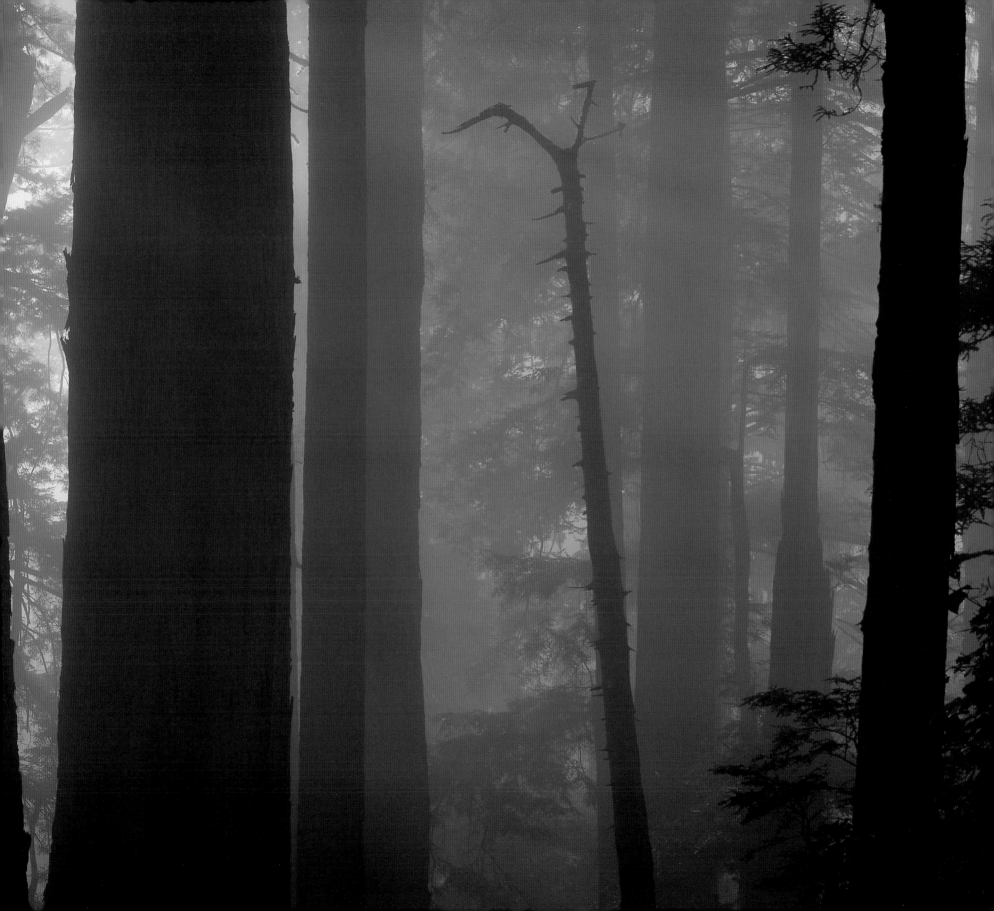

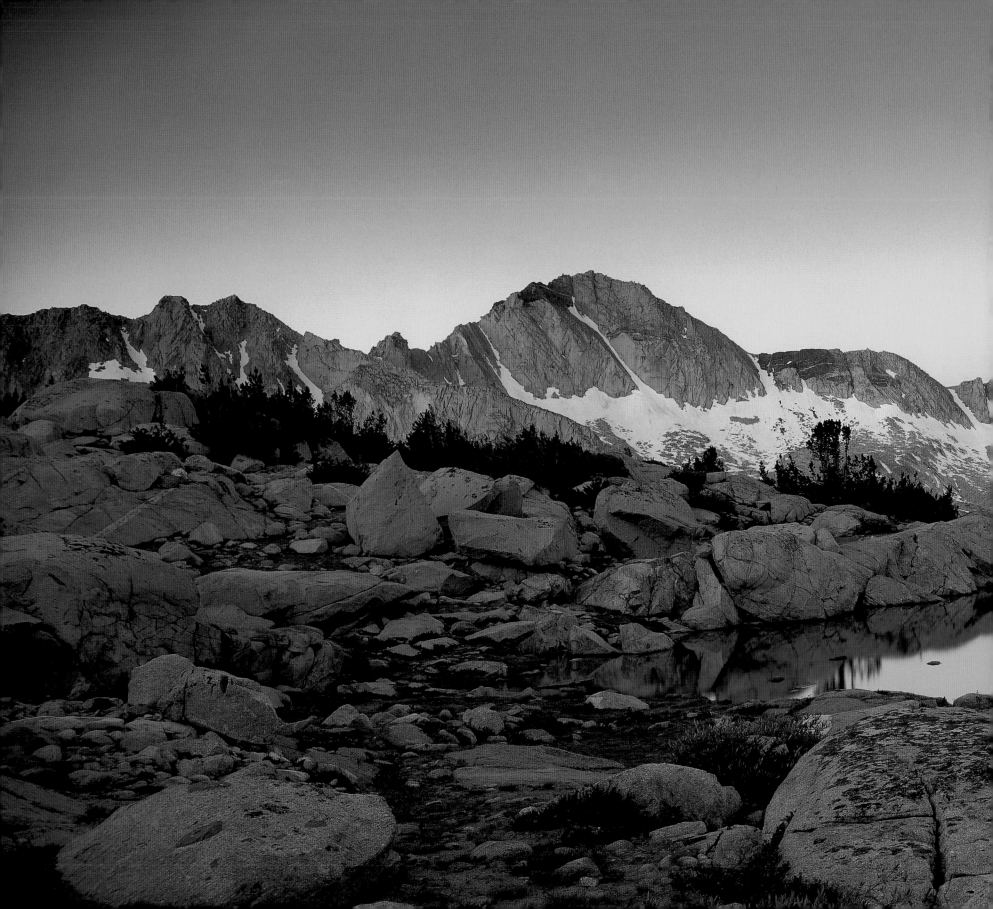

MOUNTAIN

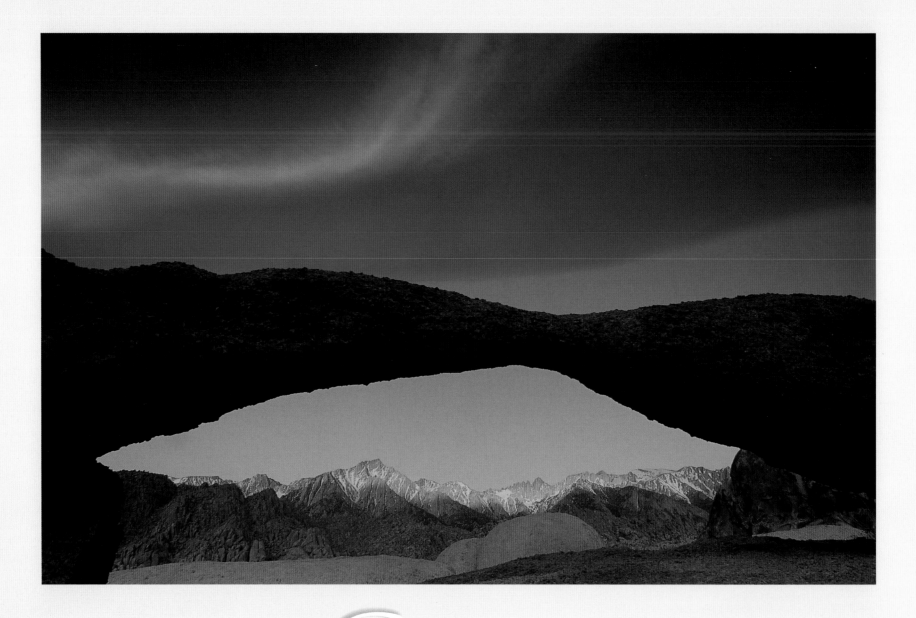

Cup your left hand and reach out as if to let a waterfall's ribbons beat down into your palm. See the length of your thumb, a strong rounded form from wrist to nail, wide and thick with muscle at its base. See also your four fingers, splayed and upright, each a sentinel arranged in series, a row, a range.

Sitting on the soft, lower portion of my pack beside the John Muir Trail in the High Sierra's Evolution Valley, I considered this hand. I was hopping from fingertip to fingertip, following California's highest trail for 212 miles from end to end. I reached into waterfalls. I stood atop passes so high they look down on most mountains. I did not, however, see more than a small fraction of the state's vertical topography.

California's mountains ring the soft palm of its great Central Valley with varying degrees of age, elevation, and angularity. In the north, two ranges push down into the state: the Klamath Mountains near the coast and, more inland, the diminishing southern tips of the Cascade Range. They bring with them elements commonly thought of as belonging to the Pacific Northwest. In the Klamath region, for example, hikers walk through knee-high glens of the flowering shrub western azalea (*Rhododendron occidentale*), and fishermen drift down three rivers famed for salmon and steelhead runs: the Klamath, Smith, and Trinity. In California's Cascades, two restless volcanic cones, Mount Shasta at 14,162 feet and Mount Lassen at 10,457 feet, have erupted in recent history: Shasta in 1786 and Lassen in a series between 1914 and 1921. Here the state is still young

and venting, cloaked in deep snow, glaciers, and great forests fed by more than eighty inches of precipitation a year. These are California's least-known, least-visited ranges, yet they boast scenery equal to the Sierra Nevada's popular national parks.

Along the state's western edge, the Coast Ranges extend from near the Oregon border south 500 miles to a point where the shoreline makes a long, graceful arc, or bight, eastward from Point Conception. Fault lines carve these ranges throughout, straining the land to a point where it either creeps gradually or lurches catastrophically after building up energy in a locked zone, as happened in 1906 and again in 1989 along the San Andreas fault near San Francisco. Geologists estimate that most of this region west of the Central Valley was once 300 miles southeast of where it is today, and movement continues at an average of about two inches per year. Yet many areas of these mountains also give the state its nurturing, bosomy profile of rolling grasslands interspersed with copses of oak trees. From the Napa Valley down through Monterey County and beyond, tawny hills range from a few hundred to a few thousand feet in elevation. Three of the state's great literary voices, John Steinbeck, Robinson

Overleaf: Giraud Peak (12,608 feet), Dusy Basin, Kings Canyon National Park

Left: Granite arch frames Lone Pine Peak (12,944 feet) and Mount Whitney (14,494 feet) from Alabama Hills

Jeffers, and Wallace Stegner, celebrated this coastal mountain landscape in most of their works, wondering at both its nurturing peacefulness and its ferocity—a side most evident during winter storms each year when mud slides, windstorms, and falling trees suddenly rearrange the land as if an angry giant had raked a garden free of its tenuous summer crops.

In Southern California, North America's only major east-west–trending mountain range crosses part of the state immediately to the north of Los Angeles. The Transverse Ranges wall up so close to the sea and the state's most populous areas that a hard-driving adventurer can surf early in the morning and still be on a ski slope before noon. That same ski slope might look east to a distant vista of the Mojave Desert. Like joined ropes, the Santa Ynez, Santa Monica, San Gabriel, and San Bernardino mountains form this fence line, with a high point of 11,502 feet atop Mount San Gorgonio at the southeast end of the San Bernardinos. Standing on Gorgonio's windswept, almost barren rock-pile summit, I have looked across Joshua Tree National Park and farther south over the Persian-carpet lights of desert towns toward the Salton Sea, then turned west to gaze at a setting sun over the

trapped hydrocarbons of the Los Angeles basin. Never has a natural wall between desert and sea, wilderness and humanity, seemed so abrupt.

California's southernmost mountains, the Peninsular Ranges, begin where Mount San Jacinto, at 10,805 feet, rises above the windswept pass at Banning. From here the San Jacintos, Santa Rosas, and Lagunas march to the U.S.–Mexico border, respecting no political boundaries as they continue south along the spine of Baja California. Biological diversity in this region reaches bewildering intensity, on both the cismontane and transmontane slopes of mountains that again hold a desert at arm's length from the sea. A relatively mild year-round climate has also attracted a rapidly growing population, so that San Diego County now has more endangered species than any other county in the United States.

No range has so terrified and fascinated Californians or would-be Californians as the state's Sierra Nevada. Westbound pioneers viewed the Sierra with more than just apprehension: crossing even the most accommodating passes was life threatening, particularly by September, the end of the "safe" season. As I continued walking up Evolution Valley, through several pine groves flattened by avalanches, I

wondered how perceptions could change in less than 150 years. Pioneers would have thought it absurd to come to the Sierra for recreation. They probably never considered it at all. Perhaps Muir and his knapsack confederates in the Sierra Club should receive most of the credit for coaxing us all into an era of appreciation; prior to their activities in the early 1900s the Sierra was still recovering from long periods of misuse, its quartz veins and foothill rivers torn apart for gold and silver, its highest meadows grazed by what Muir called hoofed locusts—the millions of sheep that fed a hungry state. Conservation activism aside, the club introduced the Sierra to the thousands of post-Victorian adventurous Californians who first camped and fished here for sheer pleasure.

At the end of Evolution, the trail climbed steeply through a series of glaciated granite cups and saucers, a mad hatter's tea party of domes, spires, mirrored lakes, and tumbling streams. Boulders looked like broken biscuits strewn over a polished counter. All around me, the Sierra crest was shaking itself free of a winter's worth of moisture. I climbed another 1,000 feet, feeling the air cool predictably by another three to five degrees despite a full midday sun—an elevation effect called adiabatic cooling.

Above me, Muir Pass gradually clocked around into view, a talus-strewn saddle guarded by a line of dark, ragged peaks to either side. The sky bristled with windswept clarity. I made camp early in an alpine fell, finding a gravel trough for my pad and sleeping bag that was free of the many silver-haired cushion plants that struggle to trap moisture and nutrients on this fast-percolating ground. Tough, but fragile—like most mountains. I spent the rest of the afternoon listening to a distant thunderstorm that never seemed to move within a few dozen miles of me. Perhaps my ring of mountains held it at bay. I was atop the throne, above the kingdom, free to feast on the quiet. Before I slept, I pulled the stars down tight over me, like a quilt I'd never known belonged on my bed, every night, until then.

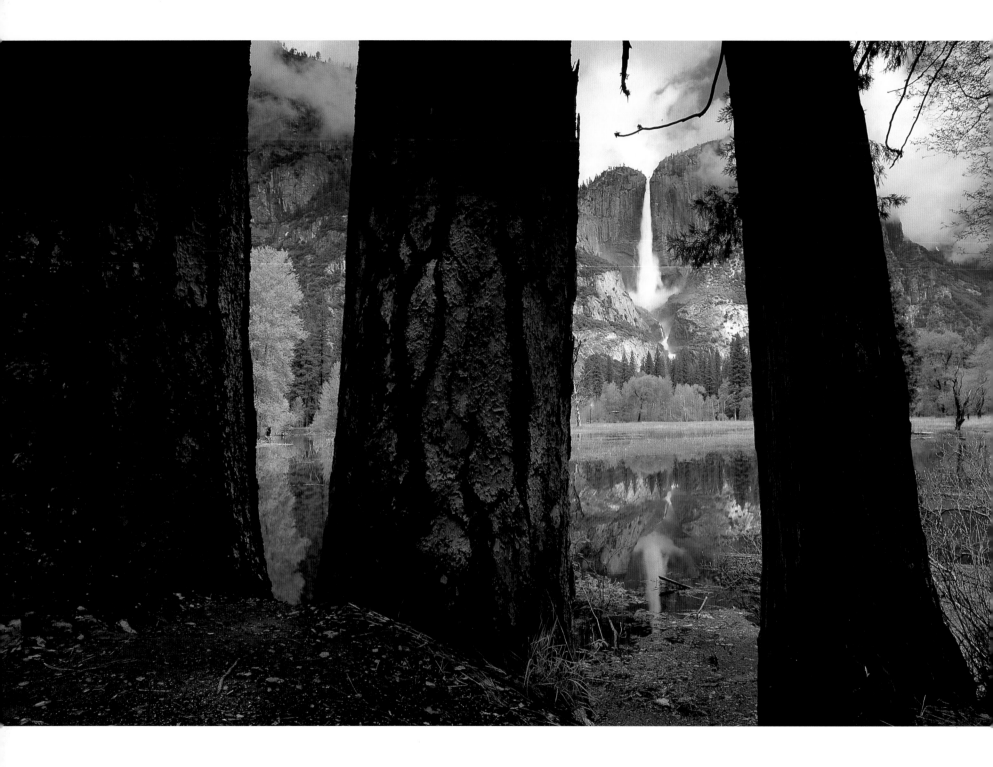

Left: Yosemite Falls reflected in Merced River, Yosemite National Park

Right: Vernal Fall, Merced River, Yosemite National Park

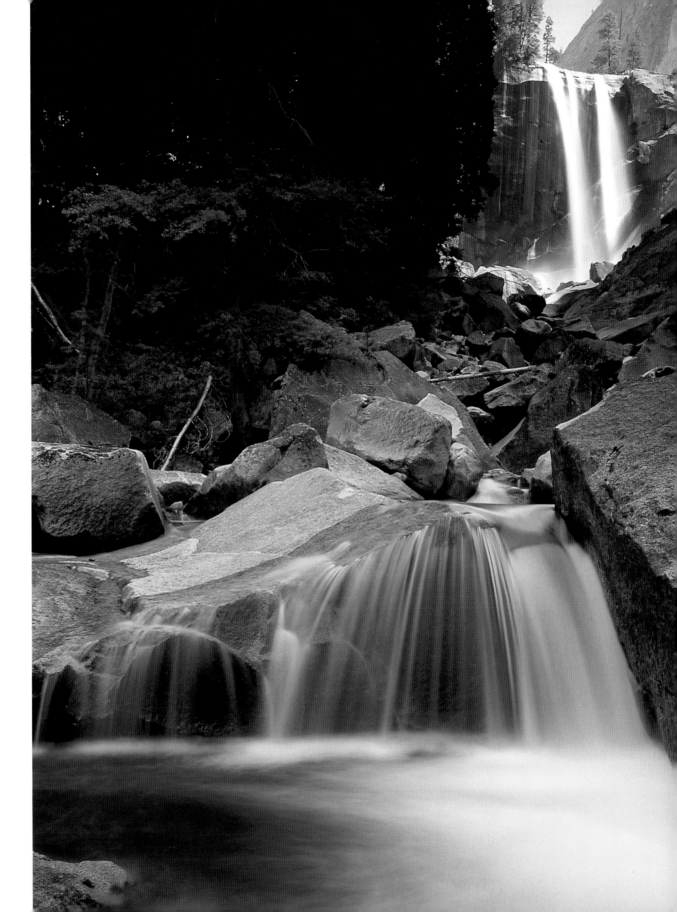

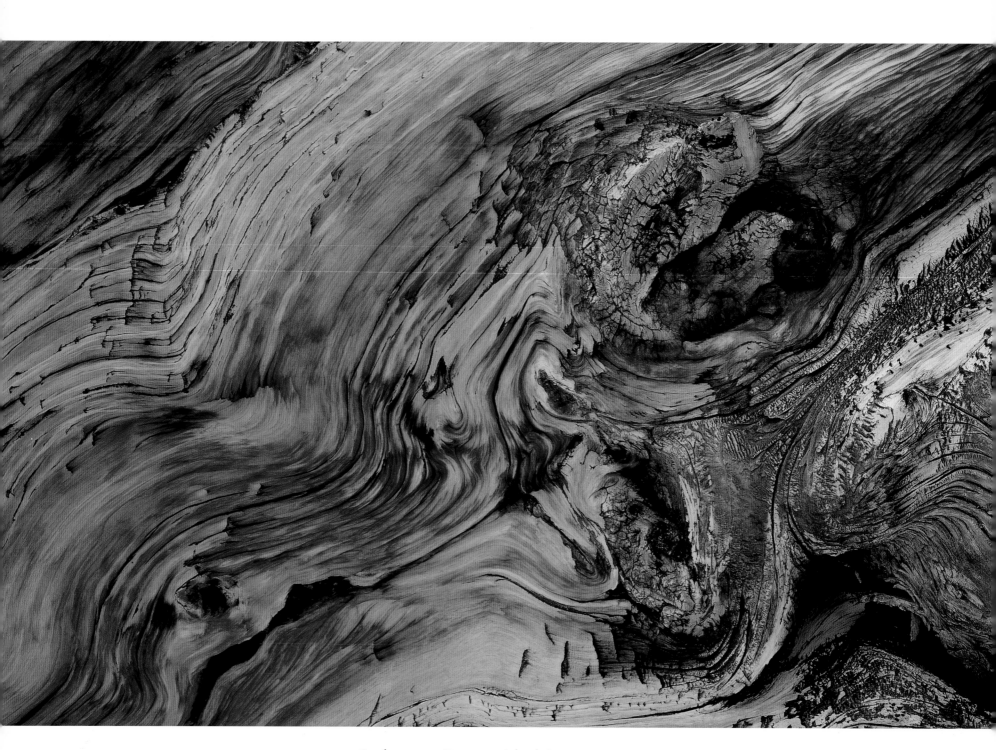

Bristlecone pine (*Pinus aristata*) detail, Ancient
Bristlecone Pine Forest, White Mountains

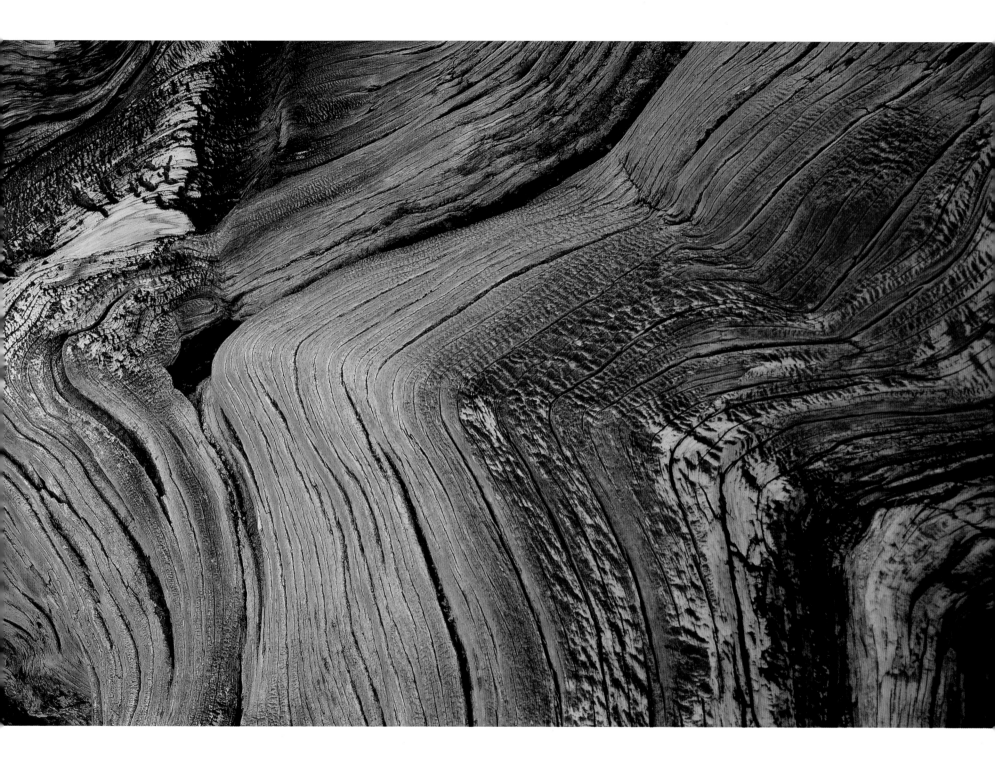

Below: Wildflowers, Strawberry Valley

Right: Shooting star (*Dodecatheon pulchellum*), Kings Canyon National Park

Far right: Black bear (*Ursus americanus*), cinnamon phase, foothills of Sierra Nevada

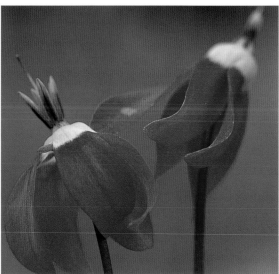

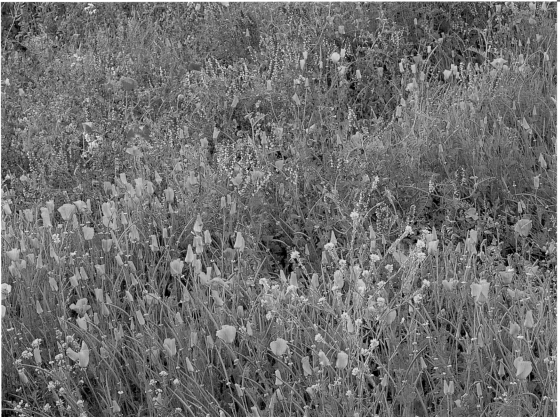

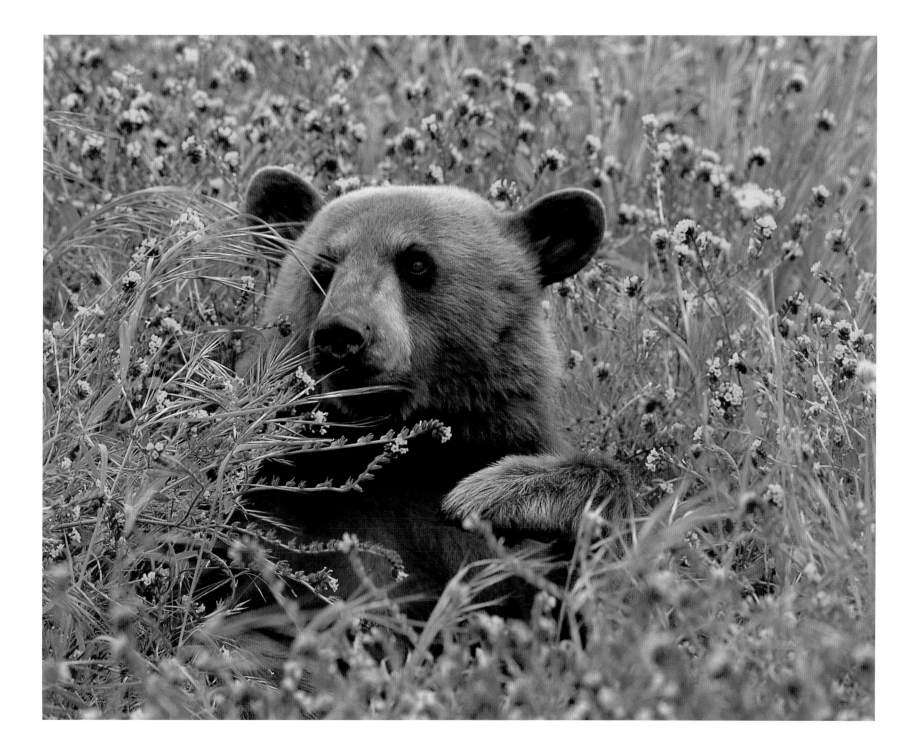

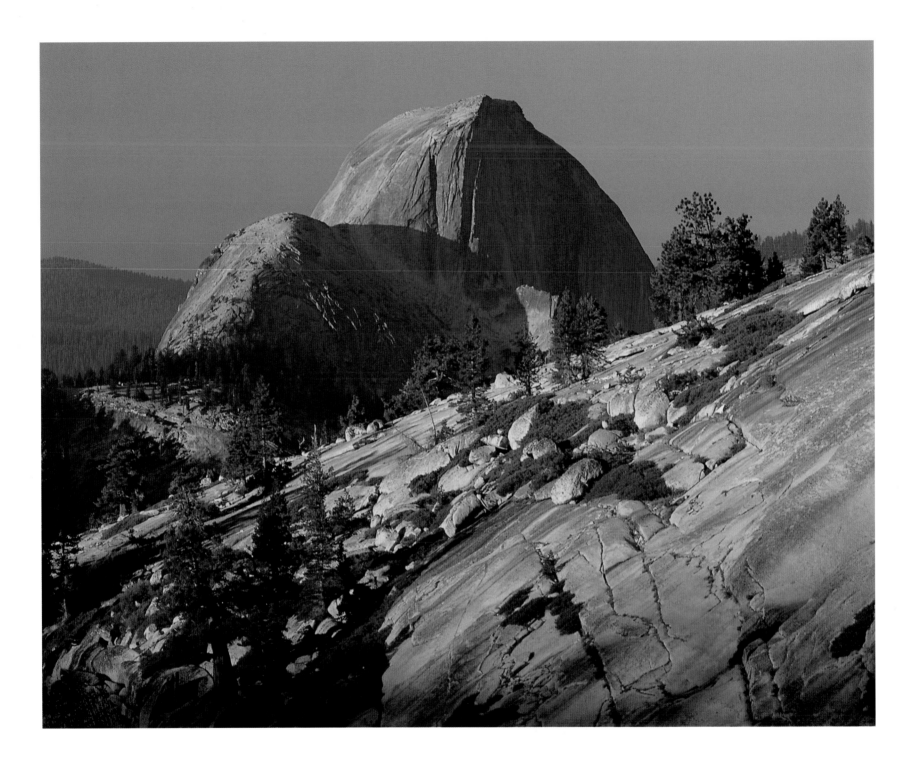

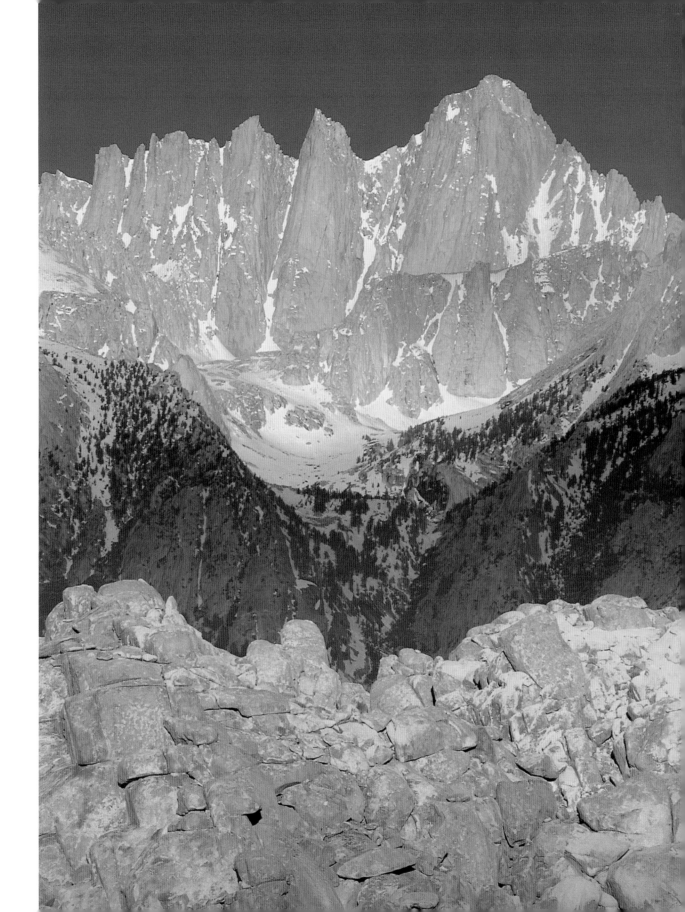

Left: Half Dome from Olmsted Point, Yosemite National Park

Right: Mount Whitney (14,494 feet) from Alabama Hills

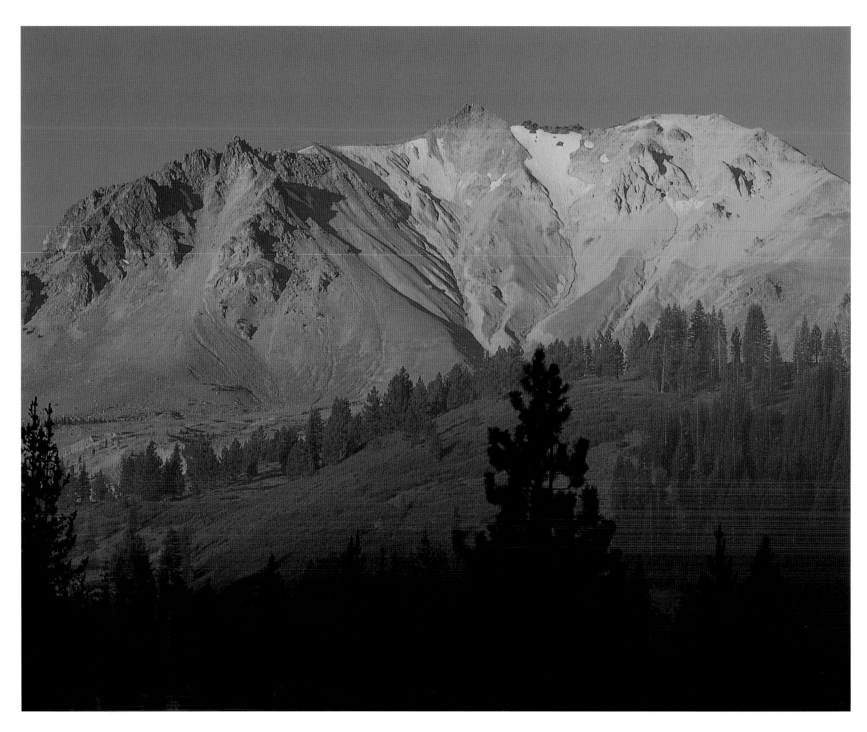

Lassen Peak (10,457 feet), Lassen Volcanic
National Park

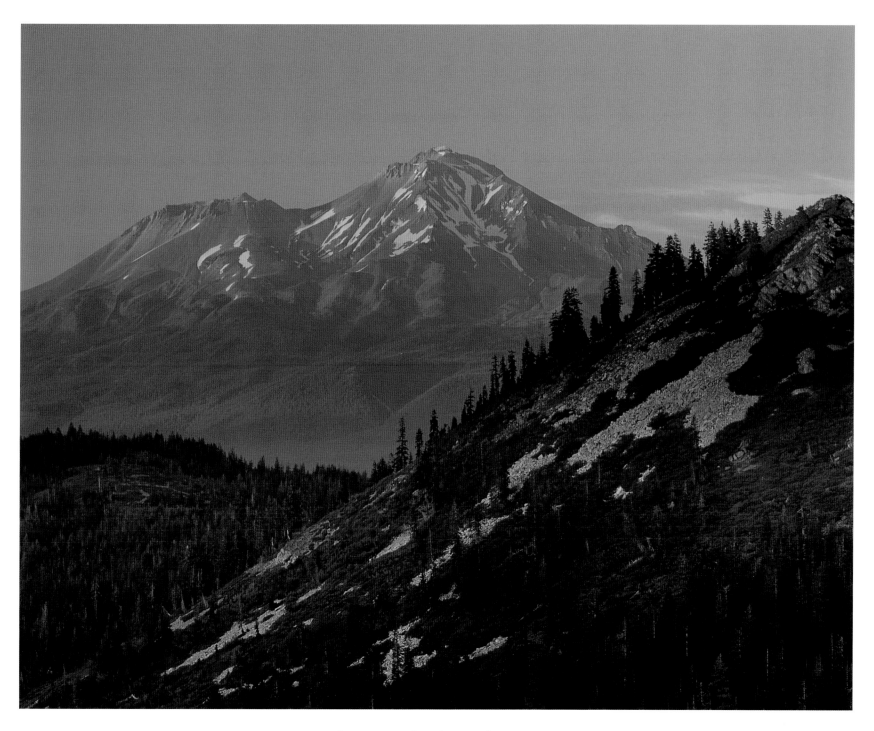

Mount Shasta (14,161 feet), from Castle Crags
Wilderness, Shasta-Trinity National Forest

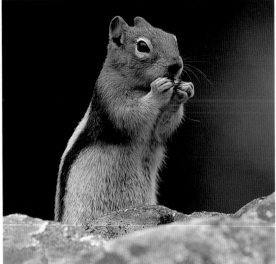

Left: Golden-mantled ground squirrel (*Spermophilus lateralis*), Yosemite National Park

Below: Mountain lion (*Felis concolor*), Lassen Volcanic National Park

Right: Aerial over Sierra Nevada, Kings Canyon National Park

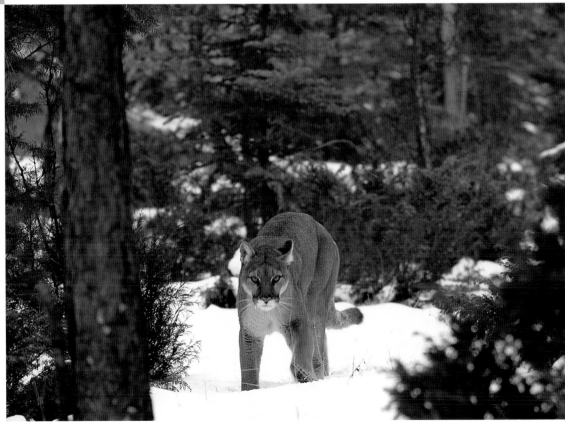

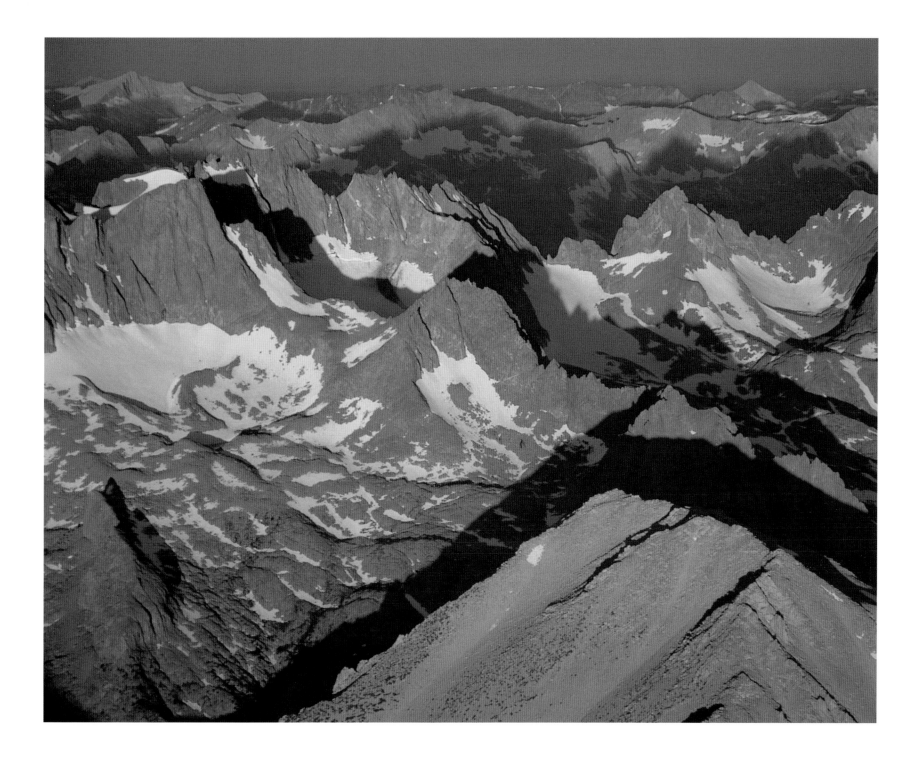

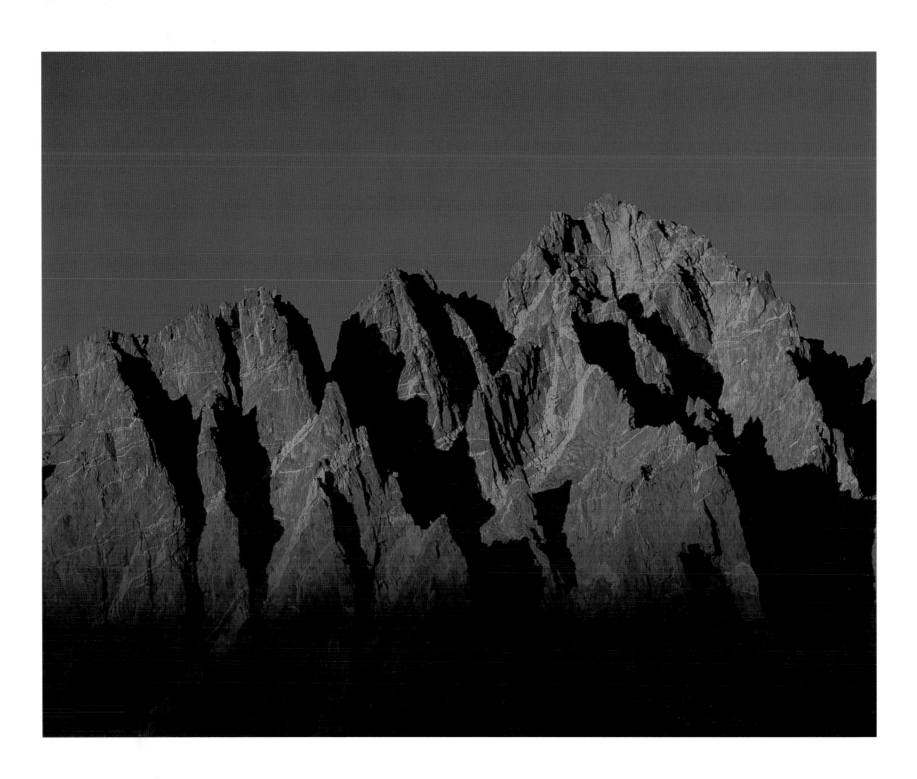

Left: Sunset on Mount Winchell (13,768 feet) from Dusy Basin, Kings Canyon National Park

Right: Mount Agassiz (13,891 feet) and Mount Winchell from Dusy Basin, Kings Canyon National Park

Following page: Giraud Peak (12,608 feet) from Dusy Basin, Kings Canyon National Park

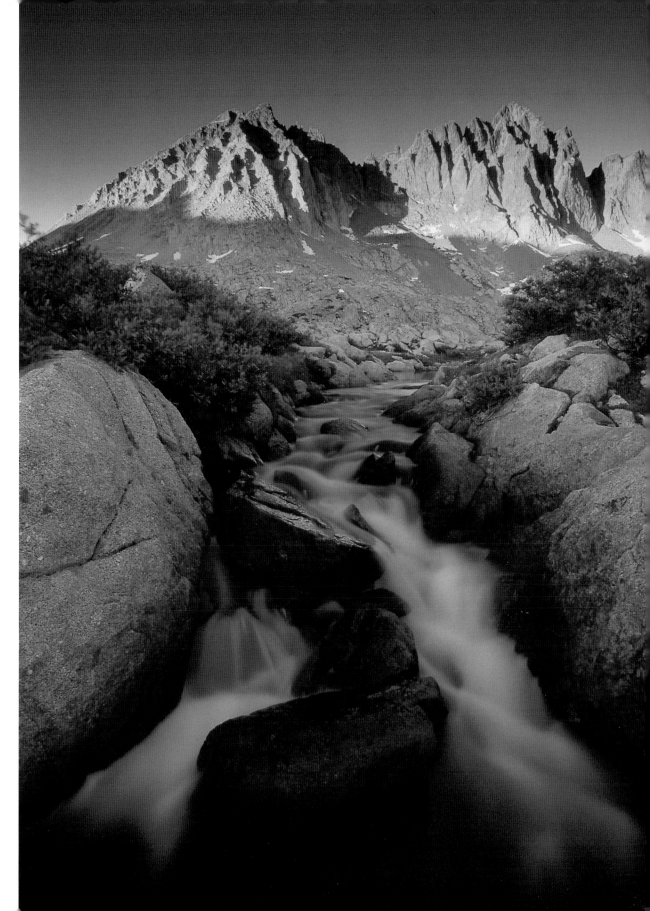

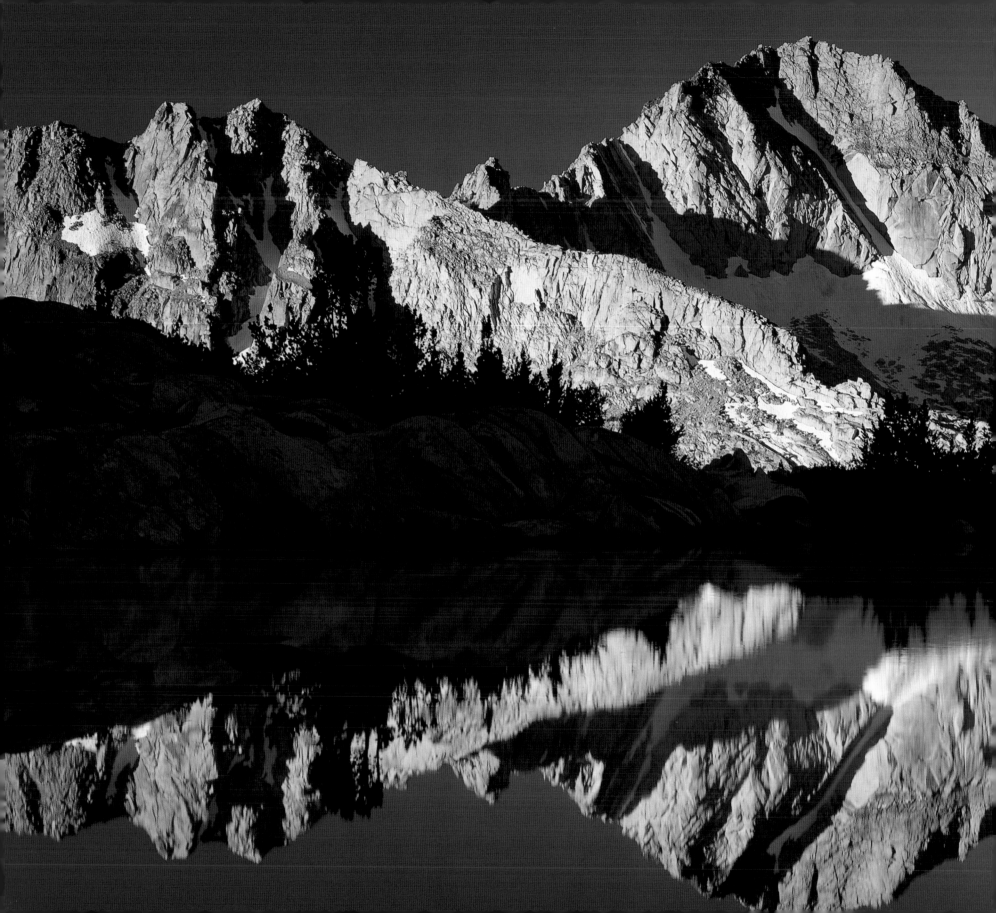

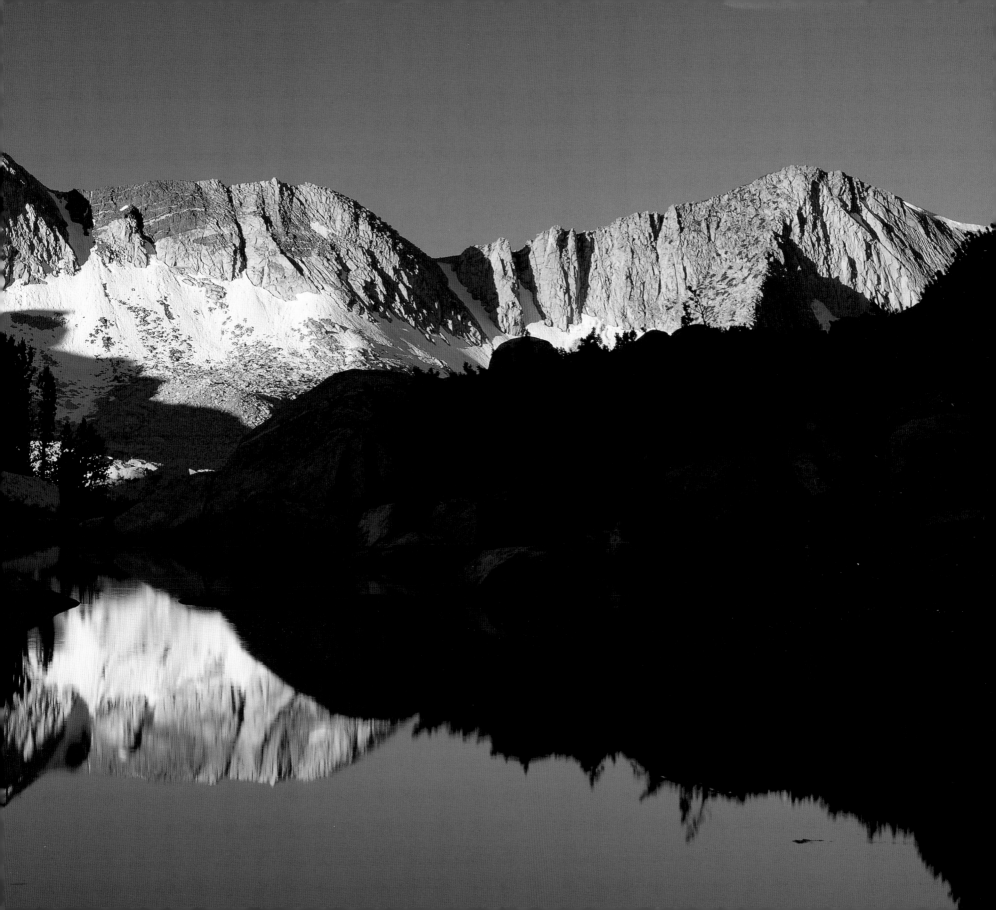

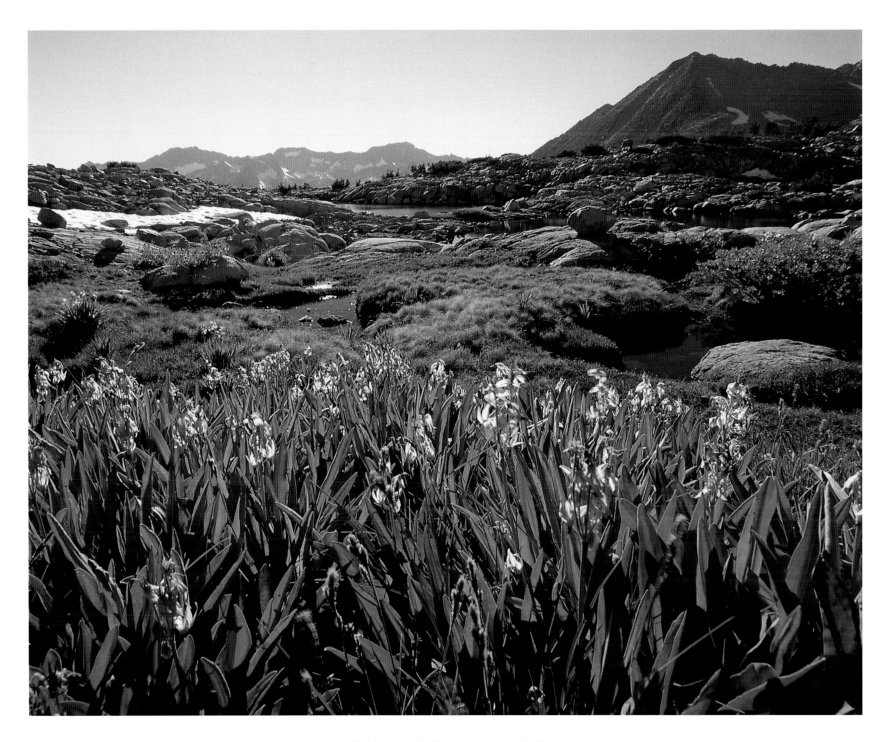

Dusy Basin landscape with shooting stars (*Dodecatheon pulchellum*) in foreground, Kings Canyon National Park

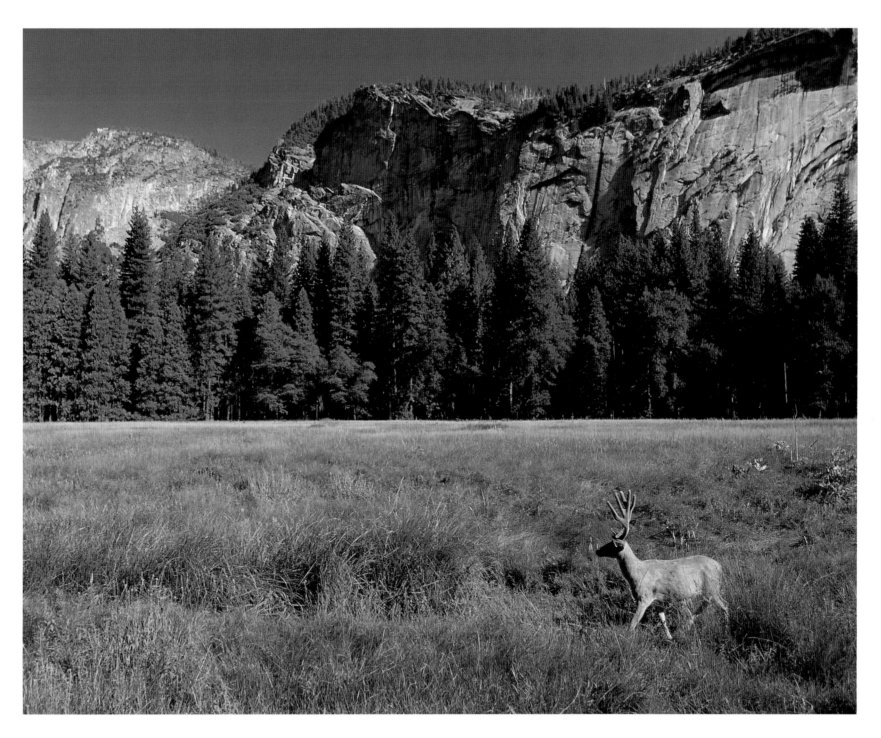

White-tailed buck (*Odocoileus virginianus*), Yosemite
National Park

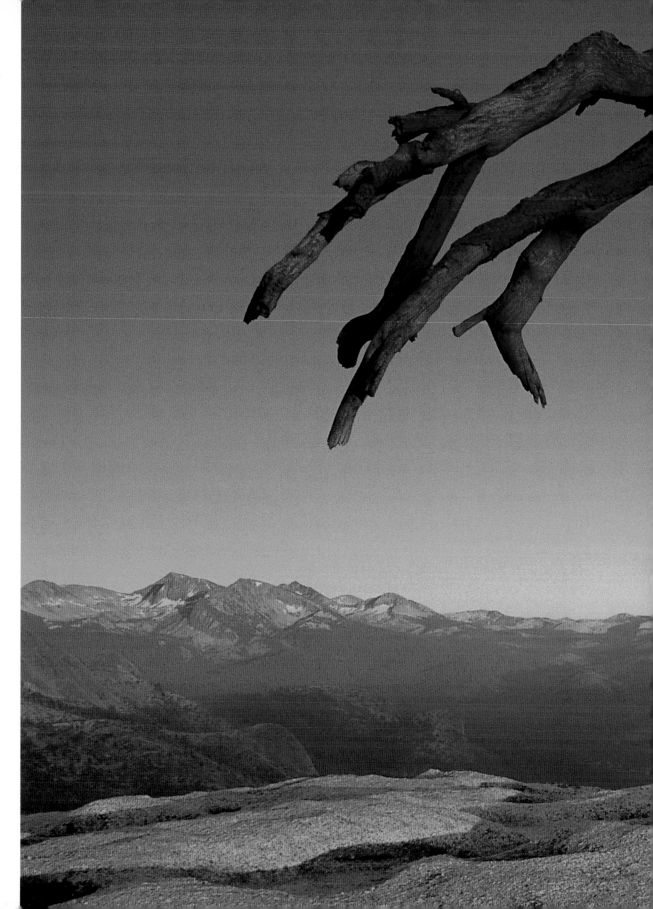

Jeffrey pine (*Pinus jeffreyi*), Sentinel Dome, Yosemite
National Park

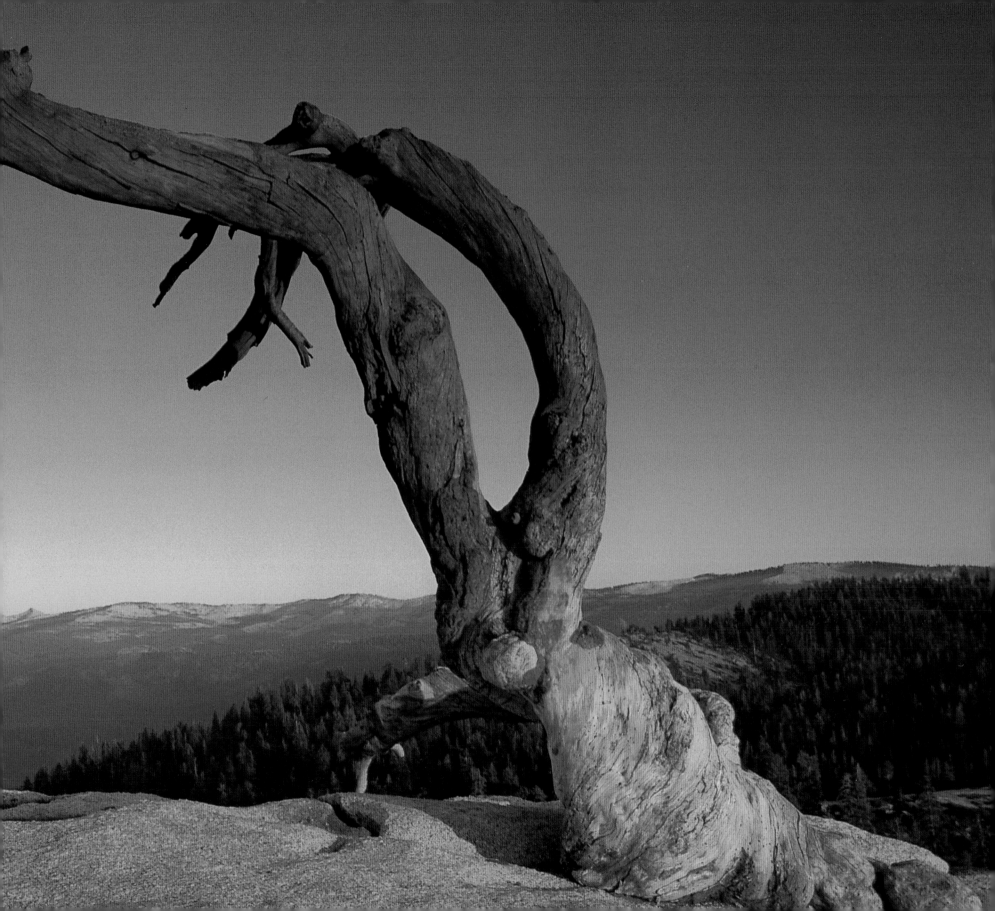

Left: Lichen on quartz, Dusy Basin, Kings Canyon National Park

Below: Alpine chipmunk (*Tamias alpinus*), Yosemite National Park

Right: Golden eagle (*Aquila chrysaetos*), John Muir Wilderness, Inyo National Forest

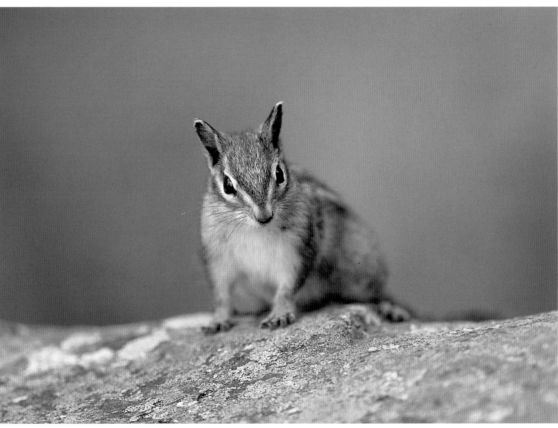

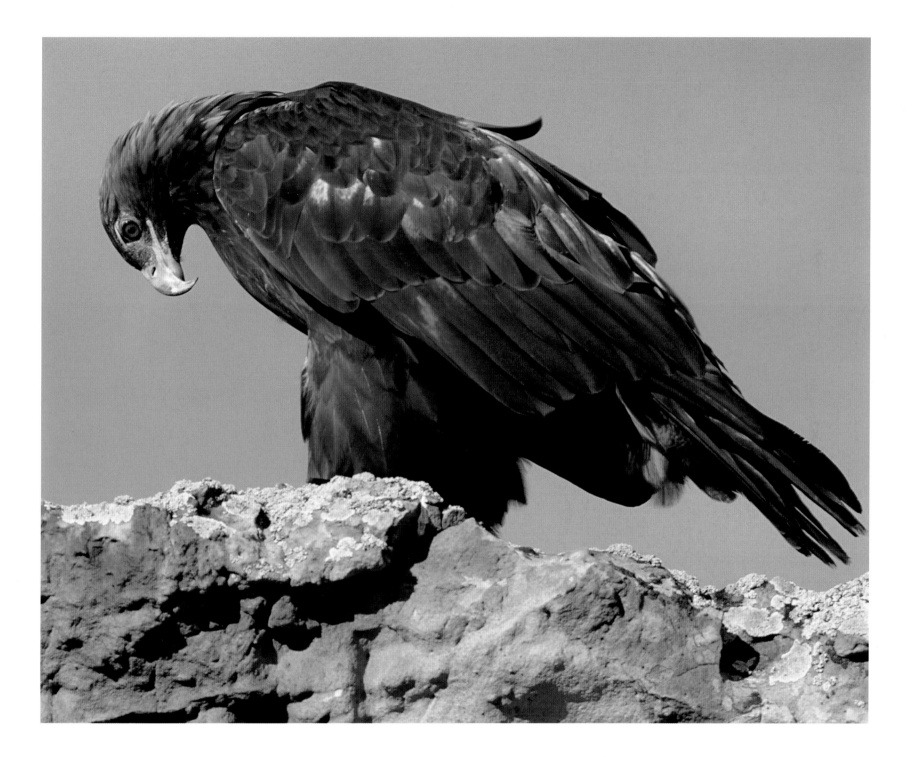

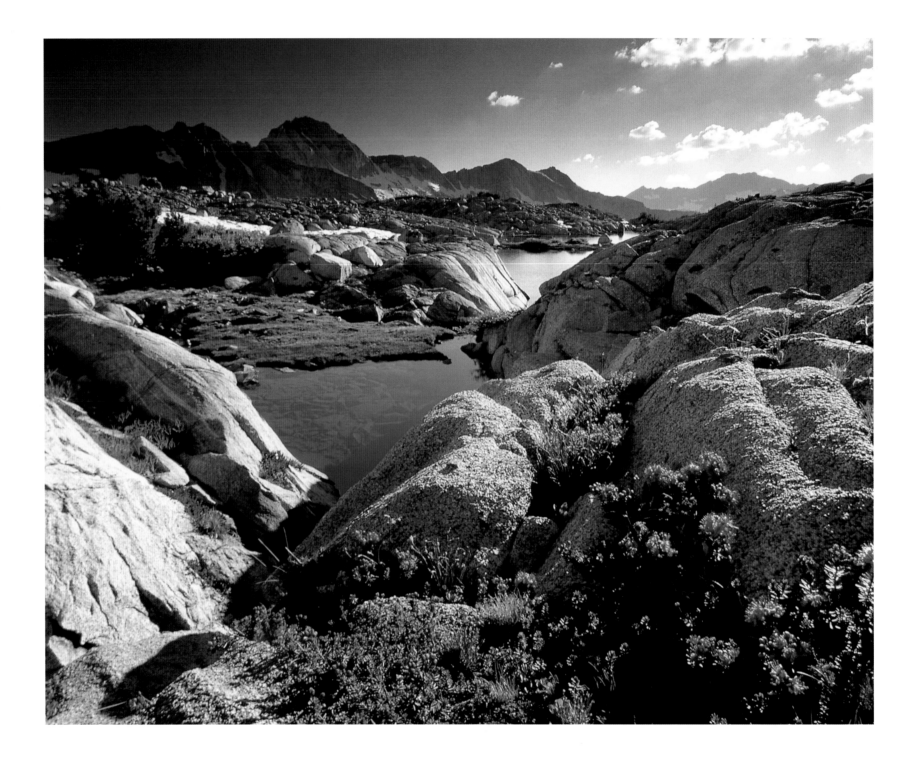

CALIFORNIA

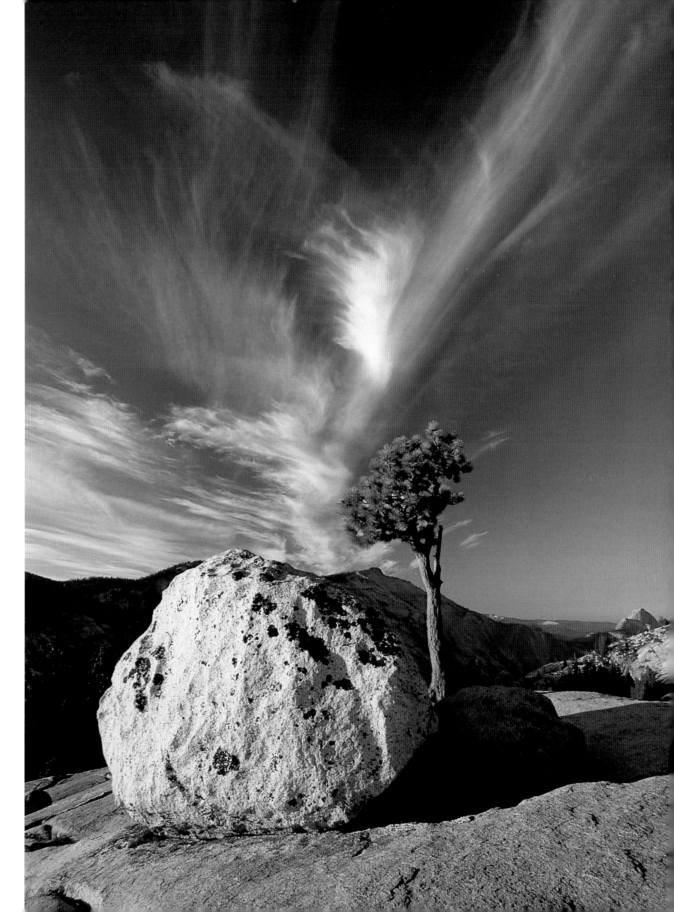

Left: Alpine tarns, Dusy Basin, Kings Canyon
National Park

Right: Jeffrey pine (*Pinus jeffreyi*) and granite boulder,
Olmsted Point, Yosemite National Park

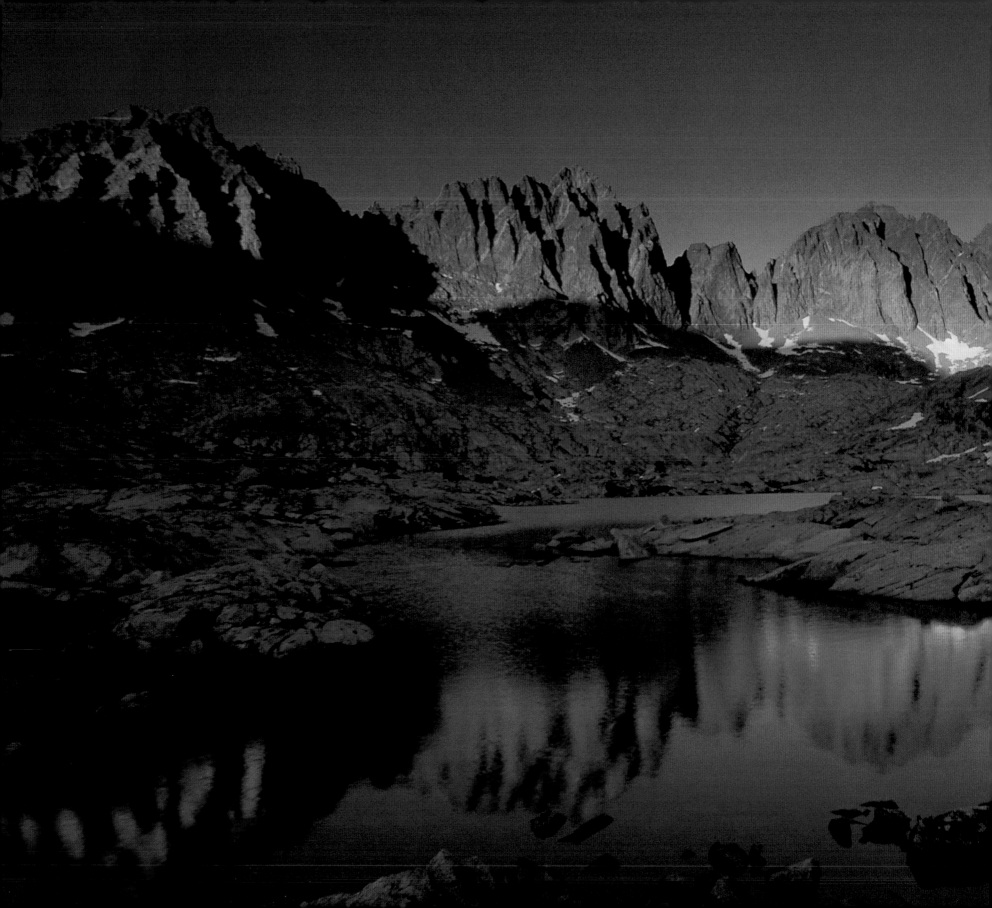

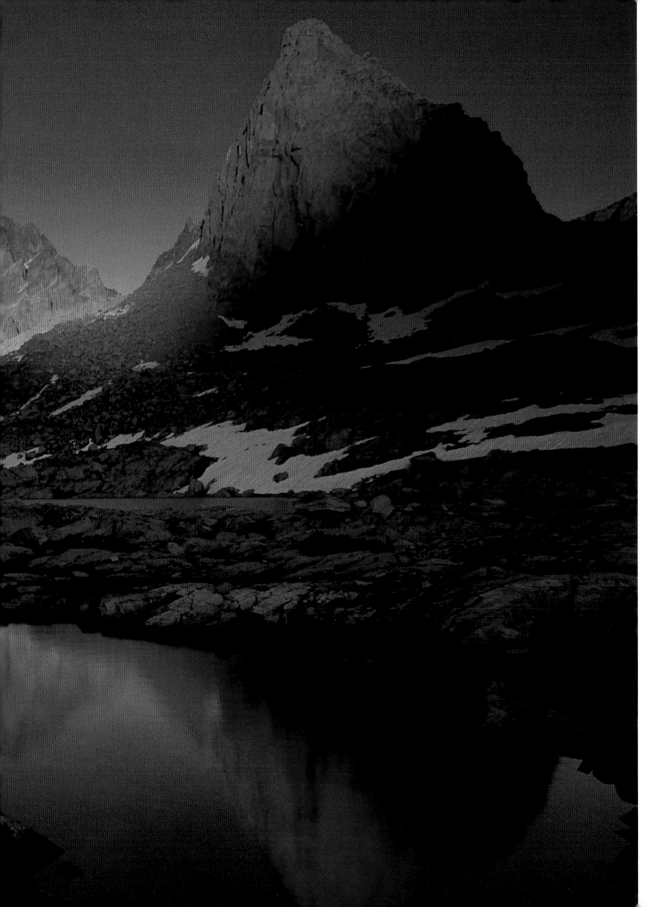

Alpenglow on North Palisade (14,242 feet),
Mount Agassiz (13,891 feet), Mount Winchell
(13,768 feet), and Isosceles Peak (12,321 feet),
Dusy Basin, Kings Canyon National Park

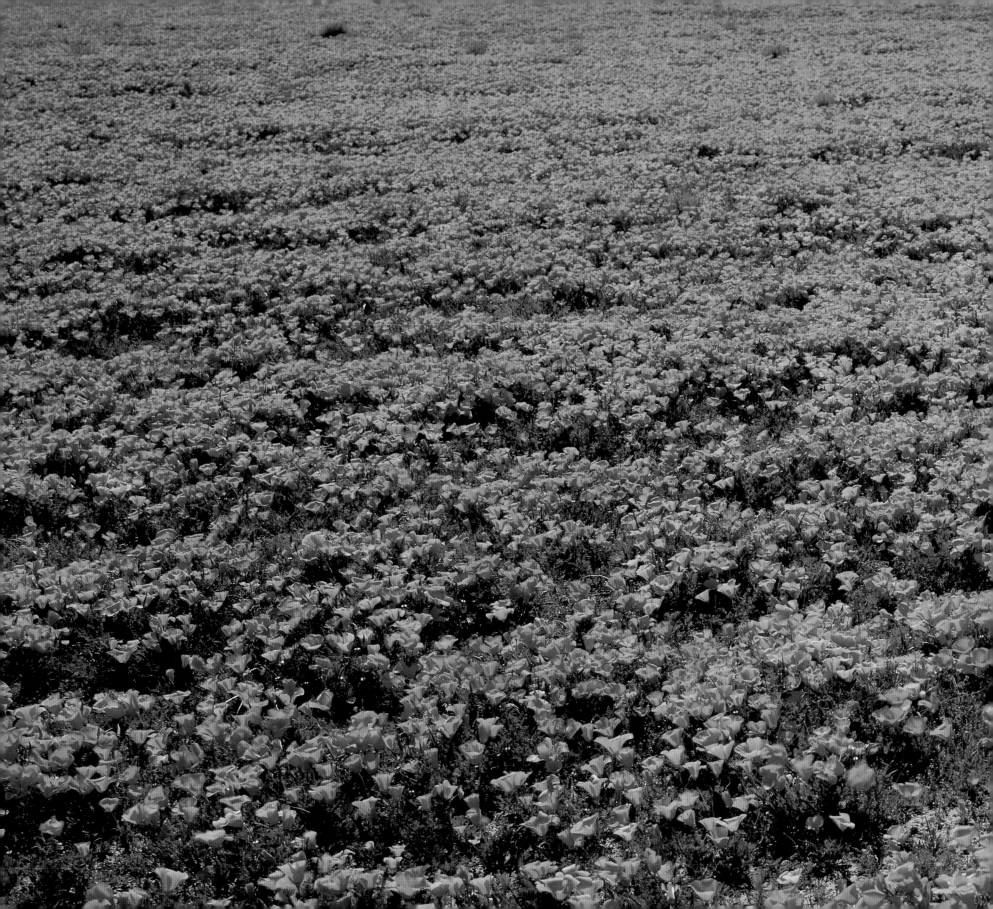

CENTRAL VALLEY

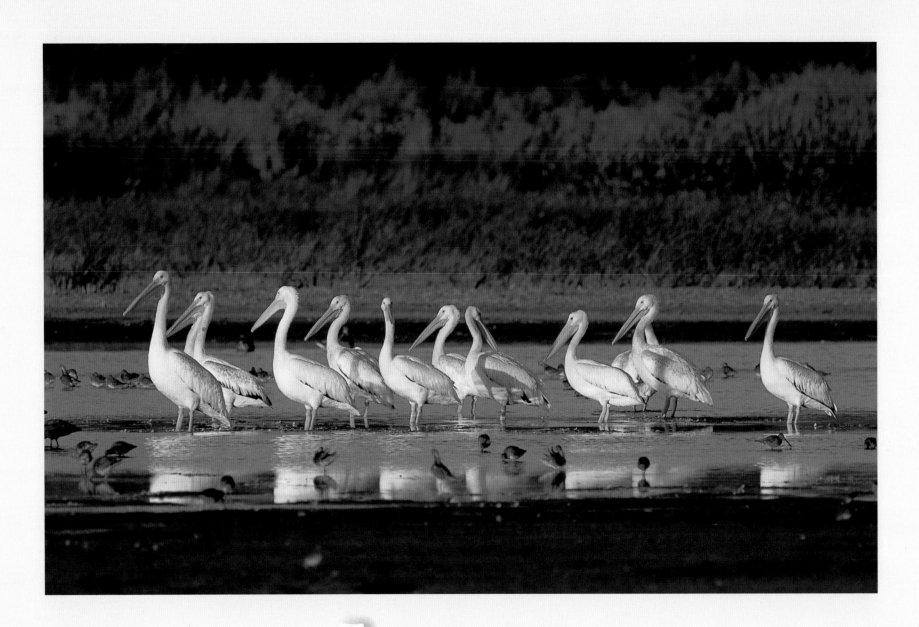

At dusk, with the last banners of sunset blocked by the dark shoulders of Mount Diablo, I drove west across the Sacramento–San Joaquin delta lands near Stockton. A clear, cold sky above the Central Valley purpled into a remoteness of stars and a nascent moon. Good,

I thought—a good, safe night for driving two-lane farm roads that skirt fields and orchards in long straight lines only to suddenly veer right or left without warning. As fence posts stitched the sides of my car's relentless broom of light, weariness set in. I looked forward to stopping along one of the levees near a drawbridge to stretch my legs, perhaps sitting for a while on the ticking warmth of the hood, feet on the bumper, listening to the ducks paddle through the cattails in the still, sea-level sloughs below.

Held by the vastness of this relatively flat valley's 75-mile width and 430-mile length, the land murmurs its origins. In the same way a Zen garden draws its strength as much from what is beneath its surface as what is seen, the valley sinks its roots deep—as far as 30,000 feet down to bedrock. Sediments here, the oldest left by a retreating Jurassic sea and others borne by rivers, rest inside a mountain-ringed basin bounded by the Sierra Nevada to the east, the Transverse Ranges to the south, the Coast Ranges

to the west, and the Klamath Mountains and Cascade Range to the north. Except for Sutter Buttes near Marysville, an isolated cluster of andesite plug domes rising to an elevation of 2,100 feet, the valley stretches like a frozen inland sea of soil.

Remarkably fertile soil.

Until the mid-1800s, perennial bunchgrasses, especially purple needlegrass, covered these tracts in a profusion of green each spring. Lupines and poppies ran wide brush strokes of blue and gold over the canvas, climbing into the surrounding rolling hills on all sides. Most of the bunchgrasses are gone now, pushed out by annual grasses introduced in the feed and droppings of European cattle and sheep. Few places remain where this splendor returns with the region's typically sparse rains, but where it does, the pollen can dust your boot toe tops and laces with a powdery gold whose brilliant hue is eclipsed only by the petals of the poppies themselves—a spectacle John Muir called "a burning color—not orange, not gold, but if pure gold were liquid and could raise a cream. . . ."

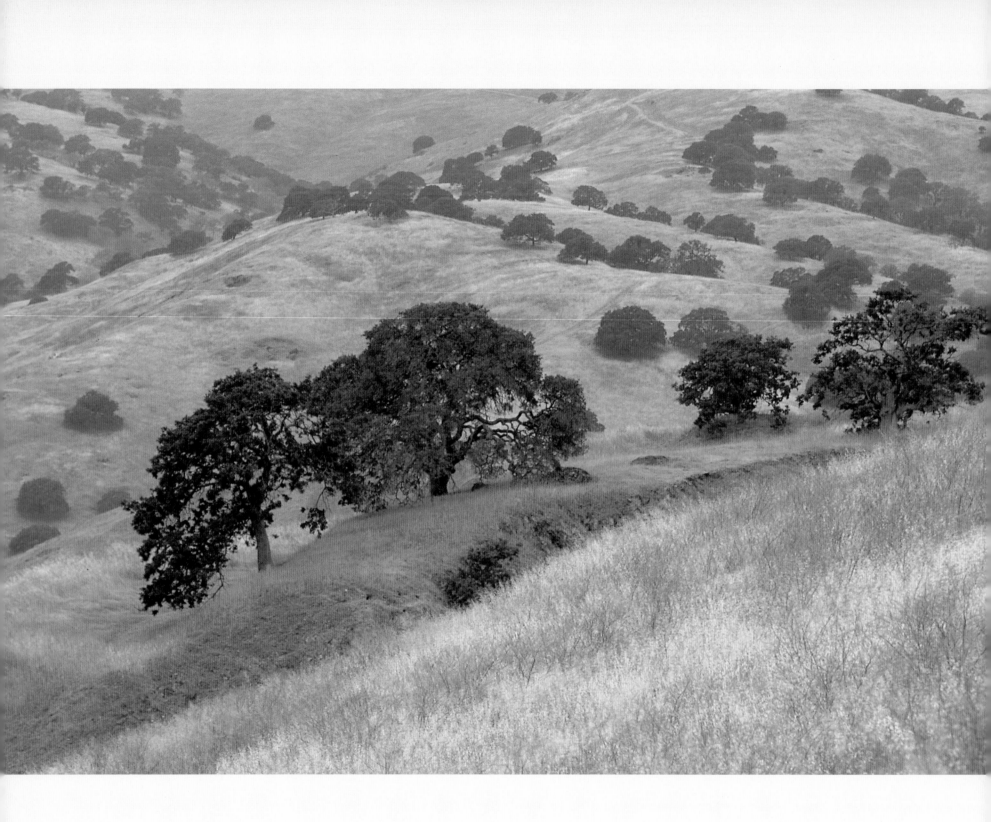

Tule elk, also known as tule wapiti, and pronghorn antelope commonly grazed these grasslands before the arrival of crops, sheep, and cattle. Predators included gray wolves, grizzly bears, and mountain lions; only mountain lions remain, and these now hide in remote foothills and rugged canyons well above most open grasslands, preying on deer herds. Conservation efforts have saved two small herds of wapiti, one located in a preserve at the southern end of the Central Valley near Taft, the other on the east side of the Sierra Nevada in Owens Valley. Pronghorns, about three feet tall at the shoulder and known for their speed and endurance (some have been observed traveling thirty-five miles per hour over a distance of four miles), have retreated to their last natural stronghold, the Modoc Plateau in the state's northeasternmost corner.

In places dome-shaped leafy green crowns rise from the land, supported by trunks as large as the stone pillars inside a Chartres or Westminster. These great valley oaks, members of the many riparian woodlands that follow a web of rivers and streams, sometimes achieve a girth that five men can barely encircle with outstretched arms. Most of the ancients came down as firewood or mine timber in the nineteenth century, but

some hold out in places like the Cosumnes River Preserve, the ground beneath them as spacious and shaded as an abandoned dance hall.

Again, valley roots must run deep, spread wide. Except along the rivers and freshwater marshes, there is thirst here. If it weren't for water thundering down from higher sources, much of the valley would be considered a desert. At its southern end, scarcely six to eight inches of precipitation occurs in a year. Moving north, the rainfall increases gradually, reaching eighteen inches by mid-state, and finally thirty-eight inches near Redding at the northernmost end. Water is spoken for, coaxed, channeled, and drilled to the ends of a billion furrows, finally spreading like the infinite teeth of a glistening comb over turned fields.

Once three great lakes and a host of smaller freshwater marshlands created tule-edged margins that meandered for some 2,100 miles of shoreline in a grand jigsaw at the foot of the rivers Kaweah, Kern, and Kings. Once Tulare Lake was the largest freshwater lake in a nineteenth-century West, covering about 700 square miles. Today a few thousand acres remain. Once the long, gently scalloped leaves of the Pacific, black, and red willows crowded the marsh edges where the saturated soil almost imperceptibly

Oak trees (*Quercus* spp.), San Luis Reservoir State Recreation Area

gives way to higher ground. Once. That plaintive word reminds us of what has passed.

Yet despite the overwhelming encroachment of agriculture and communities, nature still rules the great valley. As I drove into the night, through fields lower than sea level, protected only by earthen levees, I could feel the delta's waters waiting for weakness. When it presents itself, the water widens the break, and then fans out in what news reports will call a flood, and what nature might call a simple reclamation. Where the road rose to one of these levee tops to cross one of the delta's many drawbridges, I spotted a fisherman still seated in his aluminum folding chair, a twelve-foot bamboo pole bent downward into darkness, waiting for a catfish dinner. Two great rivers flow through the Central Valley, the southward-bound Sacramento and the northward San Joaquin, joining mid-state to flow through the tidewater navel of the San Francisco Bay system. Both are spawning grounds for innumerable fish, including salmon and monstrous white sturgeon, some over ten feet in length and highly prized by fishermen for their masses of roe—an American caviar.

Above it all, a whirl of bird life sees the Central Valley—and the dominant grasslands and marshes of California's innumerable other valleys—as both resting place and home. Solitary raptors, including golden eagles, white-tailed kites, and American kestrels, hunt mostly open habitat and can often be seen perched atop telephone poles or an abandoned Aeromotor. Flocks of crows pester farmers and raid walnut crops, their raucous calls a pervasive valley refrain. Perhaps most spectacular are the mass gatherings of migratory waterfowl of the Pacific Flyway on flooded fields near Orland, Willows, and Colusa. In refuges there I have stood a few hundred yards from a honking mass of wintering snow geese, binoculars trained on a gliding rush hour of alert dark eyes carried by perfect white swoops of head and neck. Lifted, as one, by some unseen and unheard warning, the entire group bursts into the air, wings thundering. You step back, buffeted by the clamor.

Now my tires clatter on metal. Stars blink in a sudden movie reel of passing girders. With a bound where bridge rejoins the bank, I drive down the other side and into the complete whiteness of a tule fog. The valley's most legendary phenomenon occurs each winter when cold air draining off surrounding mountains gathers over warmer fields and marshes. Sometimes it is more of a pervasive overcast, blocking the sun for weeks, but on a night like this it hugs the ground in a motionless layer no higher than a man. I slow to a crawl and lean close to the windshield. At times I put my head out the side window, moisture gathering in my beard, searching for the centerline of the road. My tongue catches dew from my moustache, and I taste an ancient, unchanged exhalation of grasses and tides, marshes and woodlands. The valley is breathing. I am near its very mouth.

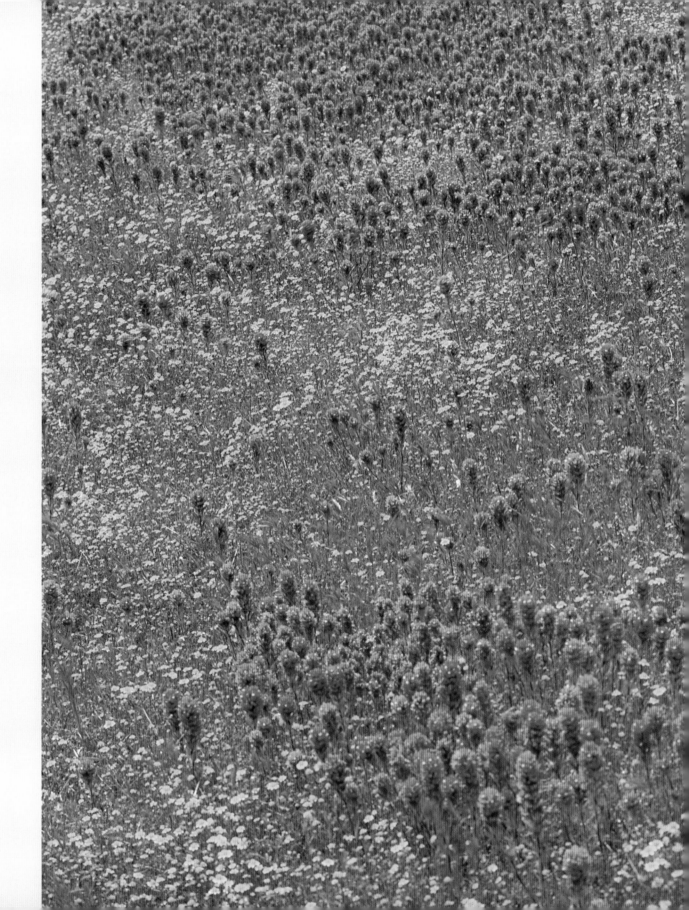

Purple owl's clover (*Castilleja exserta* ssp. *exserta*) carpeting a hillside, Lancaster

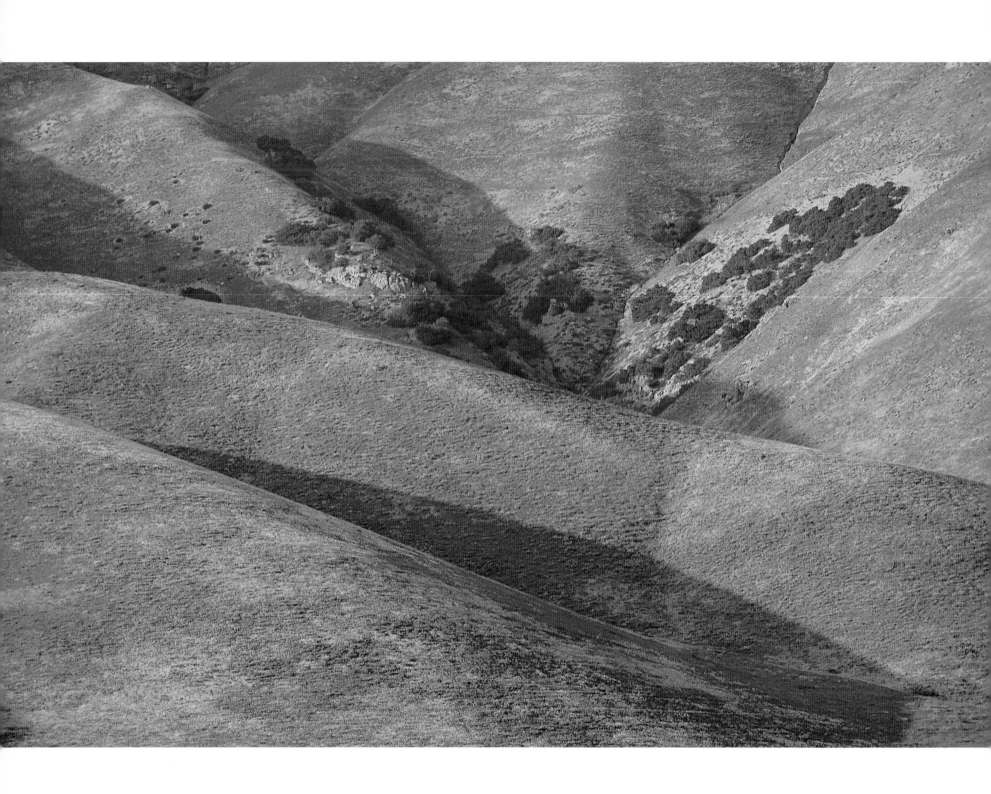

Left: Wildflower-covered landscape, Lancaster

Below: Red-winged blackbird (*Agelaius phoeniceus*), Sacramento National Wildlife Refuge Complex

Right: Cooper's hawk (*Accipiter cooperii*) intently watching for small birds, San Luis National Wildlife Refuge Complex

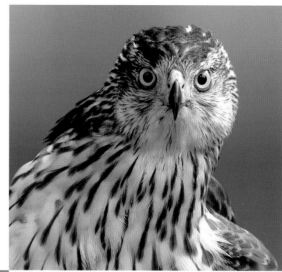

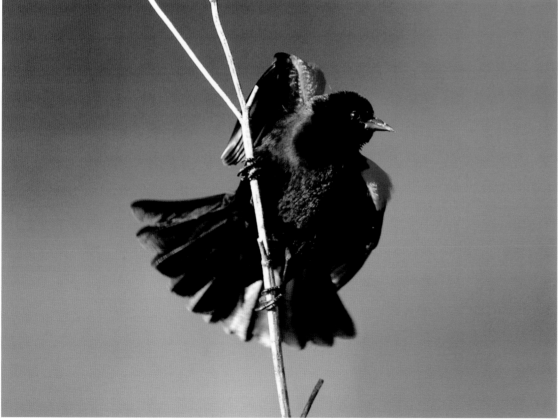

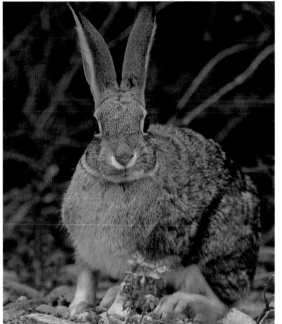

Left: Cottontail (*Sylvilagus* sp.), Los Banos Wildlife Area

Below: Black-crowned night-herons (*Nycticorax nycticorax*),
San Luis National Wildlife Refuge Complex

Right: American white pelicans (*Pelecanus erythrorhynchos*),
San Luis National Wildlife Refuge Complex

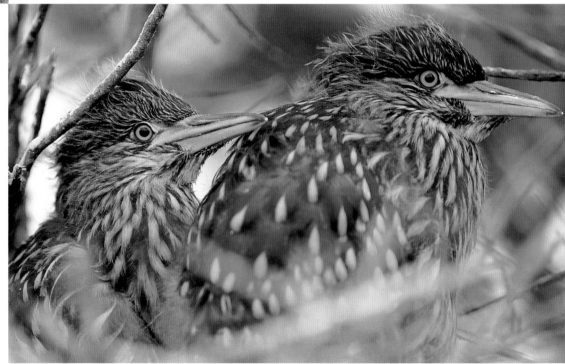

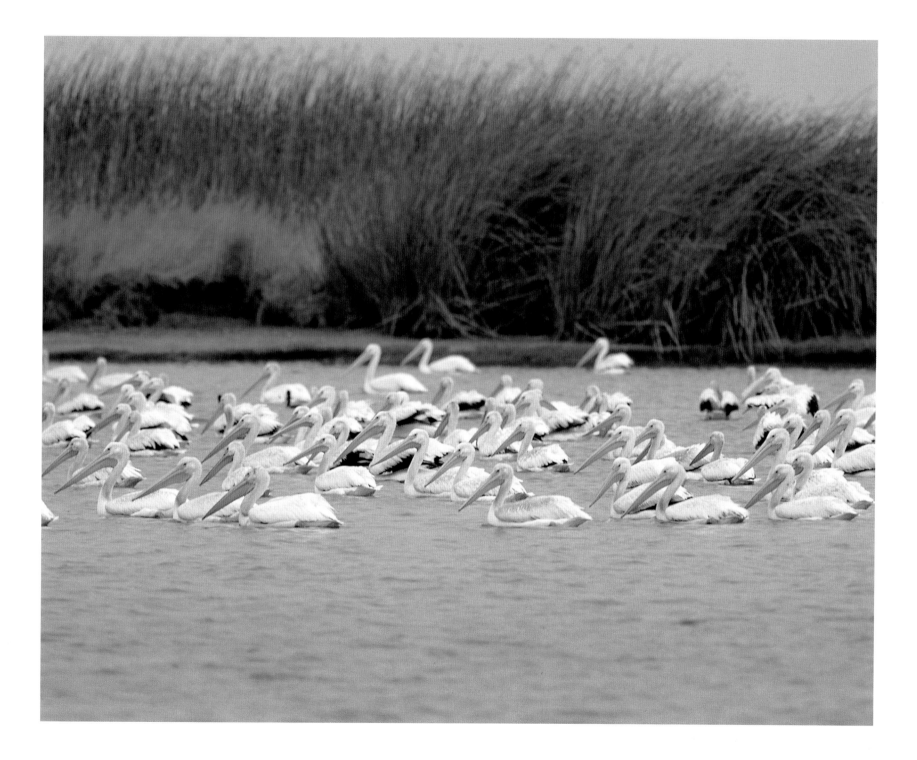

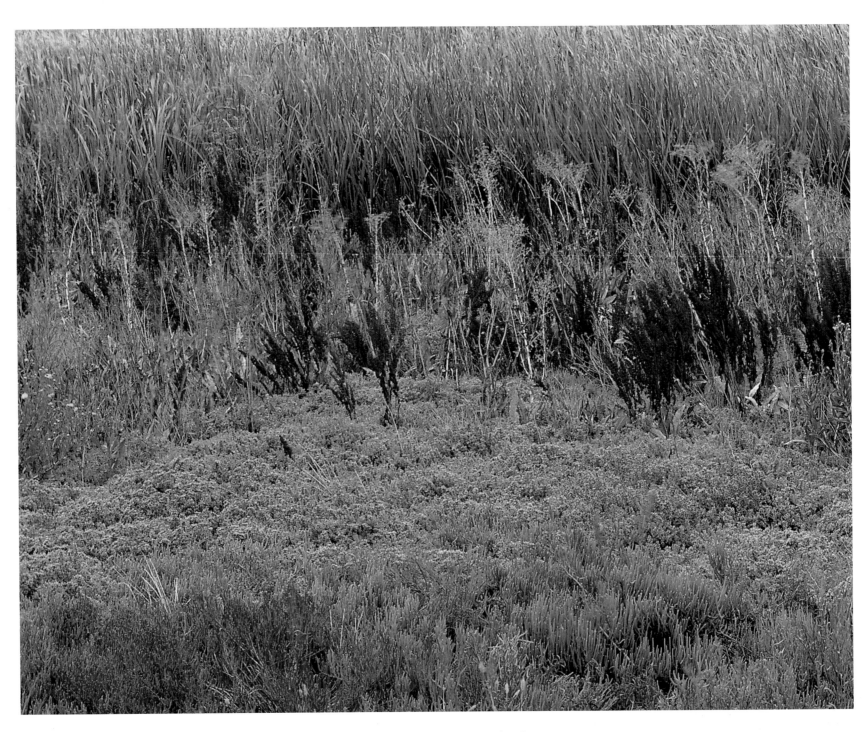

Variety of plants flourishing in nutrient-rich soil,
Los Banos Wildlife Area

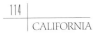

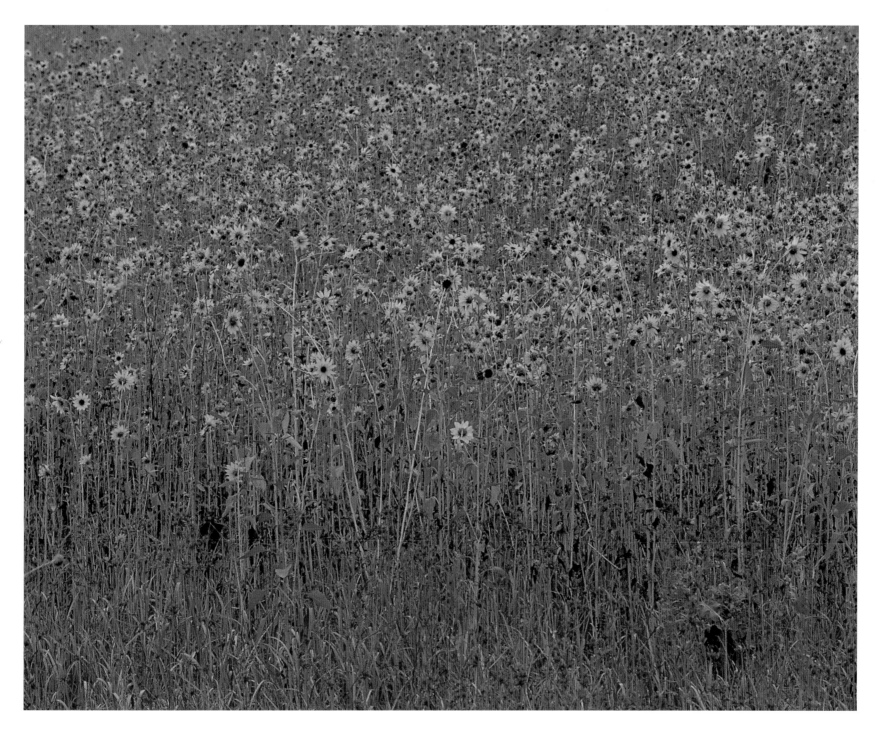

Common sunflowers (*Helianthus annuus*), Los Banos

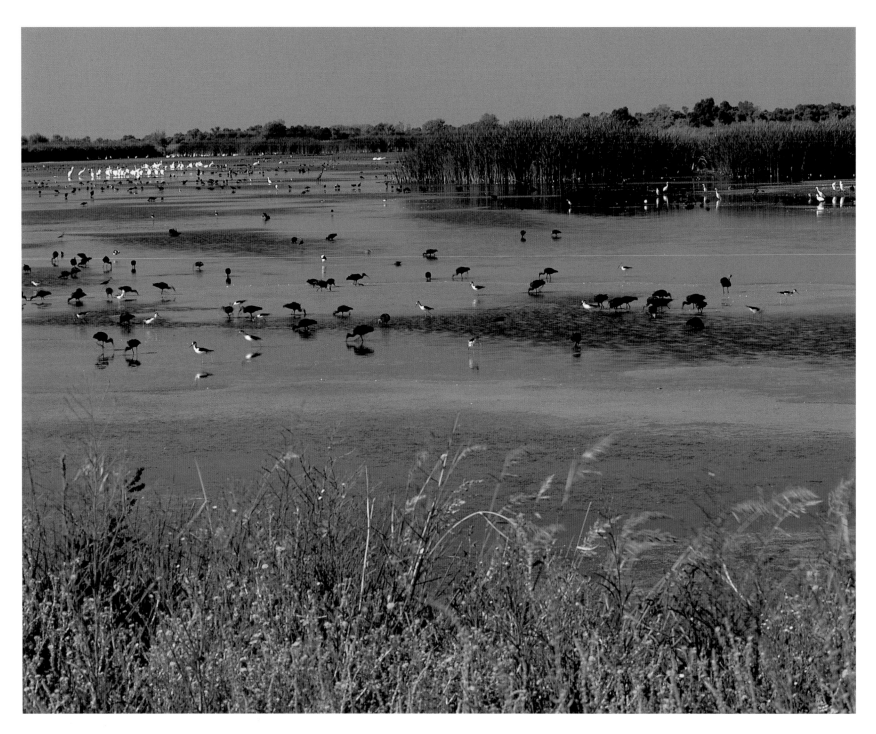

Wading birds feeding in marsh, San Luis National
Wildlife Refuge Complex

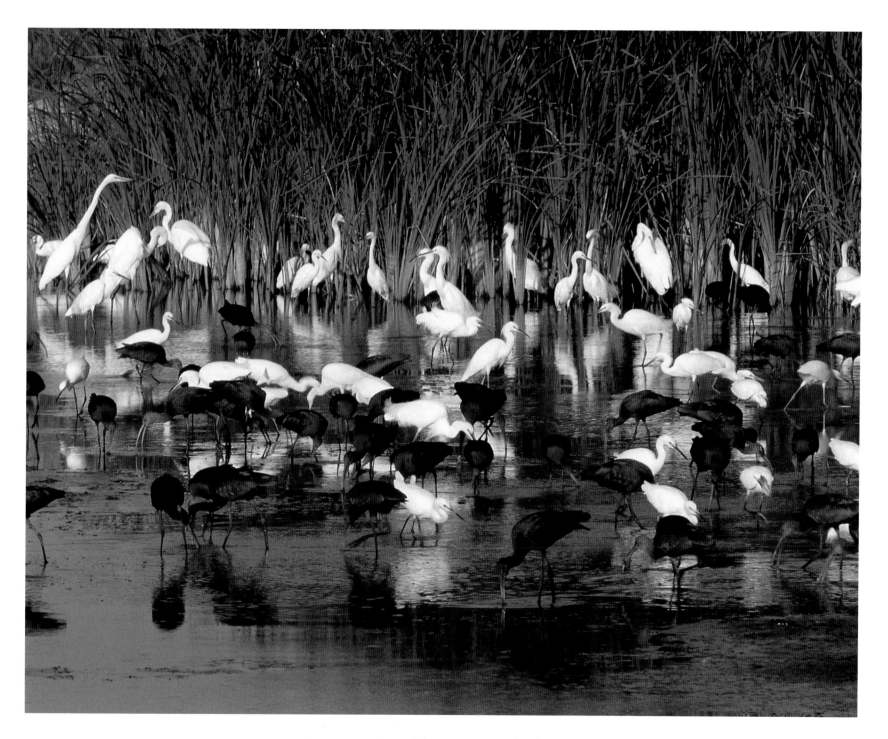

Snowy egrets (*Egretta thula*), great egrets (*Ardea alba*),
and white-faced ibis (*Plegadis chihi*) feeding on small
fish, San Luis National Wildlife Refuge Complex

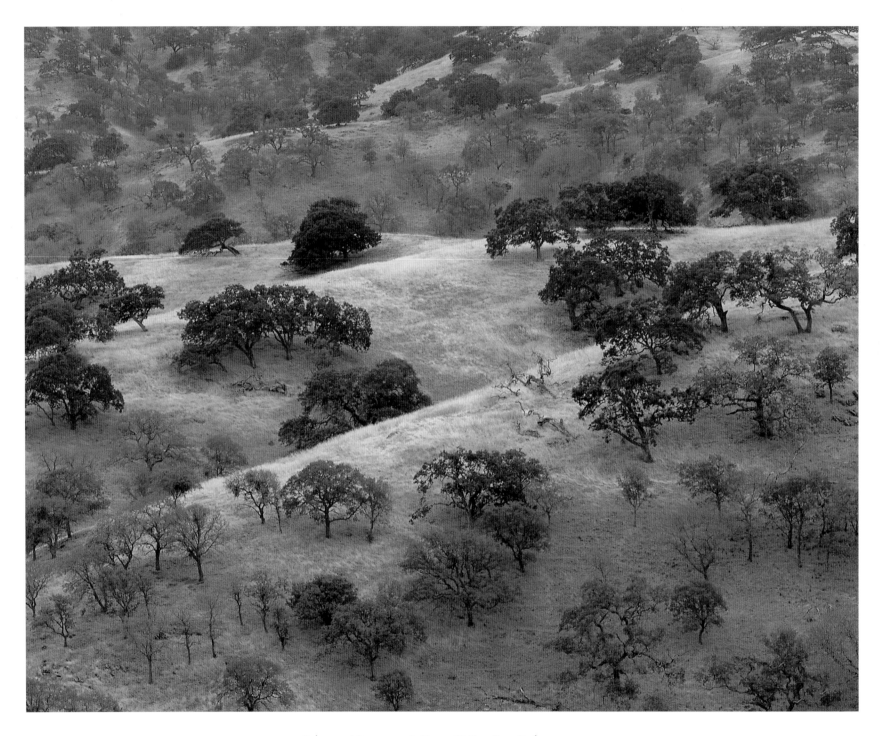

Oak trees (*Quercus* spp.), Henry W. Coe State Park

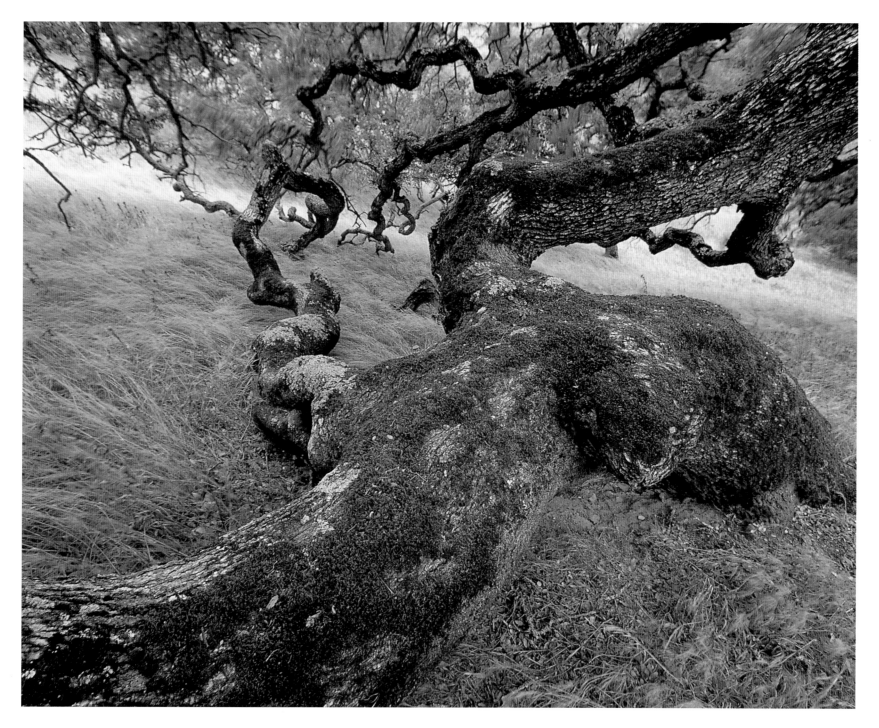

Oak tree (*Quercus* sp.), Henry W. Coe State Park

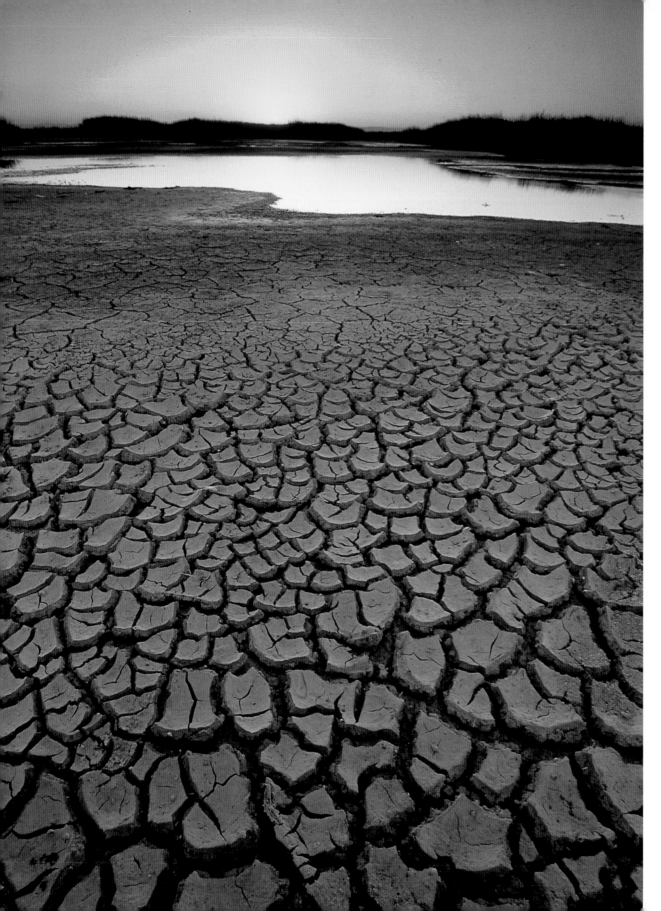

Left: Cracked mud along the shore of a marsh, San Luis National Wildlife Refuge Complex

Right: Raccoon tracks (*Procyon lotor*), San Luis National Wildlife Refuge Complex

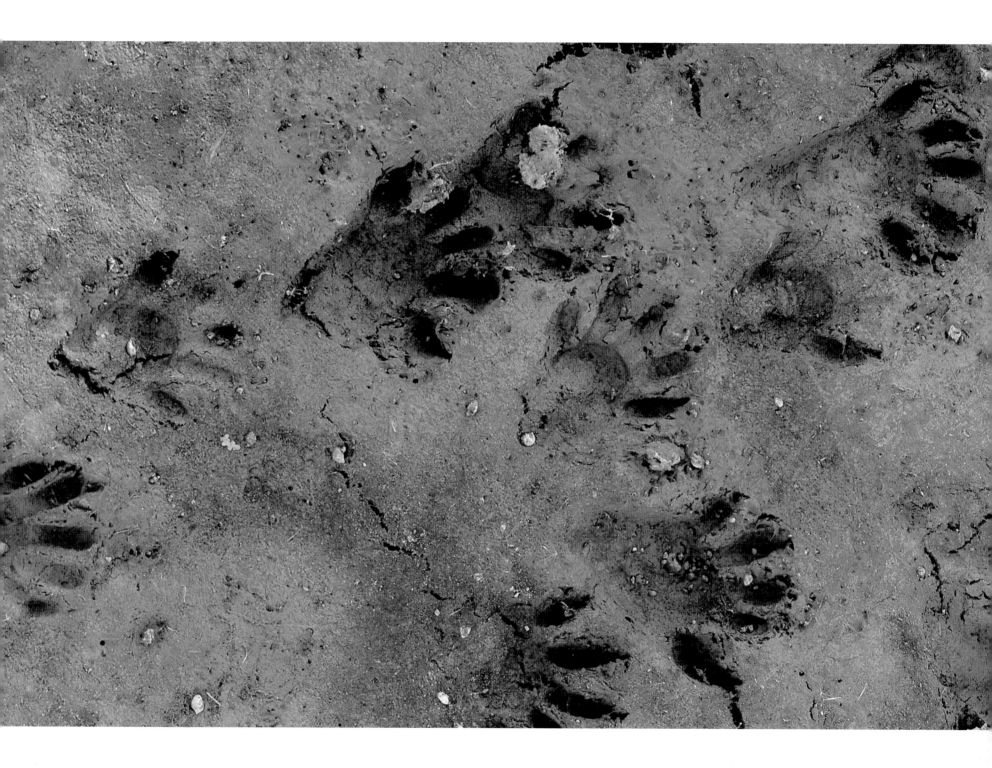

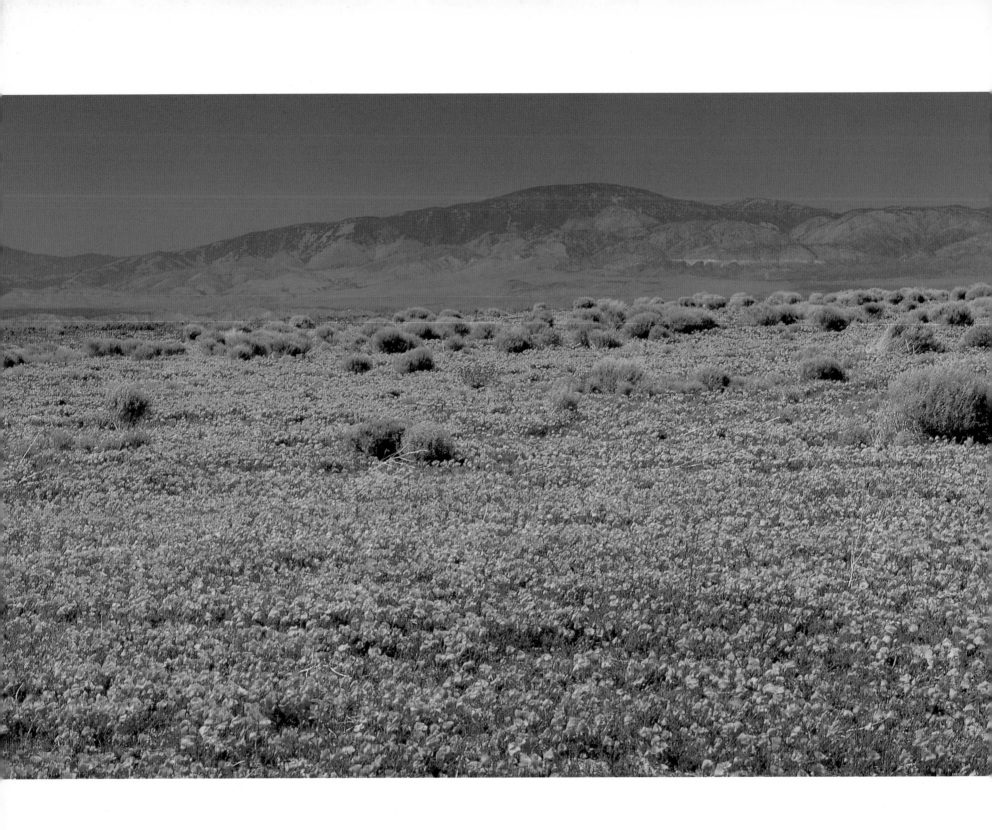

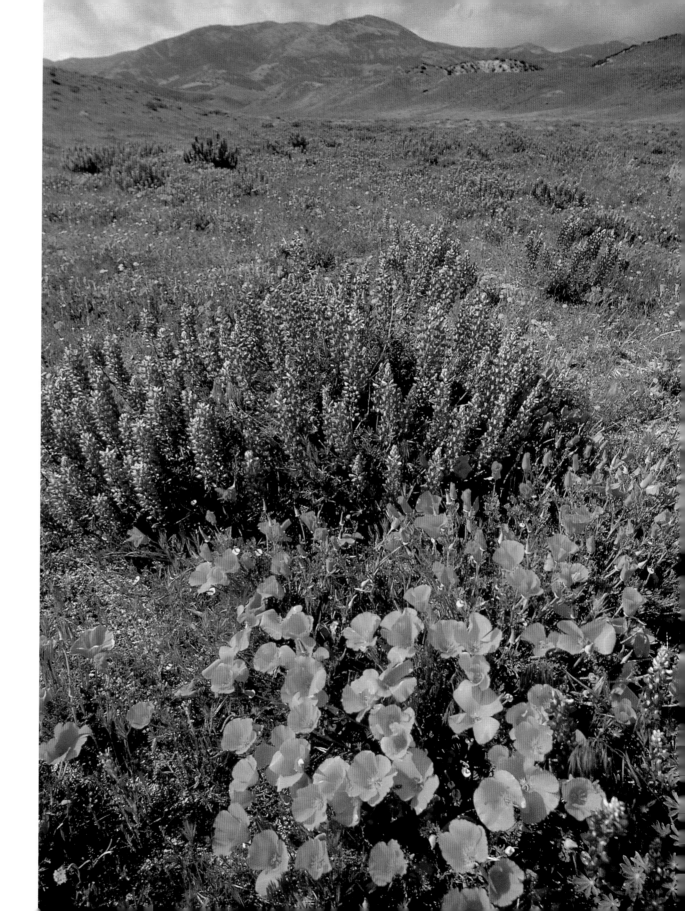

Left: California poppies (*Eschscholzia californica*), Antelope Valley California Poppy Reserve

Right: Wildflower variety, Lancaster

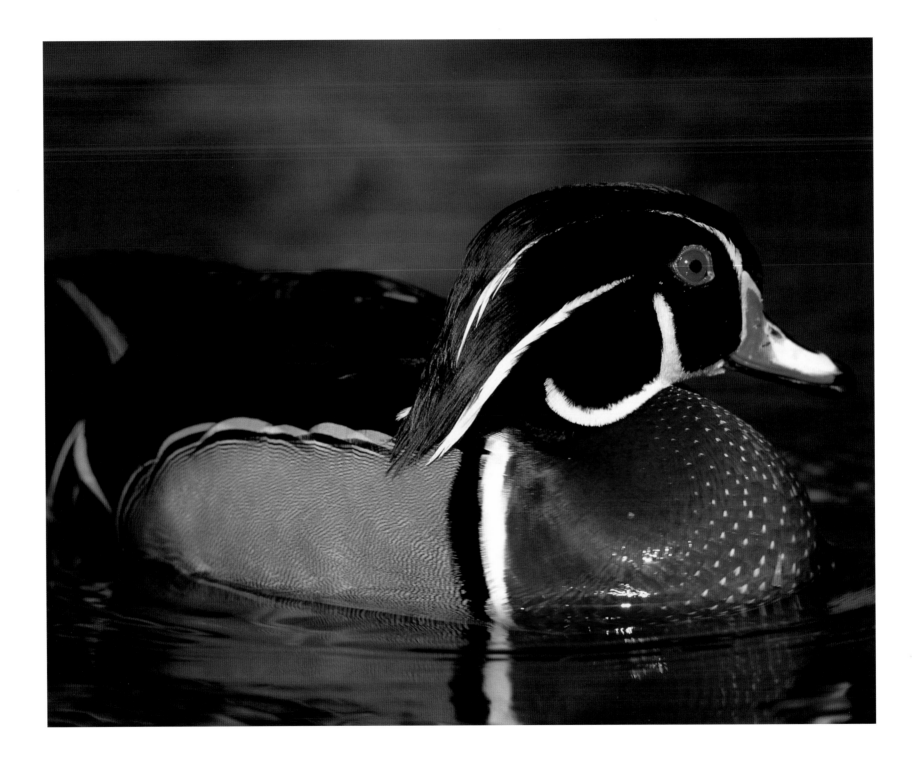

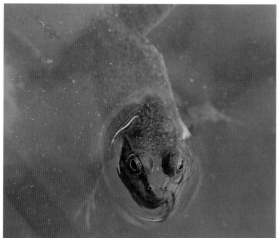

Far left: Wood duck (*Aix sponsa*), Sacramento National Wildlife Refuge Complex

Left: North American bullfrog (*Rana catesbeiana*), Sacramento National Wildlife Refuge Complex

Below: Young river otters (*Lutra canadensis*), Sacramento River, Central Valley Basin

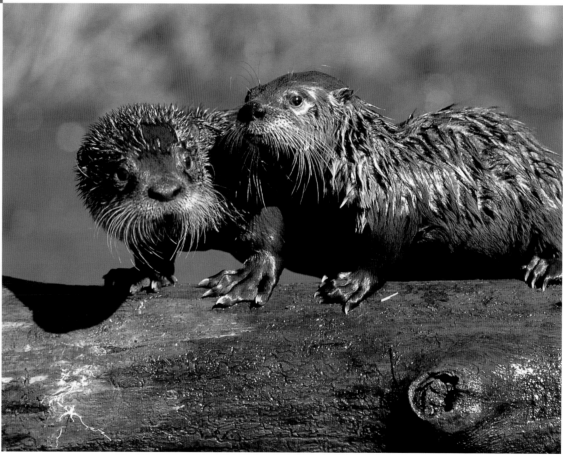

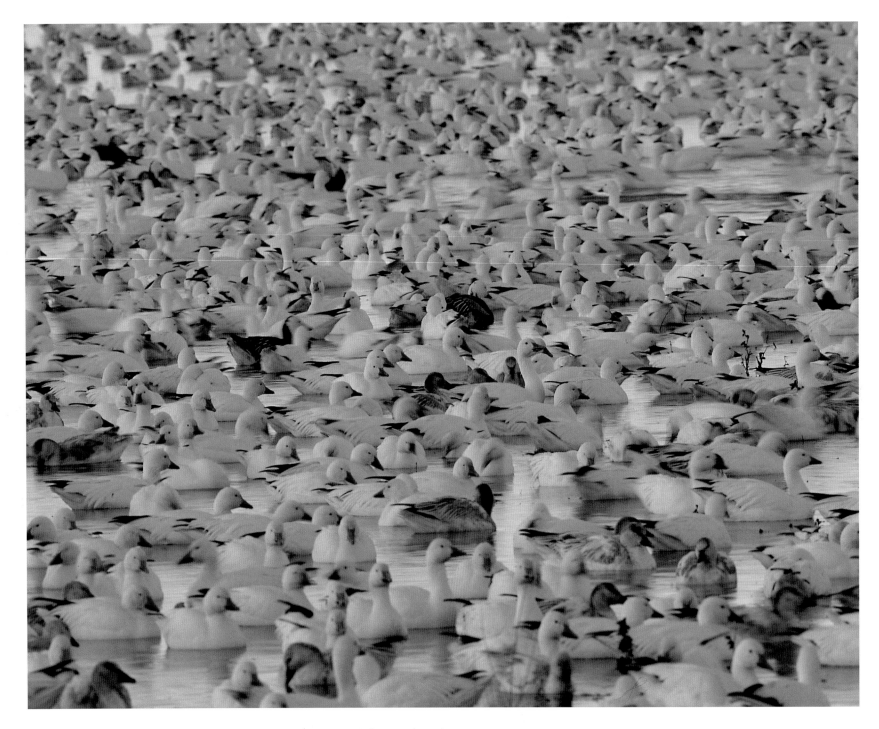

Snow geese (*Chen caerulescens*) over-wintering,
Sacramento National Wildlife Refuge Complex

126

CALIFORNIA

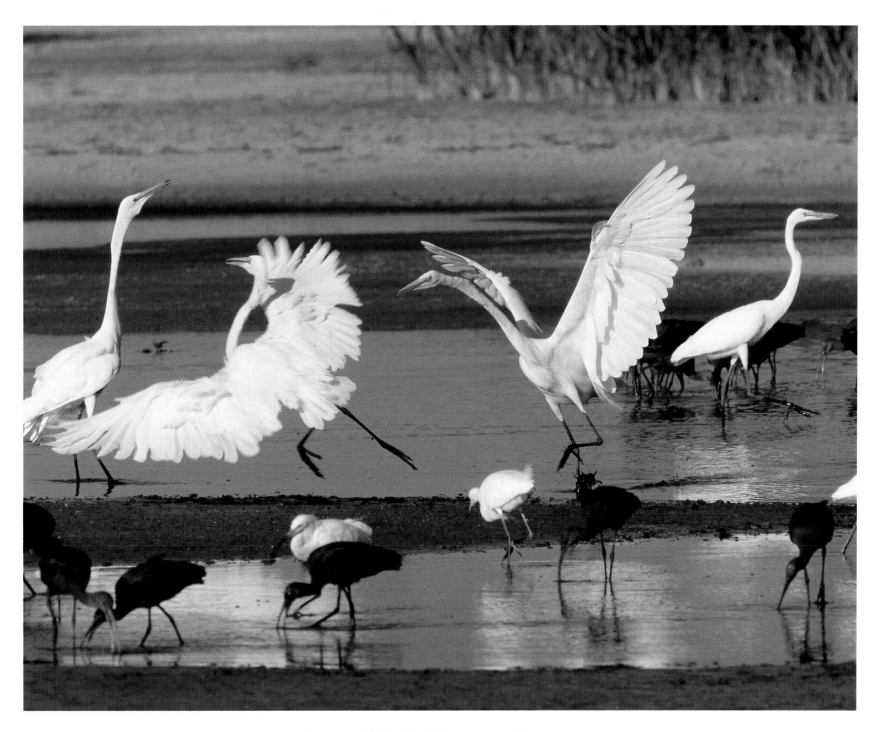

Great egrets (*Ardea alba*) challenging one another over prime feeding territory, San Luis National Wildlife Refuge Complex

Sunset over marsh, San Luis National Wildlife Refuge
Complex

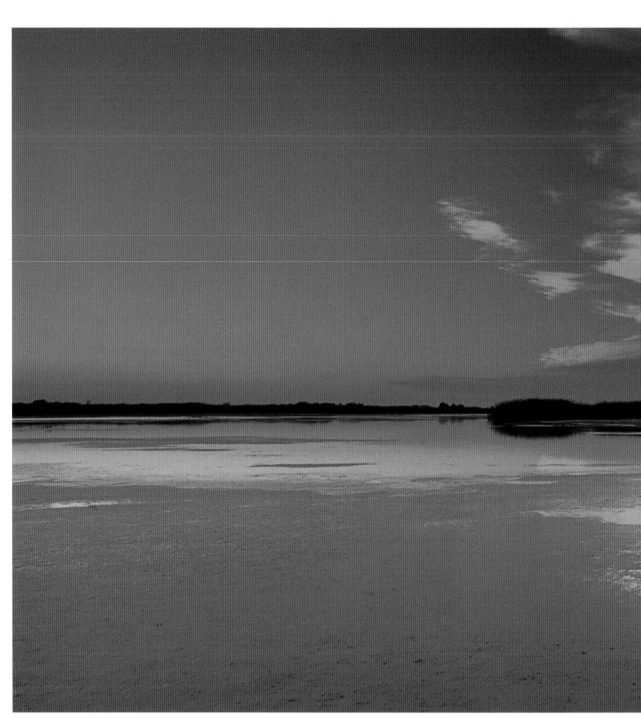

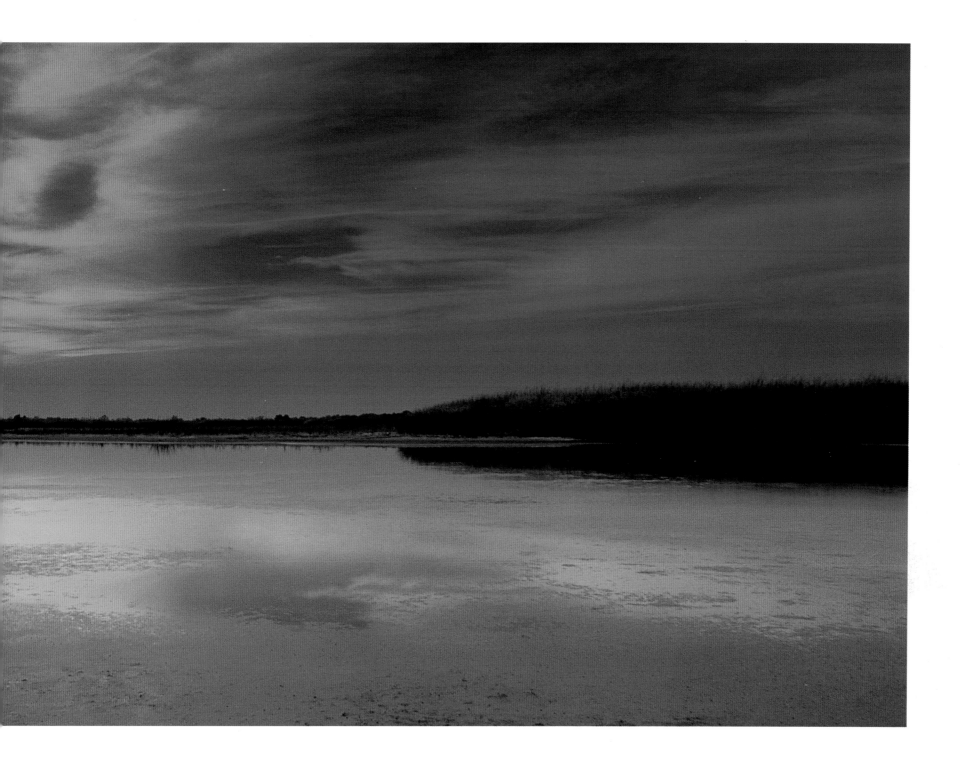

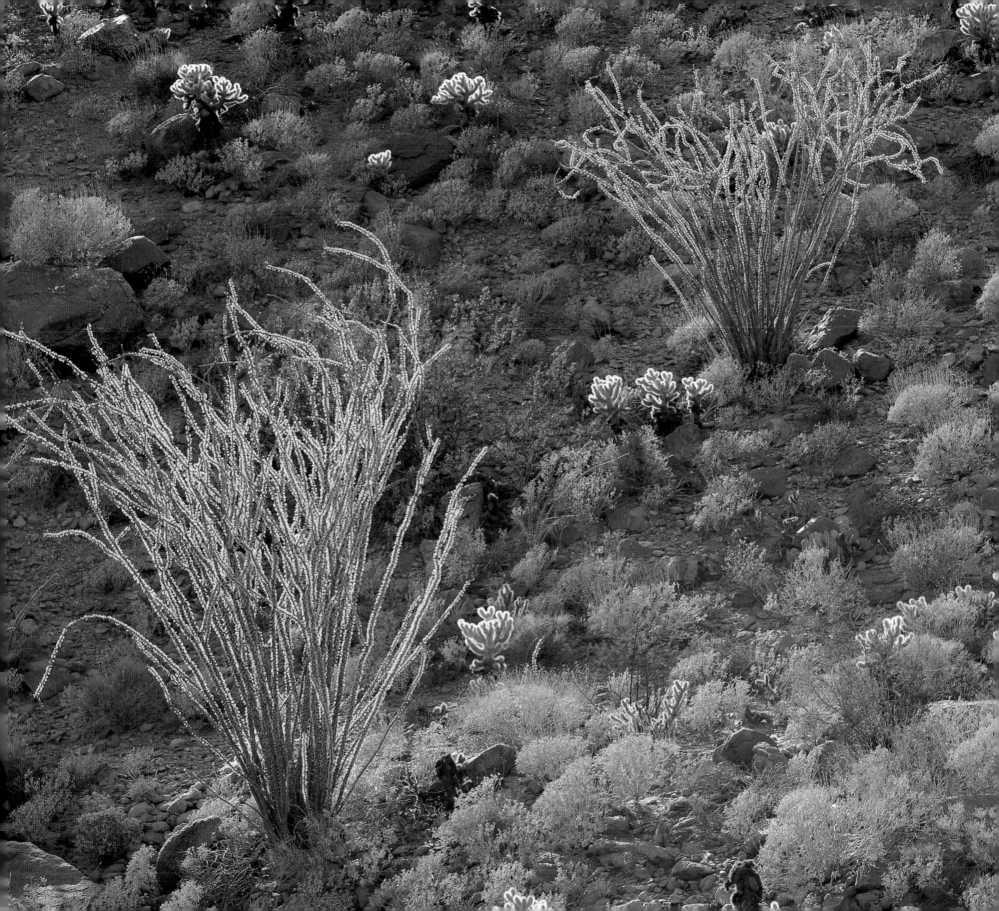

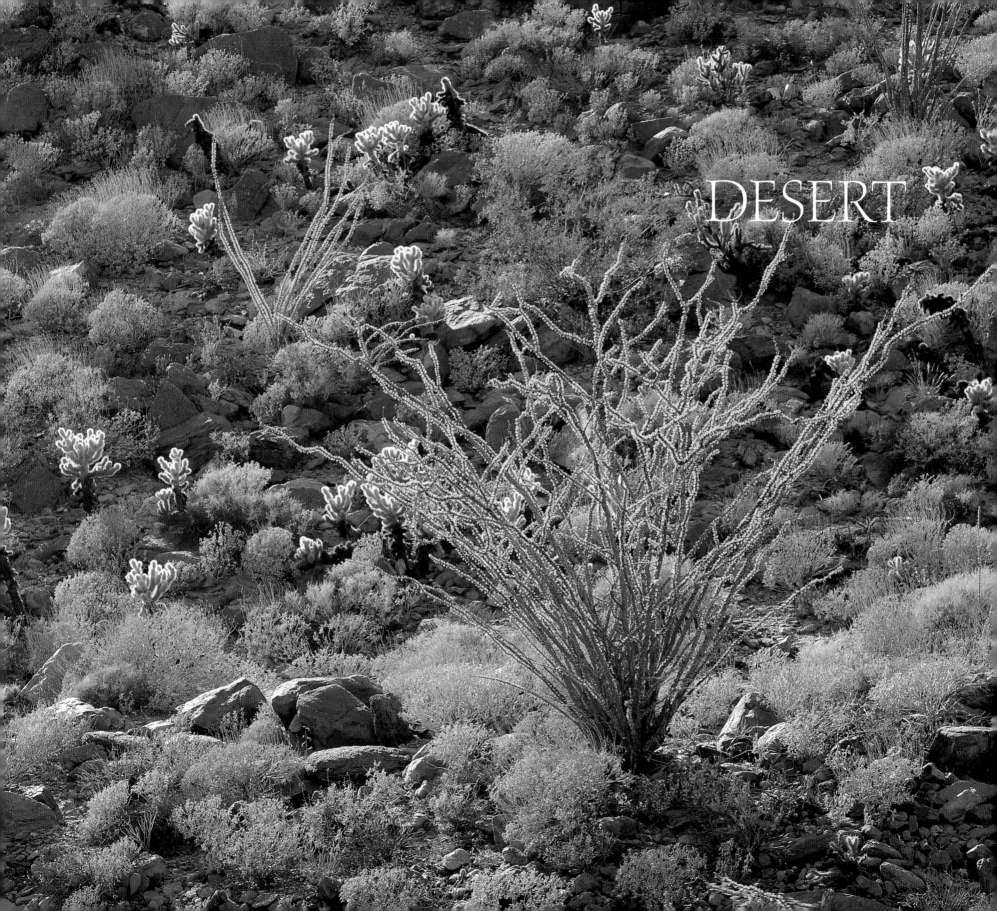

DESERT

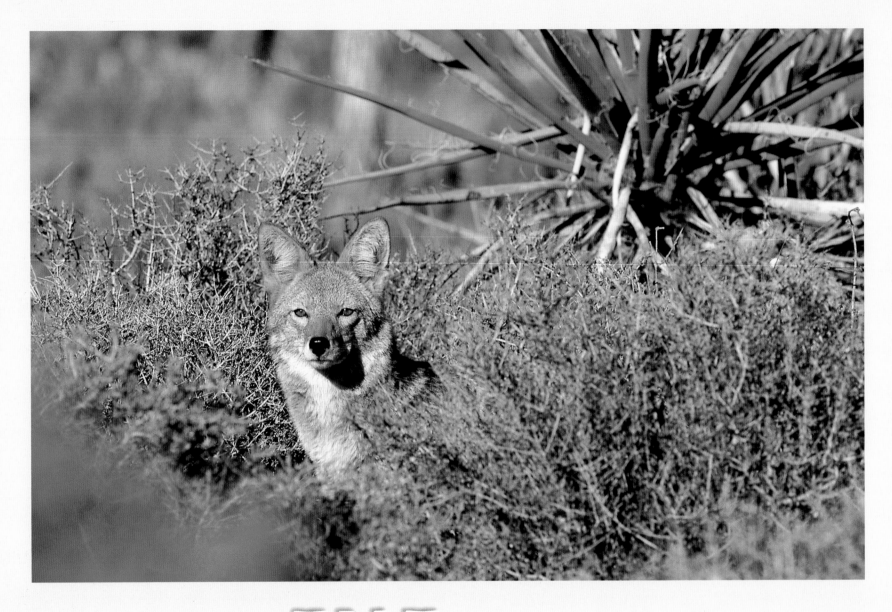

When the storm sailed in, it moved eastward up the ancient dry bed of the Mojave River. Growing darker, the cloud galleons bumped across the spilled lava flows of the Devils Playground, glided anchorless over the cream-colored swirls of the Kelso Dunes system, and

then tore their heavy keels on the Providence Mountains. Tore them completely off.

A cargo of water, falling now as swirling snow, blew down the steep rock-pile slope where we'd made our campsite high on the 5,000- to 6,000-foot range's eastern side. Tents bowed and strained in the wind while the desert around us turned an eerie white. After sundown, I looked again through the flaps, hoping to see a broken sky and stars. Nothing. No lights of towns or cars, just a dark wilderness so complete that my knowledge of cities planted somewhere else on this desert seemed ludicrous, especially rumors of an electric oasis called Las Vegas eighty miles to the northeast. We went to sleep that night listening to the wind's frustration as it tried to pierce and level the granite wall at our backs.

I come to the desert to feel fragile and alive. Years of living by the sea in Southern California have coddled me. The moderating effect of the ocean on weather patterns seems to muffle my day-to-day experience into a long, pleasant journey of warm, foggy summers and almost equally warm, clear winters. The Mojave, on the other hand, gives me what I want. Extremes. This huge wedge, extending from Death Valley in the northeast corner, south to Joshua Tree, and west to the Antelope Valley and the Tehachapi Mountains, seems driven into the state's lower trunk like a splitting maul of fierce heat and equally astonishing cold.

East from the railroad town of Barstow, old Route 66 plays tag with its usurper, Interstate 40. Bypassed "towns" such as Ludlow, Amboy, Essex, and Bagdad fry in the heat and turn brittle with winter cold, often in the same day. Temperatures can range fifty degrees between afternoon highs and predawn lows. The atmosphere buffets you with its ground effect of rising, superheated air. Coupled with this sun come to earth, the Bagdad area has also been called the driest place on earth, thanks to a stretch of 767 days without a wisp of precipitation.

Well to the north of Bagdad, but tucked into a corner of this same province often called high desert, Death Valley's Furnace Creek recorded a high of 134.6°F on July 10, 1913. For a week the thermometer never dipped below about 93°F. Here the valley is anything but high as it dips to the lowest elevation in North America: 282 feet below sea level at Badwater, an alkali sink that mirrors the Panamint Mountains. As always in the desert, one extreme never seems far from another.

I drive the desert more than I hike. The distances command it. But when pavement gives

way to gravel, then washboard, then deepening ruts and pools of sand, I leave the car and strike out on foot, several bottles of water stashed in my pack pockets. In California's southernmost desert, the Colorado, I work my way up canyons in search of fan palm groves and deep, still pools. Named for its proximity to the river, not the state, the Colorado encompasses the Salton Trough, a huge basin once inundated by the Pleistocene Lake Cahuilla, whose wave-cut waterline is still visible in side canyons and buttressing alluvium of the Santa Rosa Mountains west of the Salton Sea. The palm groves occur primarily on this east side of the Transverse and Peninsular Ranges, where water seeps from side rifts of the San Andreas Fault.

On a hike in Anza-Borrego Desert State Park in late spring of a drought year, two events occurred in a single day that I didn't expect in my lifetime. Scrambling up the side of a wash, I reached down at the top for a last handhold. There, as if dropped the year before, were the shards of an ocher-colored pot inscribed with faint slip lines and rhythmic indentations made by a stylus or fingernail. I saw the accident clearly. Reaching down with one hand a few hundred years before me, a tribesman or -woman returning to the cool groves and pine forests above had stumbled and dropped the pot.

Later that same day I pulled myself higher into a granite bowl cut by a year-round stream. Crouched in shade, I looked up at a cluster of overhanging boulders. Atop one, less than thirty feet away, a male Peninsular bighorn sheep appeared. His horns curled back from just above his eyes in a tight-arced series of ridges. He moved warily toward the edge and scanned the grove below. Three ewes joined him, poised against the skyline. Masters of speed and camouflage, these acrobats are seldom seen up close; the drought had made them bolder. They stood looking over the canyon, then moved off downstream and out of sight, wraiths of adaptation and elusion in a place that offers little physical solace and even fewer water sources.

That morning on the Providence slope, we hiked back to the trailhead quickly. We knew that the view from Kelso Dunes would equal a desert Switzerland. On Kelso's highest summit later that afternoon, the cool sand was dry despite being almost 700 feet above the surrounding desert floor. The atmosphere crackled with clarity. Providence rose to our east, true to its name, its snowy summits offering a salvation of endless views, humbling scale, and constant change.

Right: Last Chance Range, Eureka Valley

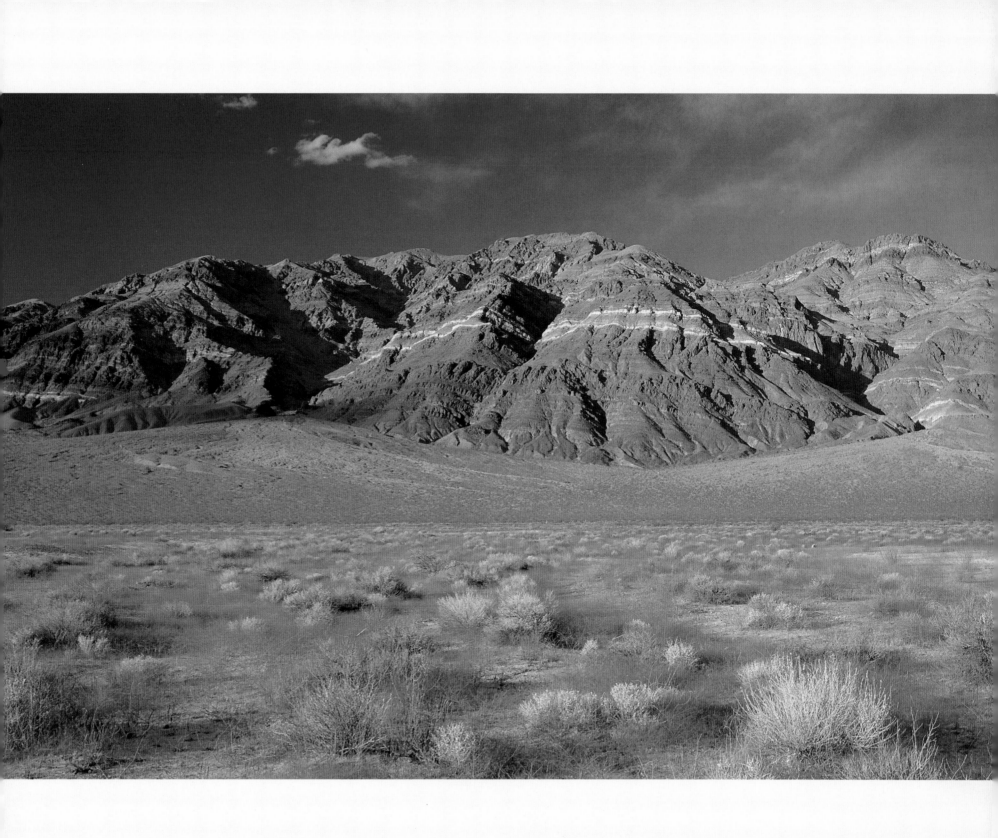

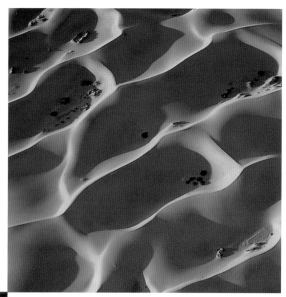

Left: Aerial of sand dunes, Death Valley National Park

Below: Aerial landscape, Zabriskie Point, Death Valley National Park

Right: Aerial landscape, Mesquite Flat Sand Dunes, Death Valley National Park

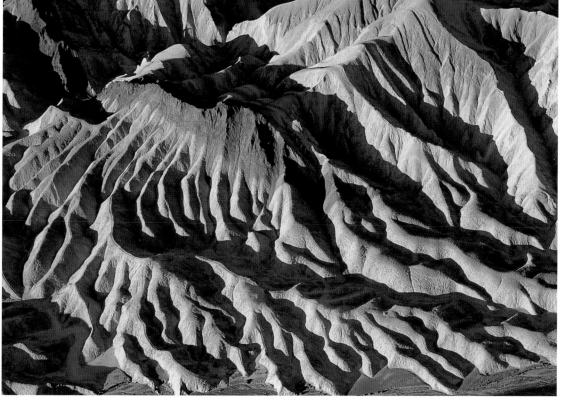

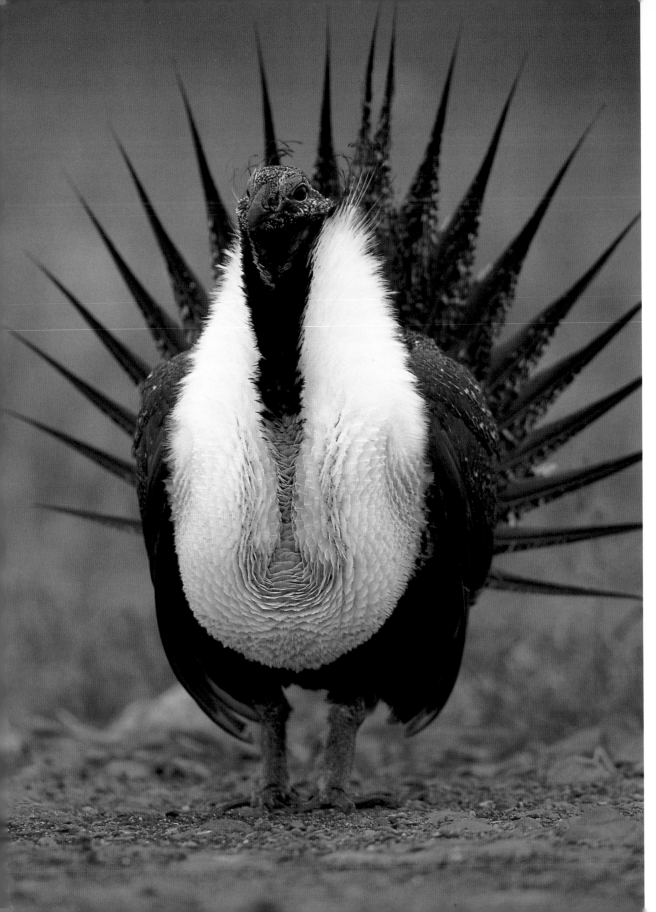

Left: Greater sage-grouse (*Centrocercus urophasianus*), Owens Valley

Right: Sunrise over tufa towers, Mono Lake Tufa State Reserve

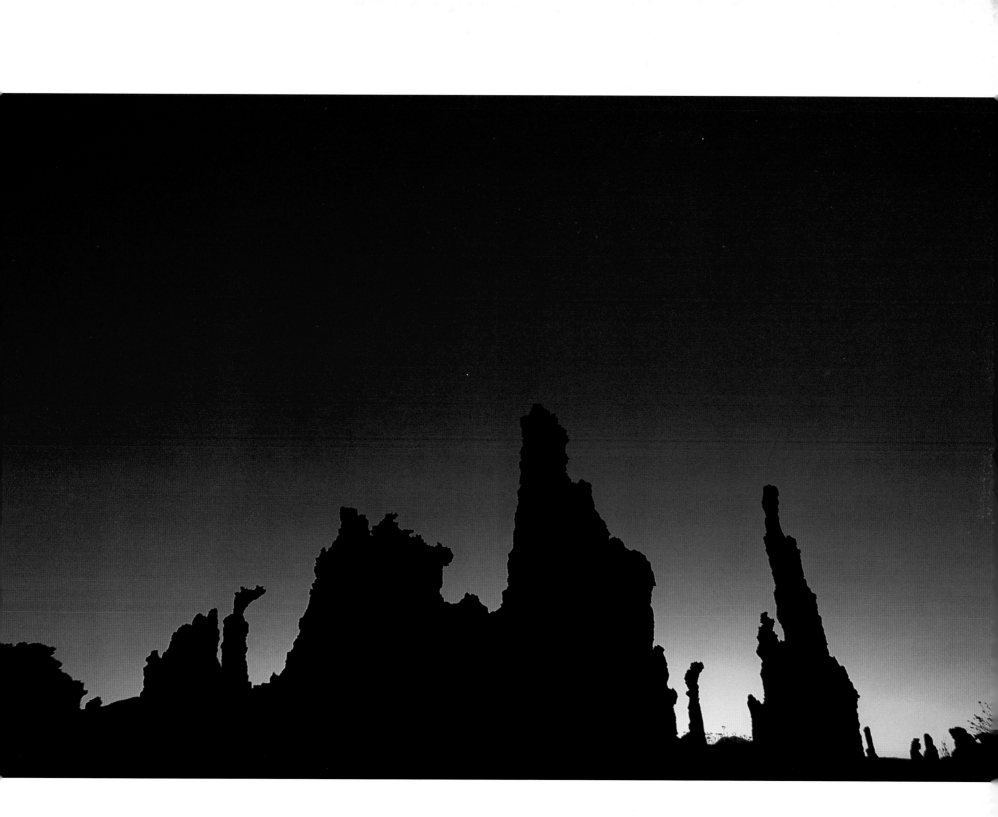

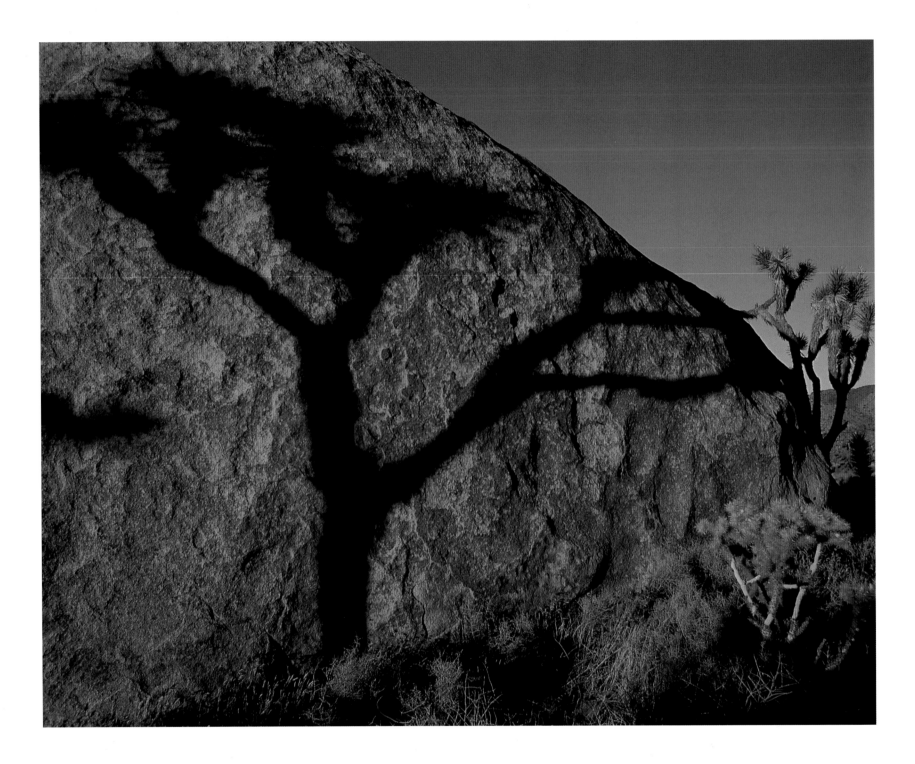

CALIFORNIA

 Shadow of Joshua tree (*Yucca brevifolia*), Joshua Tree National Park

Right: Joshua trees (*Yucca brevifolia*) at sunrise, Joshua Tree National Park

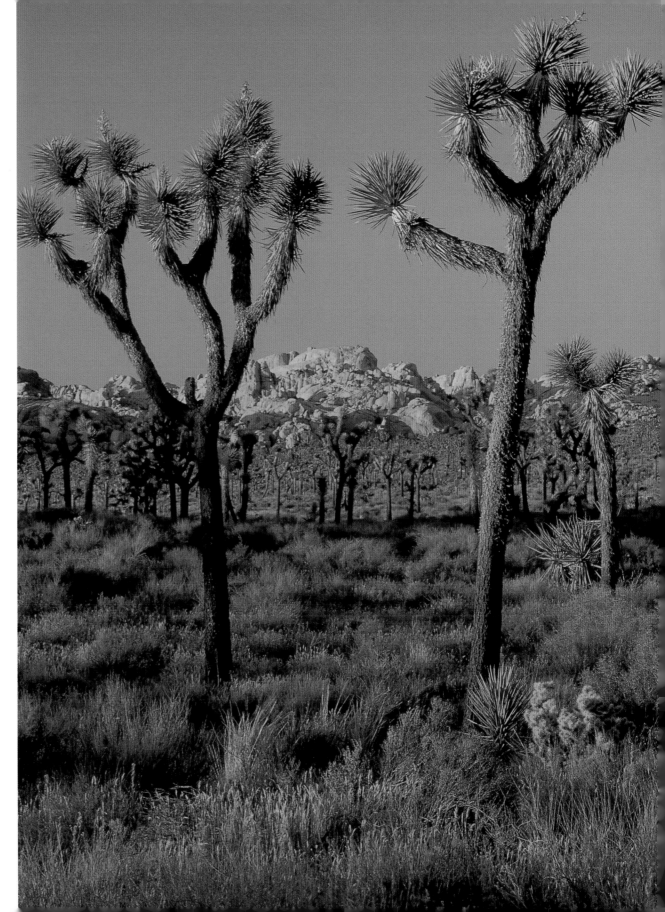

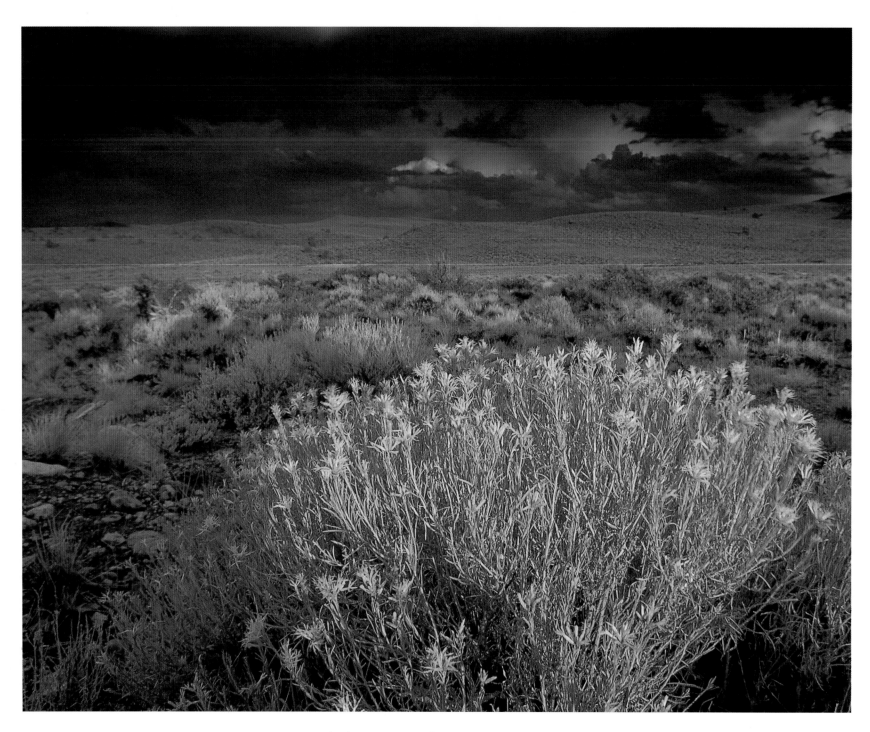

Desert landscape, Owens Valley

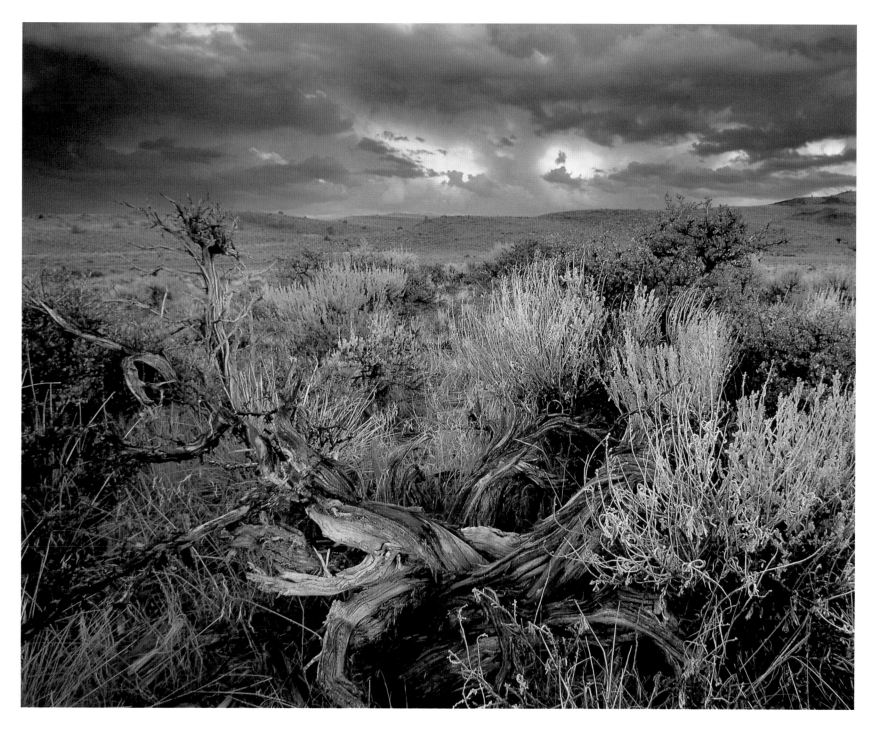

Thunderstorm over desert, Owens Valley

Below: American avocets (*Recurvirostra americana*) along the shallow waters of Owens Lake, Owens Valley

Right: Dried mud puddle, Death Valley National Park

Far right: Moonrise, Owens Lake, Owens Valley

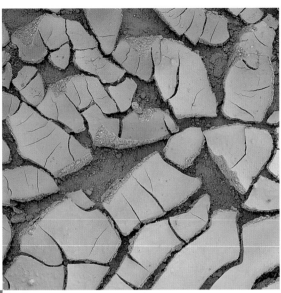

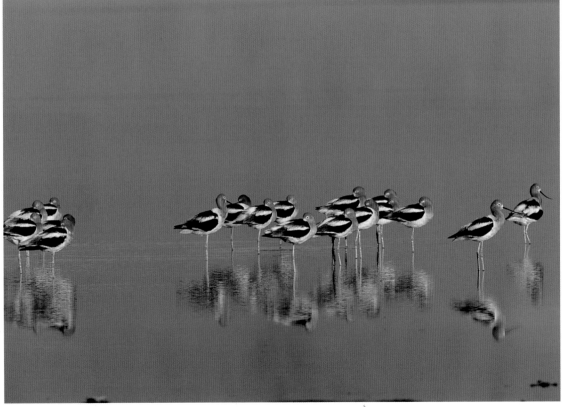

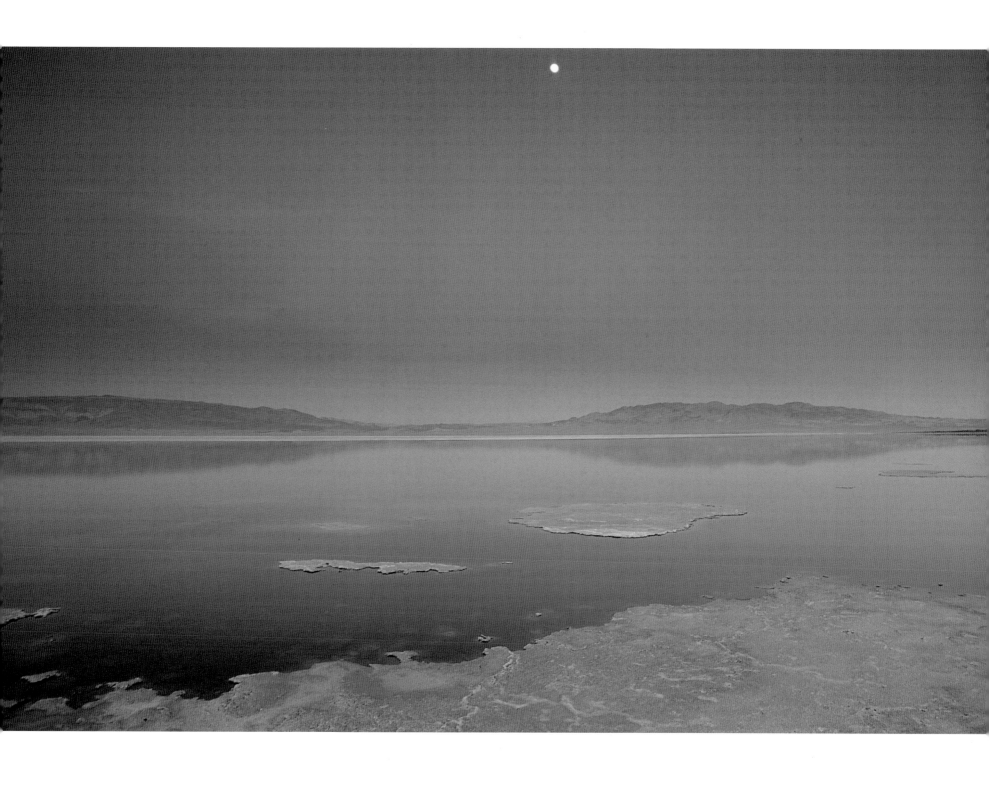

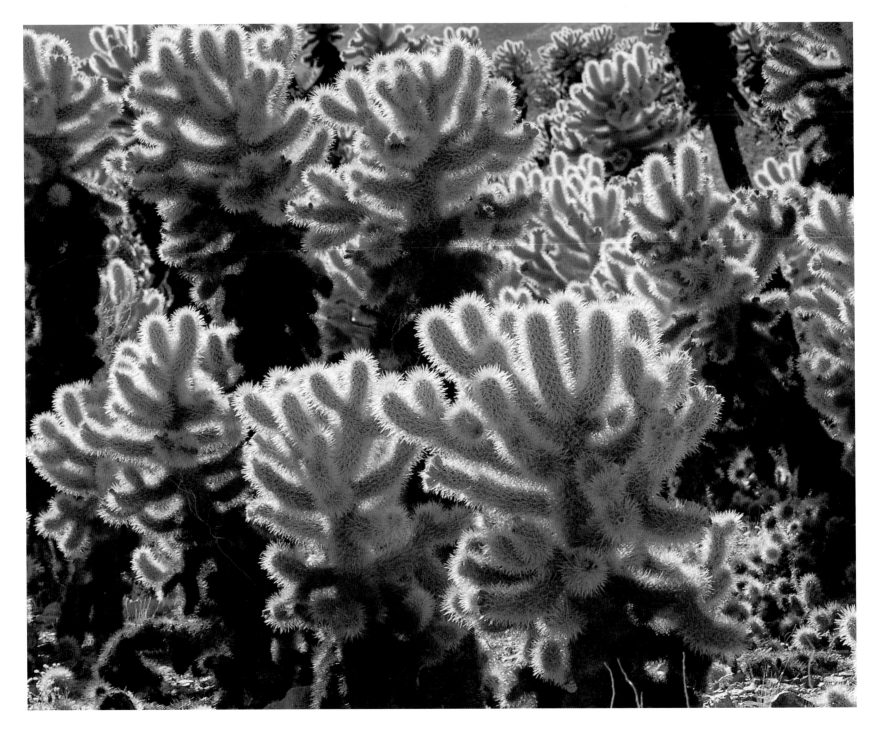

Teddy bear cholla "jumping cactus" (*Opuntia bigelovii*),
Joshua Tree National Park

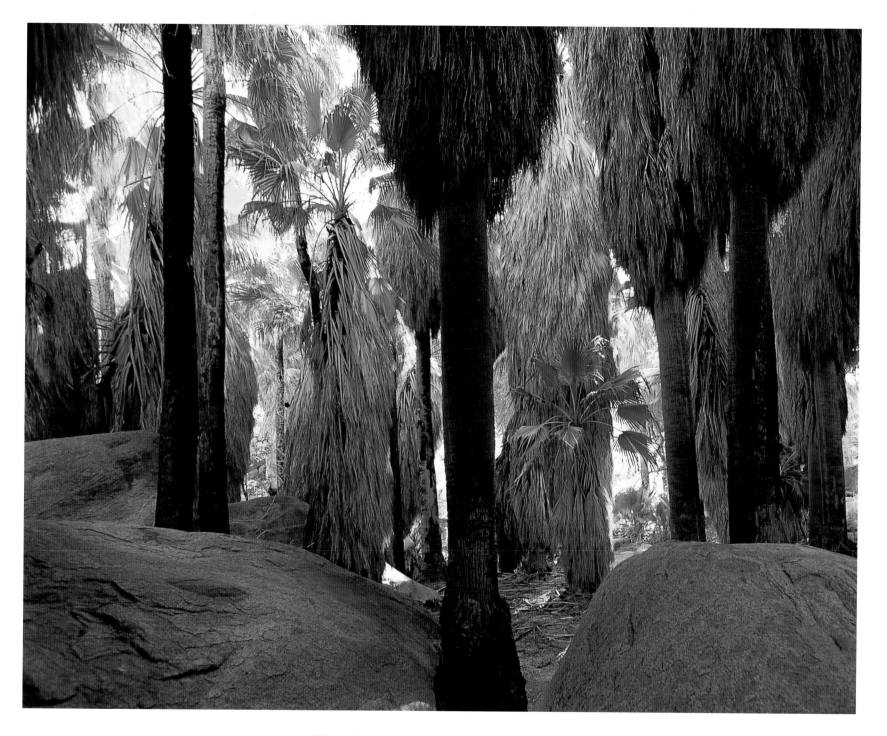

California fan palm (*Washingtonia filifera*) oasis,
Anza-Borrego Desert State Park

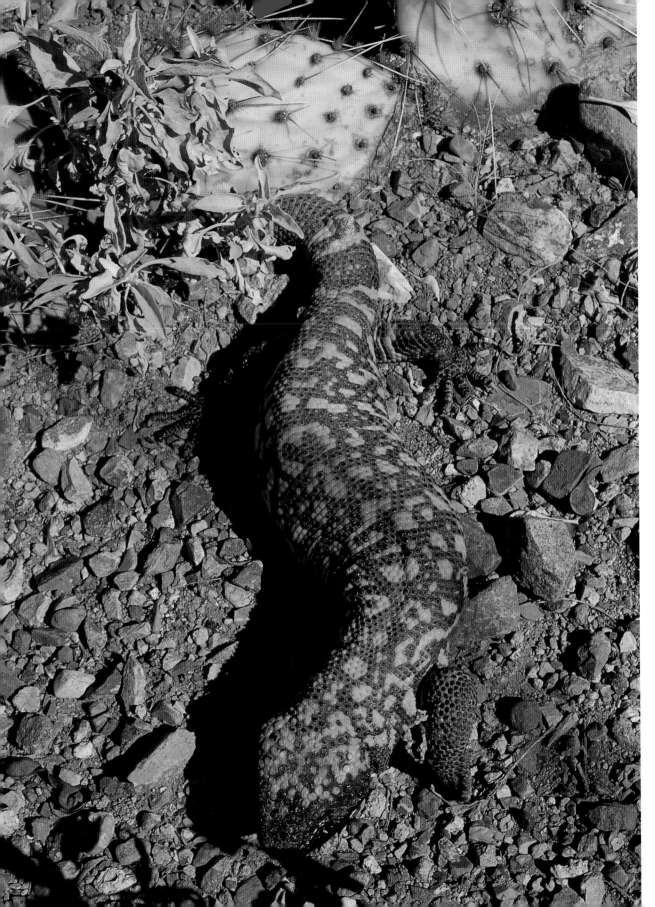

Left: Gila monster (*Heloderma suspectum suspectum*), McCoy Mountains

Right: Desert snowfall, Anza-Borrego Desert State Park

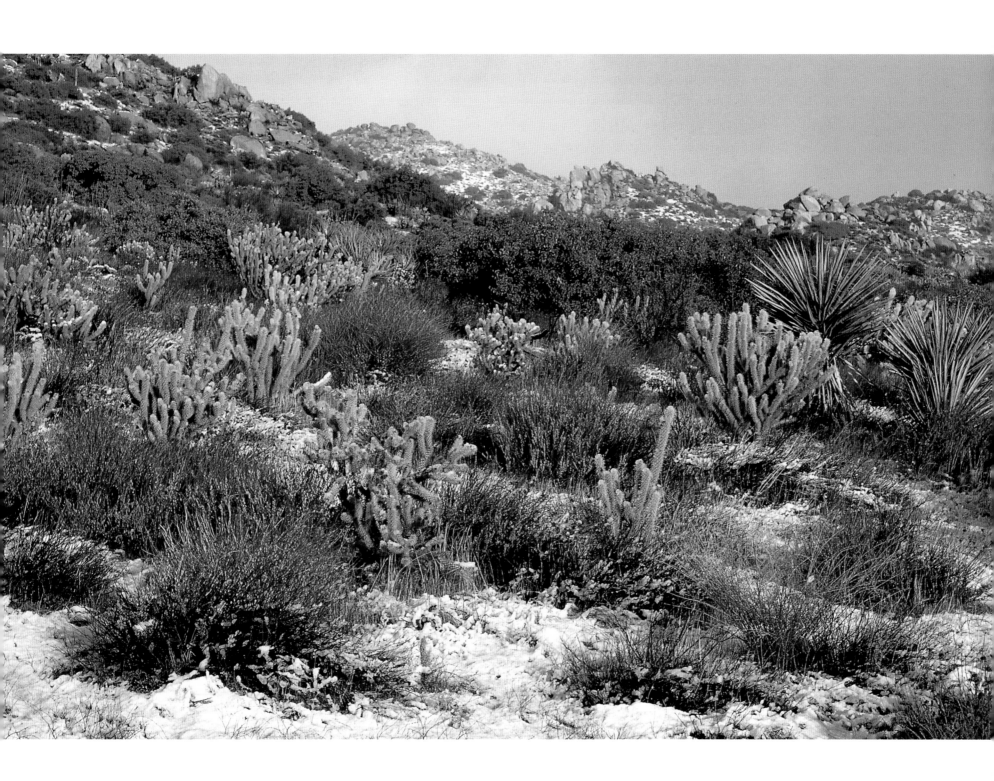

Below: Gambel's quail (*Callipepla gambelii*), Anza-Borrego Desert State Park

Right: Burrowing owlets (*Athene cunicularia*), Owens Valley

Far right: Last Chance Range, Eureka Valley

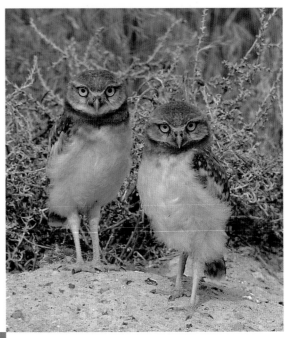

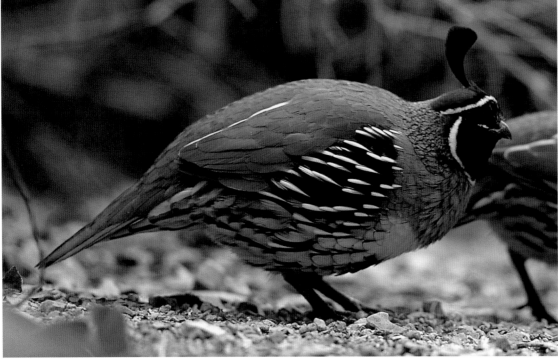

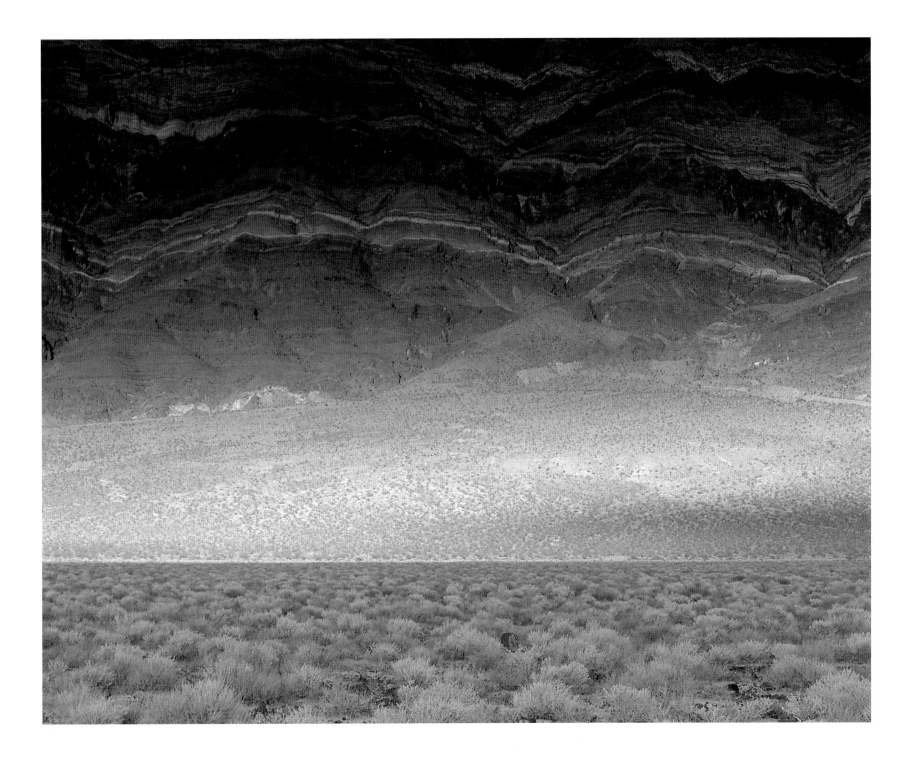

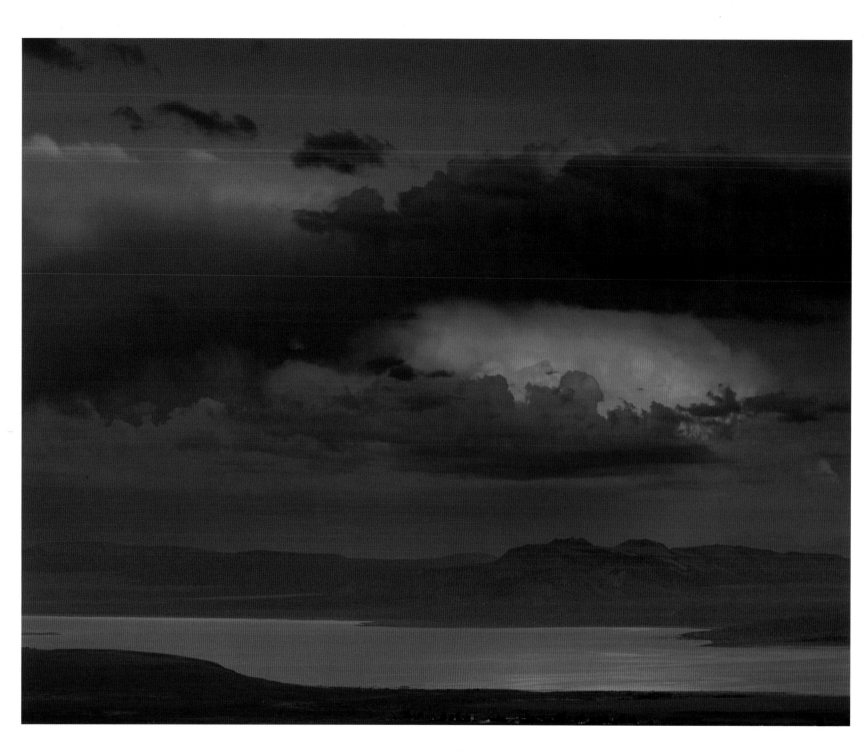

Sunset over Mono Lake, Mono Lake Tufa State Reserve

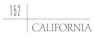

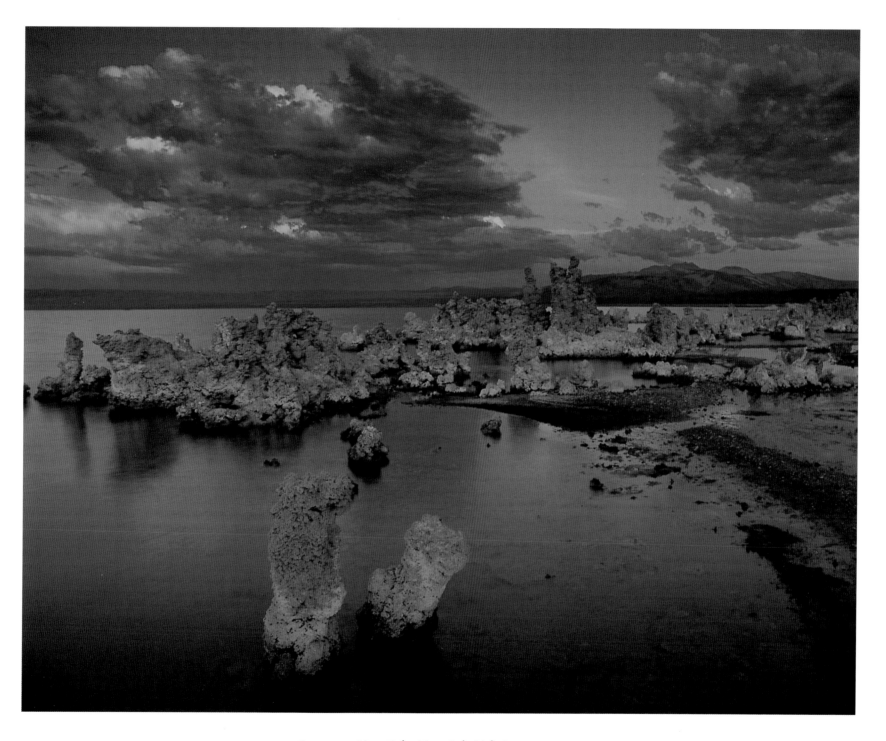

Sunset over Mono Lake, Mono Lake Tufa State Reserve

Left: Joshua tree (*Yucca brevifolia*), Joshua Tree National Park

Right: Desert landscape, Anza-Borrego Desert State Park

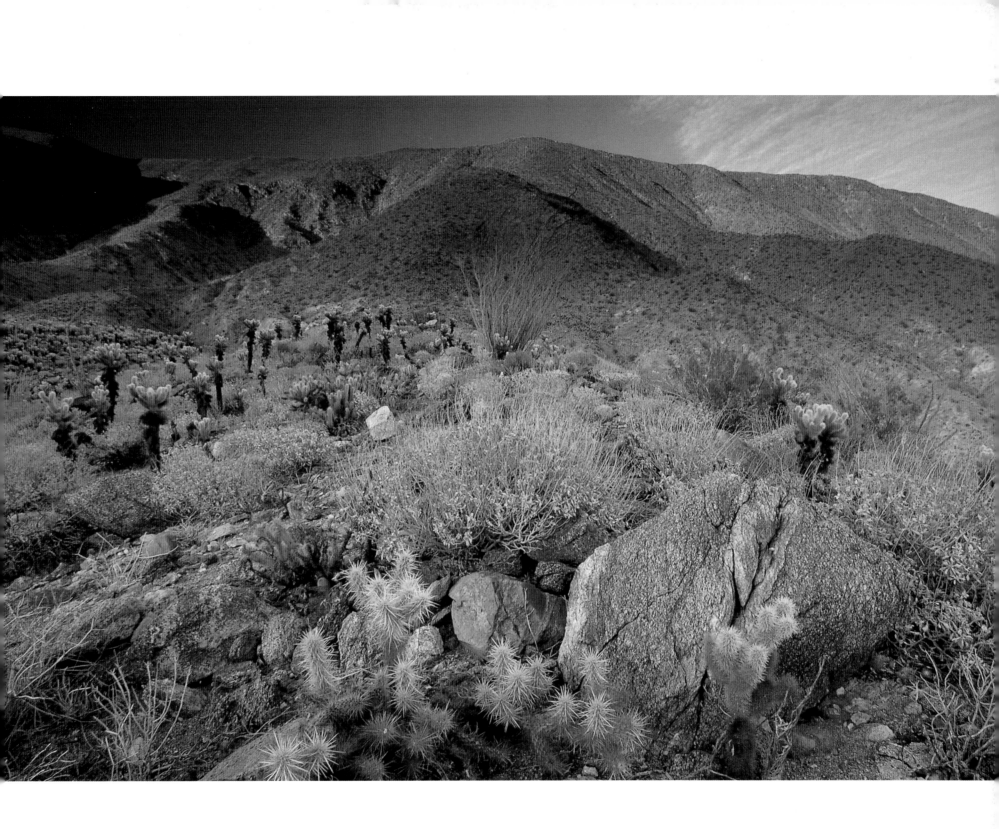

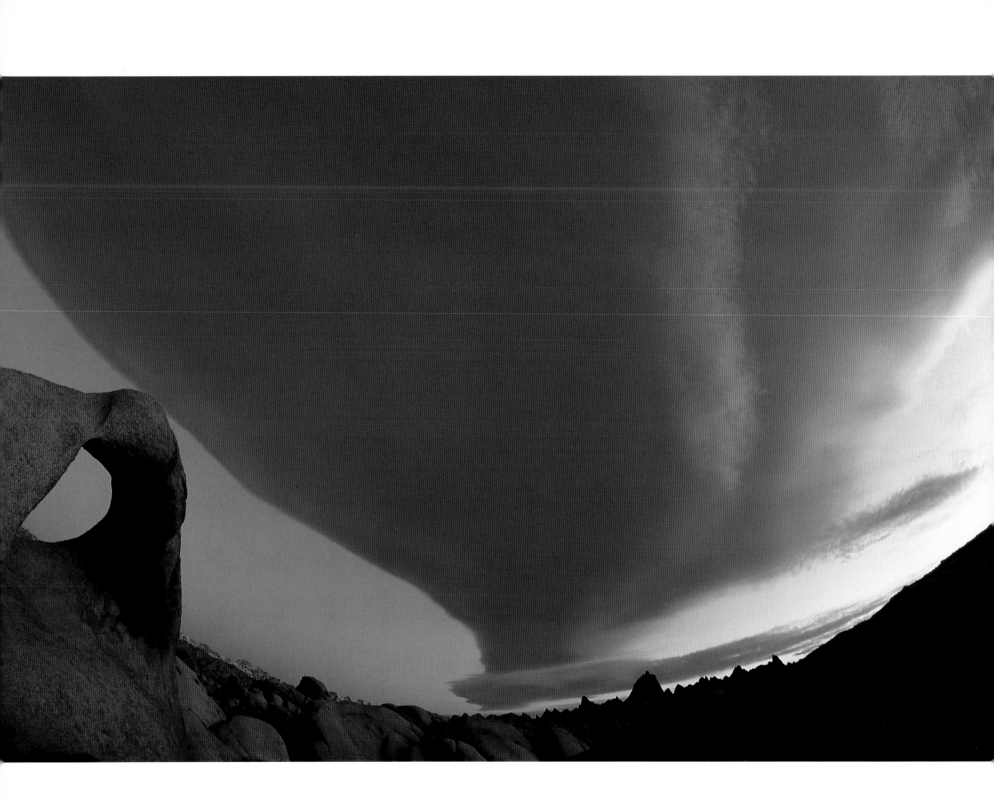

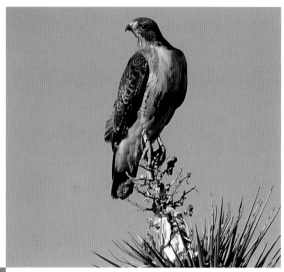

Left: Granite arch, Alabama Hills

Below: Peninsular bighorn sheep (*Ovis canadensis cremnobates*), Anza-Borrego Desert State Park

Right: Red-tailed hawk (*Buteo jamaicensis*), Joshua Tree National Park

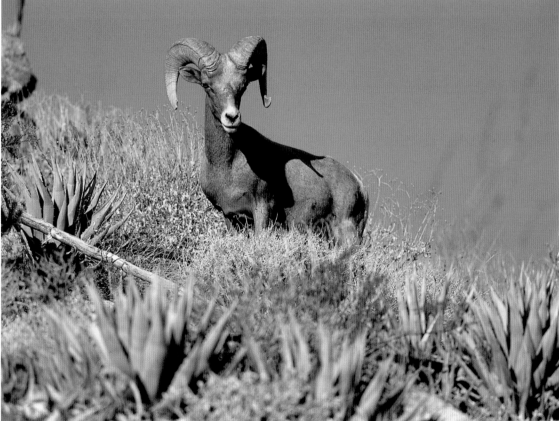

RESOURCE LIST

We hope that this book will increase your appreciation of all that California has to offer. We also hope that it will stimulate concern, and in turn lead to action to ensure a sound future for such a varied and special place. In support of this, we are including a partial list of California organizations that have dedicated themselves to this future.

American Land Conservancy
456 Montgomery Street, Suite 1450
San Francisco, CA 94104
Tel: 415-403-3850
Fax: 415-403-3011
Email: mail@alcnet.org
www.alcnet.org

American River Conservancy
P.O. Box 562
Coloma, CA 95613
Tel: 530-621-1224
Fax: 530-621-4818
Email: dtach@arconservancy.org
www.arconservancy.org

Bay Area Action
Susan Stansbury
3921 E. Bay Shore Road
Palo Alto, CA 94303
Tel: 650-962-9876
Email: baaction@igc.org
www.baaction.org

Big Sur Land Trust
P.O. Box 221864
Carmel, CA 93922
Tel: 831-625-5523
Fax: 831-625-0716
Email: mail@bigsurlandtrust.org
www.bigsurlandtrust.org

California Biodiversity Council
1416 9th Street, Room 1311
Sacramento, CA 95814
Tel: 916-227-2661
Fax: 916-227-2672
Email: erin-klaesius@fire.ca.gov
ceres.ca.gov/biodiv

California Clean Water Action (California CWA)
Marguerite Young
23 Grant Avenue, Floor 3
San Francisco, CA 94108-5828
Tel: 415-362-3040
Fax: 415-362-3188
Email: cwasf@cleanwater.org
www.cleanwateraction.org/us/ca/california.htm

California Coastal Coalition (CalCoast)
1133 Second Street, Suite G
Encinitas, CA 92024
Tel: 760-944-3564
Email: steveaceti@calcoast.org
www.calcoast.org

California Environmental Protection Agency
1001 I Street
Sacramento, CA 95814
Tel: 916-445-3846
Fax: 916-445-6401
Email: epasecty@calepa.ca.gov
www.calepa.ca.gov

California Futures Network
2201 Broadway, Suite 815
Oakland, CA 94612
Tel: 510-238-9762
Fax: 510-238-9769
Email: info@calfutures.org
www.calfutures.org

California League of Conservation Voters (CLCV)
1212 Broadway, Suite 630
Oakland, CA 94612
Tel: 510-271-0900
Fax: 510-271-0901
Email: jrainwater@ecovote.org
www.ecovote.org

California Native Plant Society (CNPS)
1722 J Street, Suite 17
Sacramento, CA 95814
Tel: 916-447-2677
Fax: 916-447-2727
Email: cnps@cnps.org
www.cnps.org

California Oak Foundation (COF)
1212 Broadway, Suite 810
Oakland, CA 94612
Tel: 510-763-0282
Fax: 510-208-4435
Email: oakstaff@californiaoaks.org
www.californiaoaks.org

California Public Interest Research Group (CALPIRG)
3435 Wilshire Boulevard #385
Los Angeles, CA 90010
Tel: 213-251-3680
Fax: 213-251-3699
Email: calpirg@pirg.org
www.pirg.org/calpirg

California Trout
870 Market Street, #1185
San Francisco, CA 94102
Tel: 415-392-8887
Fax: 415-392-8895
Email: branco@caltrout.org
www.caltrout.org

California Wilderness Coalition
2655 Portage Bay East, Suite 5
Davis, California 95616
Tel: 530-758-0380/0382
Fax: 530-758-0380/0382
Email: info@calwild.org
www.calwild.org

Center for Community Action and Environmental
Justice / Centro para Accion de la Comunidad y
Justicia Ambiente (CCAEJ)
Penny Newman
P.O. Box 33124
Riverside, CA 92519-0124
Tel: 909-360-8451
Fax: 909-360-5950
Email: pennynewman@ccaej.org
www.ccaej.org

Forest Ethics
P.O. Box 3418
Berkeley, CA 94703
Tel: 510-533-8725
Fax: 253-399-3775
www.forestethics.org

Mono Lake Committee
Fran Spivey-Weber
2001 West Magnolia Suite F
Burbank, CA 91605
Tel: 818-972-2025
Fax: 818-972-9400
Email: info@monolake.org
www.monolake.org

Mountain Lion Foundation
P.O. Box 1896
Sacramento, CA 95812
Tel: 916-442-2666
Fax: 916-442-2871
Email: mlf@mountainlion.org
www.mountainlion.org

Napa County Land Trust
1040 Main Street, Suite 203
Napa, CA 94558
Tel: 707-252-3270
Fax: 707-252-1071
Email: info@napalandtrust.org
www.napalandtrust.org

National Audubon Society - California
555 Audubon Place
Sacramento, CA 95825
Tel: 916-481-5332
Email: jjacobs@audubon.org
www.calaudubon.wego.com

Nature Conservancy of California
Fryar Calhoun
201 Mission Street, 4th Floor
San Francisco, CA 94105
Tel: 415-777-0487
Fax: 415-777-0244
Email: Wadmin@tnc.org
www.tnc.org

Planning and Conservation League
926 J Street, Suite 612
Sacramento, CA 95814
Tel: 916-444-8726
Fax: 916-448-1789
Email: pclmail@pcl.org
www.plc.org

Save-the-Redwoods League
114 Sansome Street, Room 1200
San Francisco, CA 94104-3823
Tel: 415-362-2352
Fax: 415-362-7017
Email: info@savetheredwoods.org
www.savetheredwoods.org

Sierra Club – California Chapter
85 Second Street, Second Floor
San Francisco, CA 94105-3441
Tel: 415-977-5500
Fax: 415-977-5799
Email: information@sierraclub.org
www.sierraclub.org/chapters/ca

Sierra Nevada Alliance
P.O. Box 7989
South Lake Tahoe, CA 96158
Tel: 530-542-4546
Fax: 530-542-4570
Email: sna@sierranevadaalliance.org
www.sierranevadaalliance.org

Published by Sasquatch Books

Distributed by Publishers Group West

Printed in China

09 08 07 06 05 04 03 6 5 4 3 2 1

Cover and interior design: Karen Schober

Map illustration: Jane Shasky

Cover photograph: Point Reyes Beach, Point Reyes National Seashore; *photograph page 1:* California quail (*Callipepla californica*), Mount Tamalpais State Park; *photograph pages 2–3:* Giant sequoia (*Sequoiadendron giganteum*), Mariposa Grove, Yosemite National Park; *photographs page 5:* wave-polished rocks, Point Lobos State Reserve; California poppies (*Eschscholzia californica*), Antelope Valley California Poppy Reserve; sand dunes, Death Valley National Park; *photograph pages 6–7:* El Capitan (left), Half Dome (center), and Bridalveil Fall (right), Yosemite National Park

Library of Congress Cataloging-in-Publication Data

Wolfe, Art.

 California / Art Wolfe ; text by Peter Jensen.

 p. cm.

 ISBN I-57061-280-3 (paperback)—ISBN I-57061-279-X (hardcover)

 1. California—Pictorial works. 2. Landscape—California—Pictorial works.

 3. Natural history—California—Pictorial works. I. Jensen, Peter 1949– II. Title.

F862. W8 2003

917.94'0022'2—dc21 2003052649

Sasquatch Books

119 South Main Street, Suite 400

Seattle, WA 98104

(206) 467-4300

books@sasquatchbooks.com

www.sasquatchbooks.com